THE OTHER
HUNDRED

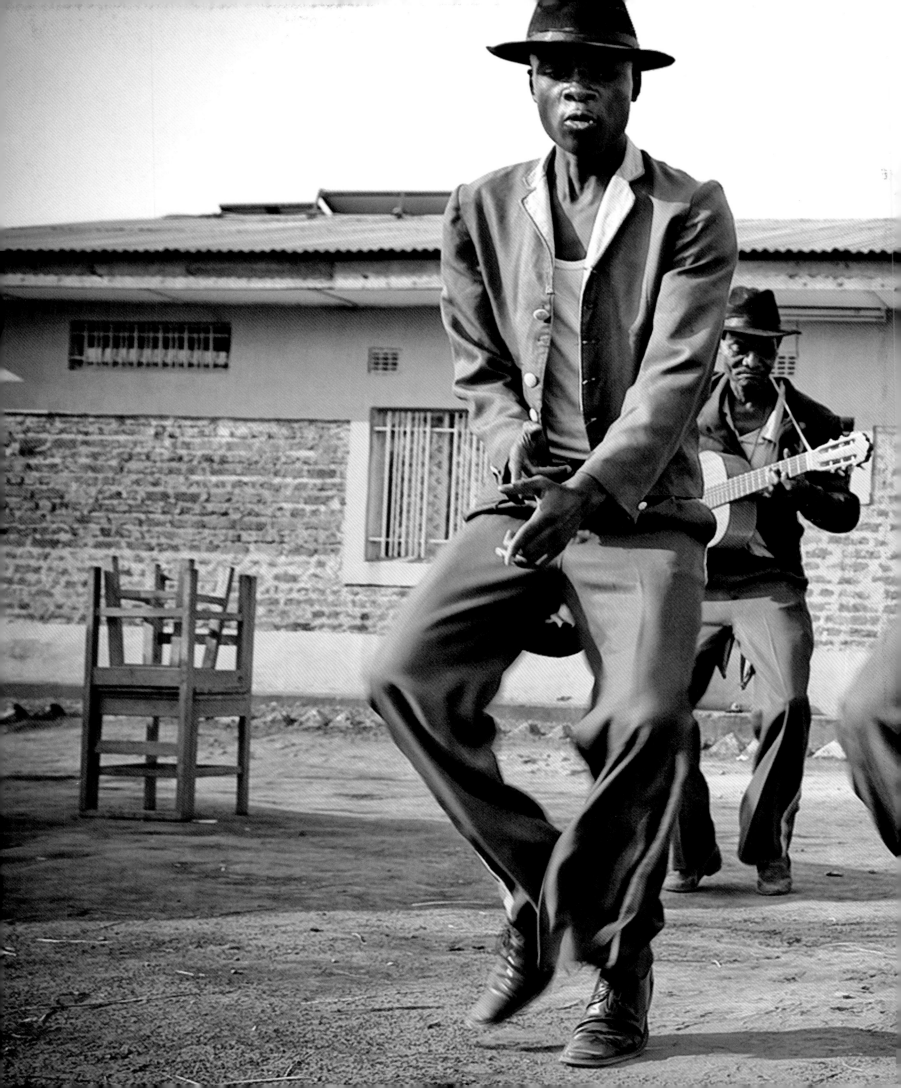

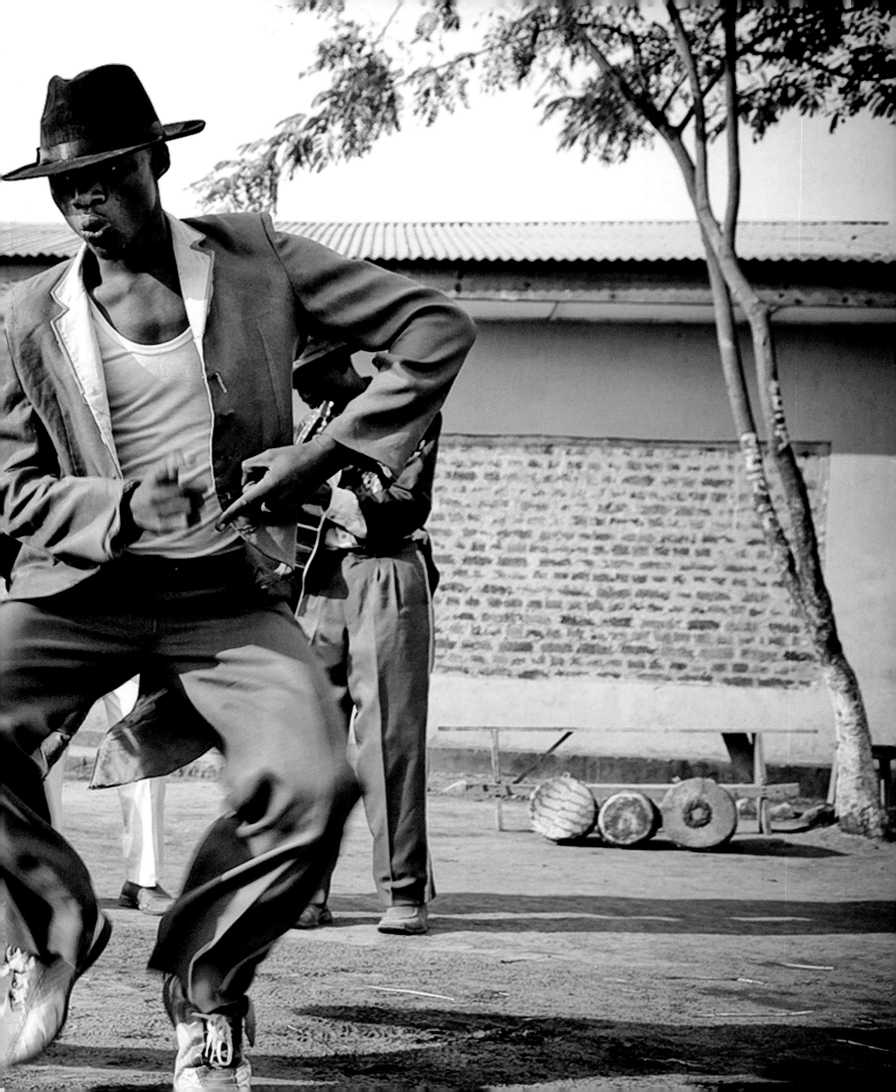

PREVIOUS PAGE

Tresor Kaluw and Joël Luya, two members of the Jeunes Comiques du Katanga – Jecoke – perform in a school courtyard in Lubumbashi, the capital of Katanga province in the Democratic Republic of the Congo.

Photographer
Gwenn Dubourthoumieu

THE OTHER HUNDRED

100

FACES
PLACES
STORIES

ONEWORLD

CONTENTS

The Other Hundred

FOREWORD

Chandran Nair

FOREWORD

Chandran Nair

For as long as I can remember, lists of the rich and famous have had a perverse hold on me. Populated with figures unlike anyone I had ever met with lifestyles the opposite of what I had always been taught was the right way to behave, they clearly could not be held up as models for emulation. And yet, with their wealth, power and influence, weren't they also meant to be models of success – figures we should be looking up to? Clearly there was confusion here – possibly even a contradiction.

My conclusion was that richlists were built around a lie. The reality is we can't all be rich. Most people on this planet can't even aspire to having even the tiniest fraction of wealth – eight out of ten live on US$10 or less a day. This is not something to celebrate, but nor should it have us despairing. Rather, it should tell us that if we want to look for success then we should look elsewhere than those celebrations of excess epitomised by the *Forbes'* billionaires list and its many imitators.

From this insight emerged the idea of The Other Hundred: to turn the notion of a richlist on its head and celebrate instead not just those at the other end of society, but the myriad ways in which people around the world use multiple means to gauge their own success and satisfaction, some material, others not.

Developing this idea took a while. I knew I didn't want to celebrate poverty – being poor is a bad thing; everyone should have enough to satisfy their fundamental needs. Nor did I want to deny that most people would like to see material improvements in their lives, and are more than

prepared to work hard to realise this. They don't wake up with the dream of becoming millionaires; rather, they set about realising more concrete, local tasks with the ideas and materials at hand. The last picture in this book is of a couple who spend 10 hours a day running a tea stall in Sulaymaniyah, a city in the Kurdish part of Iraq. Whatever their hopes and aspirations, they have certainly never involved establishing a franchise for their business.

Our pictures from Bangladesh tell a very different story. Should marriage be about love between a couple, or should other factors – family ones, for example – be given greater weight. Likewise our three series of pictures from China. The first, tea picking in east China, reflects cultural continuity; the second, about members of the 1980s generation living in a city barely older than they are, reflects change; the third brings both aspects together with its portraits of young couples who have migrated to Shanghai for work but continue to see the centre of their lives in their families and ties to their hometowns. In recent years, China's story has been told almost solely in terms of its growing economic might, as if that were all that mattered. For the people in these pictures, however, China's changing economy is nothing more than the backdrop against which they act out other more important matters of their life.

Assembling the pictures for this book was not an easy task. Our starting point was an open call to photographers around the world, challenging them to find new ways of showing the struggles and successes of people relative to their circumstances. In our effort to avoid being over-prescriptive,

perhaps we didn't state our criteria clearly enough. Although we explicitly avoided using the word poverty in our request for pictures of The Other Hundred, a good number of the 11,000 images submitted, while technically excellent, failed to move beyond stereotypes and clichés. Many interpreted our call for otherness to mean suffering, while others saw it as conflict.

Again, our point was not to deny that many people endure hard lives, especially those who live in war zones, but rather, to emphasise and to appreciate the variety of ways in which people live. To assess the success of their lives, we must also abandon that one-dimensional school of reporting which only leaves its bunker to report on victims. Thus this book's pictures from Africa include blacksmiths from Mali and coffee professionals from Rwanda, not malnourished children surrounded by flies eating from tin plates on a dirty, dusty floor; from Afghanistan they show midwives being trained and a shopkeeper, not the wreckage of war or children playing on burnt-out tanks.

Another challenge was to see if we could find ways of provoking those who have enough into questioning whether they should be aspiring for more. That didn't mean trying to stimulate feelings of guilt or helplessness, but rather of finding pictures pointing to ways of living that are less obsessed with material wealth and consumption. If, while turning the pages of this book, readers find themselves wanting to explore further any of the lives, places or cultures presented in its images and texts, then our efforts will have been successful.

We didn't meet all our goals. From the start, we strove to encourage contributions from as many countries as possible. Nonetheless, the majority of the photographers whose work is presented in this book are from the developed world. This is a shame, as how a photographer or writer sees a particular situation and seeks to capture it depends on where they are from and who they perceive their audience to be. A Cameroonian photographer will see a community in her country very differently from the way which a photographer from outside Africa would, whatever her attempts to get close to her subject.

I am also sure that in some of this book's selection of countries, people, cultures and circumstances we made choices that can all too readily be deemed as stereotypes. In mitigation, I plead that what to one person appears to be a fresh or startling view is someone else's over-used cliché. To anyone who finds themselves offended by any of the pictures in this book, I unreservedly apologise. Next time, we will try to do a better job.

Accompanying the photographs of this book are a series of brief texts by writers from around the world. We invited story tellers to fill these spots: three novelists, Chika Unigwe from Nigeria, Carlos Gamerro from Argentina and Janice Galloway from Scotland, and one poet, Bei Dao from China. Their responses to the pictures are utterly different and impossible to summarise. All I can say is read them.

I am honoured that Pankaj Mishra undertook to write our introduction. His argument that people everywhere will continue to look for the good life,

FOREWORD

Chandran Nair

as they always have, "beyond the failed rationalities of science, market and the state" perfectly sets the tone for the book.

Amy Goodman's Afterword rounds off the book with an impassioned call for far greater media diversity: that we need infinitely more ways of telling the stories of our world to escape the one-dimensional tyranny offered by much of the media in its focus on wealth and celebrity.

Naturally, I see this book as a contribution to that diversity. But even more, I hope that it will be just the first in a series of Other Hundreds, each aimed at challenging conventional wisdom to reveal the many different ways in which people around the world organise their lives.

Many people have contributed to making this book possible. Foremost are the nearly 1,500 photographers who responded to our open call and all those who formed the subjects of their pictures. These two sets of people on the different ends of the camera are the stars of this book.

To those whose submissions we passed over during our selection process, I apologise. Picking just 100 sets of work from all the submissions we received was an all but impossible task – one that consumed far more time than we had initially allowed.

I would like also like to thank several key individuals without whose contribution this book would not have been possible.

First is Stefen Chow, The Other Hundred's director of photography. To be a success, the project needed an insider from the world of photography. Stefen, a Malaysian living in Beijing, was the ideal person – extraordinarily talented at establishing and running an organisation able to attract and handle the huge number of pictures we knew we needed to make the project a success. He was also the path to our three international judges, Ruth Eichhorn, Richard Hsu and Stephen Wilkes, whose reputations lent enormous credibility to the project, helping it draw photographers of the highest calibre from around the world.

Another key individual in the project was Simon Cartledge, the book's editor. For more than a year before its launch, Simon and I shaped and refined the book's ideas. That theoretical process complete, he then oversaw its realisation into the material object you now have in your hands.

This project would have been impossible without the help and support of all my colleagues at the Global Institute for Tomorrow, especially Tingting Peng, Eric Stryson, Karim Rushdy, Mei Cheung, Surya Balakrishnan, Yuxin Hou, Feini Tuang, Helena Lim, Yuyun Chen, Caroline Ngai and our two excellent interns, Jeffrey Cheuk and Ming Chun Tang.

Finally, I would like to thank Novin Doostdar and all the other staff at Oneworld Publications. Hugely receptive to the idea of this book from the start, they were also remarkably trusting in accepting our assurances that we would deliver it on time and to the quality they expected. I hope we haven't disappointed them.

INTRODUCTION

Pankaj Mishra

INTRODUCTION

Pankaj Mishra

This marvelous book with its rich human pageantry provokes an old question: what is the good life? Since the dawn of history, this enquiry has motivated the making of art as well as philosophy. But the many answers to it – attesting to the eco-diversity of social and political systems – were never as radically shrunk as they were in the 19th century, when the good life became confused with the desires and achievements of a tiny minority of Europeans and Americans.

The modern world they made became the default mode of existence, and their thinking came to be dictated by an ideology of progress. "Backward" peoples everywhere were to be persuaded or forced to duplicate the achievements of Europe and America. And the noble end of progress justified the dubious means, such as colonial wars and massacres.

It has recently become fashionable to blame organised religions, especially monotheistic ones, for all the evils in the world. But the sinister power of the secular faiths and cults of our own time – the faith in top-down social engineering as a tool of progress – is seldom acknowledged. The power of these ideas and of the men espousing them was first highlighted by the revolutions in Europe and America and the colonisation of vast tracts of Asia and Africa.

These great and often bloody efforts to remake entire societies and cultures were led by men with increasingly rigid conceptions of the good life; they possessed clear-cut theories of what state and society should mean. They had no time for traditional religion, being inspired instead by a belief in human ability to make "history", a faith accompanied by the instrumentalist calculation that eggs have to be broken in order to create omelettes.

The prejudices have been reinforced in recent decades by the emergence of non-Western elites, who believe in even more naïve versions of the ideology of progress. Many intelligent people in Asia, Africa and Latin America embraced the conviction that Western modernity was suitable for their societies. At first, it was socialism that would help mankind march to a predetermined and glorious future. More recently, human well-being came to be linked with privatisation, deregulation and minimal governments.

Few people today argue that events have vindicated these assumptions of the political left and the right. In *Tristes Tropiques*, a prophetic reckoning in the 1950s with the fate of old societies and cultures overcome by the modern world, the French social anthropologist Claude Lévi-Strauss already feared that the remotest landscapes were being dramatically altered by the "proliferating and overexciting civilisation of the West".

The traumas of progress have become much more visible in recent years as garment factories collapse in Bangladesh, hundreds of thousands of cotton farmers exposed to fluctuations in international prices kill themselves, and Tibetan nomads and Indian tribals launch desperate battles to resist their physical and spiritual dispossession.

The West itself, struggling with multiple economic crises, rising inequality and political discontent,

has lost sight of its model of universal progress and lacks the confidence to export its cherished values to others. Its last great ideological gamble – globalisation through free-market capitalism – promised a fantastic expansion of freedom and democracy. But this economic system's built-in inequalities, which have sparked insurrections in Asia, Africa and Latin America, now also provoke leaderless revolts within the metropolitan West. Like everyone else, European and American countries live – or survive – from day to day, still technologically innovative, but no longer a vital source of redemptive moral and political ideas.

The instrumentalist worldviews and the narrow epistemologies of foreign affairs pundits, security experts and financial analysts appear to have been deeply defective. Grand, unilinear theories of globalisation – in which better technology, education, entrepreneurship and productivity were taking us all to convergence with Western-style affluence and stability – look increasingly threadbare. Elections have not produced functional democracy or even political stability, free markets have not led to freedom, or higher literacy and better communications to greater tolerance and human rights. Rather, we have witnessed political chaos, corporate greed, climactic depredation, xenophobic nationalism and ethnocide. The allegedly universal laws of progress have proved yet again to be bogus.

Sadly, as this book shows, much damage has been inflicted on many societies in the meantime. Even before market economies faltered worldwide, the absurd and dangerous fantasy of endless progress had condemned the global environment to early destruction. Though the ecological disasters caused by industrialised man's insatiable claims upon the earth were not very visible in the 1940s and 50s, Lévi-Strauss was alert to the environmental dangers of a socio-economic model premised on endless expansion. "The first thing we see as we travel around the world is our own filth, thrown into the face of mankind."

These words echo in our minds as we pick our way through the detritus of the last dominant ideology of the 20th century. But we must also be alert, as Lévi-Strauss was, to the apparently intangible but formidable spiritual resources of many peoples on the margins of the modern world. "How very little is needed to create a human community," he marvelled. "Only quality of soul can explain the ease with which these people can fit into their cosmos... They live in the open streets, each within the universe of his tiny display of goods and placidly occupied with his particular trade, among the flies, the passers-by and the hubbub made by barbers, copyists, hairdressers and craftsmen."

As the following pages attest, people continue to look for the good life, as they always have, beyond the failed rationalities of science, market and the state. Any attempt to describe the world today must acknowledge – as this book does – the deep structures of difference that exist behind the superficial unity proclaimed by the vendors of globalisation. Above the collision of inhuman ideologies with ordinary human lives looms the phantom of an alternative history, what has not but could have existed, and modes of living and thinking that may yet have a future.

THE 100 PLACES

Page number (000)

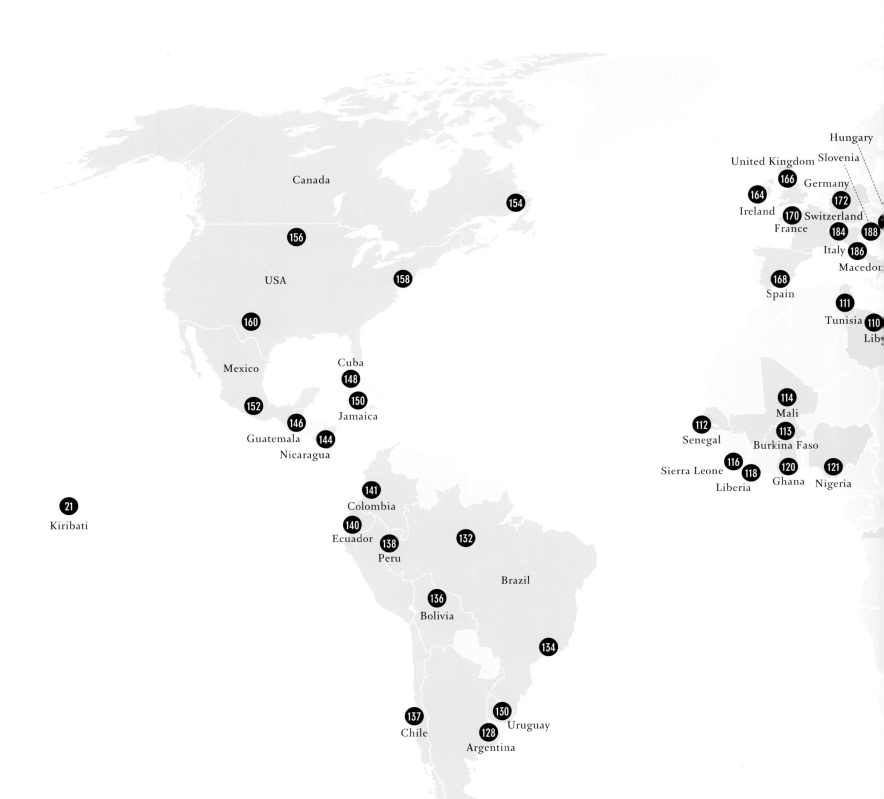

Canada

154

156

USA

158

160

Mexico

Cuba

148

150

152

146

Jamaica

Guatemala

144

Nicaragua

141

Colombia

140

Ecuador

138

132

Peru

Brazil

136

Bolivia

134

21

Kiribati

137

130

Chile

128

Uruguay

Argentina

Hungary

United Kingdom Slovenia

166 Germany

164 172

Ireland 170 Switzerland

France 184 188

Italy 186

Macedon

168

Spain

111

Tunisia 110

Lib

114

Mali

112 113

Senegal Burkina Faso

Sierra Leone 116 118 120 121

Liberia Ghana Nigeria

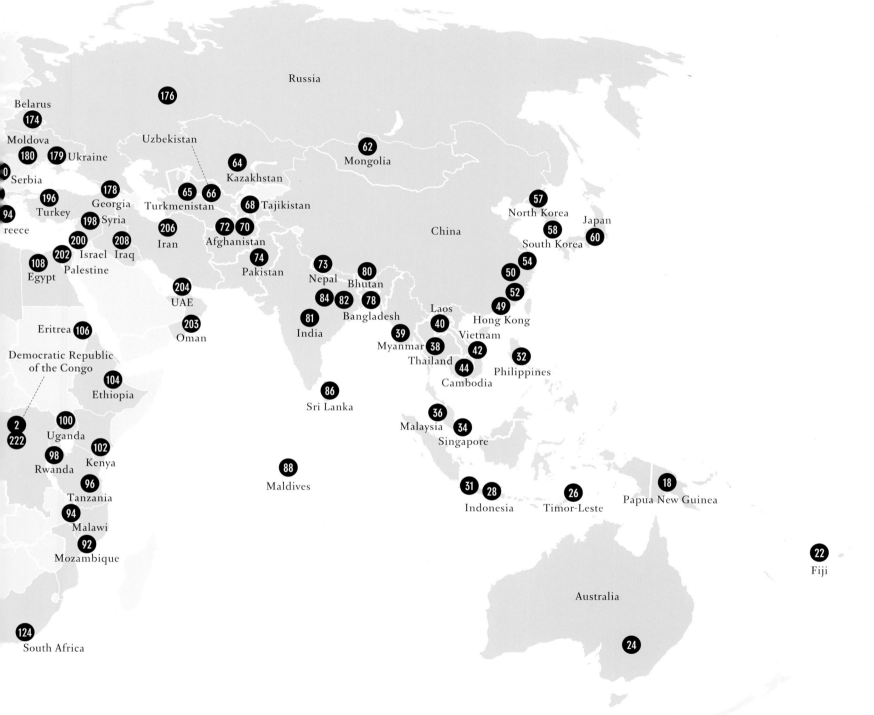

Russia

Belarus
174

Moldova
180 179 Ukraine

0
Serbia
196 178
94 Georgia
reece Turkey
198 Syria
200 208
108 202 Israel Iraq
Egypt Palestine

Eritrea 106

Democratic Republic
of the Congo

2
222 100
 Uganda
98 102
Rwanda Kenya
 96
 Tanzania
 94
 Malawi
 92
 Mozambique

124
South Africa

Uzbekistan
64
Kazakhstan
65 66
Turkmenistan 68 Tajikistan
206 72 70
Iran Afghanistan
 74
 Pakistan

176

62
Mongolia

China

57
North Korea
58
South Korea

50 54
 52
49

Japan
60

73 80
Nepal Bhutan
84 82 78
India Bangladesh

Laos
40

204
UAE
203
Oman

81

39
Myanmar

38
Thailand

42
Vietnam

Hong Kong

32
Philippines

86
Sri Lanka

44
Cambodia

88
Maldives

36
Malaysia
34
Singapore

31 28
Indonesia

26
Timor-Leste

18
Papua New Guinea

22
Fiji

Australia

24

PORT MORESBY, PAPUA NEW GUINEA

Since 2007, more than half the world's population has lived in urban areas. Of these 3.5 billion or so people, around one-third lives in what are broadly categorised as slums. In the Paga Hill district of Port Moresby, the capital of Papua New Guinea, 45 percent of the population lives in slum neighbourhoods.

One night in May 2012, around 100 police officers armed with assault rifles and machetes descended on Paga Hill. Their goal was to drive out its residents and demolish one of Port Moresby's oldest neighbourhoods to make room for Paga Hill Estates, a luxury residential development project overlooking Port Moresby bay.

The evictions were halted through the intervention of Carol Kidu, an opposition leader, but not before 21 families had been left homeless.

01 Robert and Gimsy sit in front of their house at Paga Hill. Their baby sleeps between them.

Photographer
PHILIPPE SCHNEIDER

THE SLUMS ADD UP

One in seven of the world's population lives in a slum

Billion people

1.5					
1.2		World			
0.9					
0.6					
0.3					
0.0	2000	2005	2010	2015	2020

Asia ———
Sub-saharan Africa ———
Latin America & the Caribbean ———

Source: *UN-HABITAT*

01

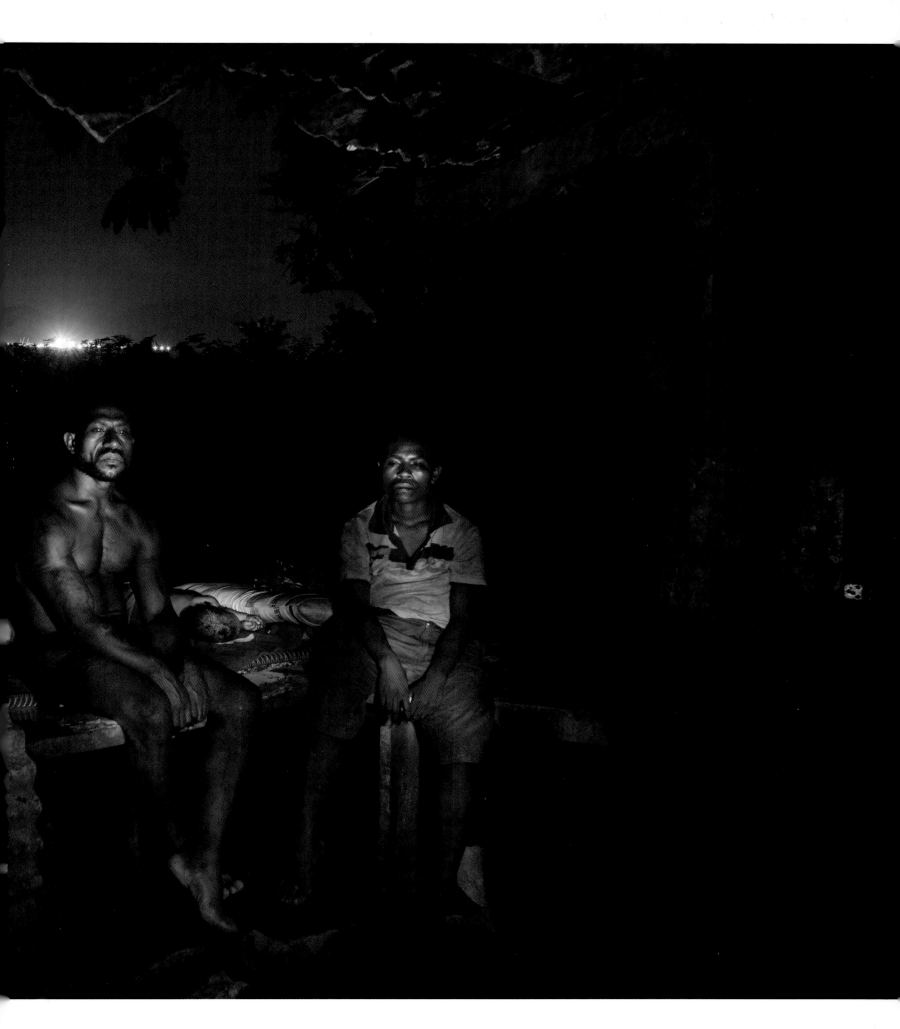

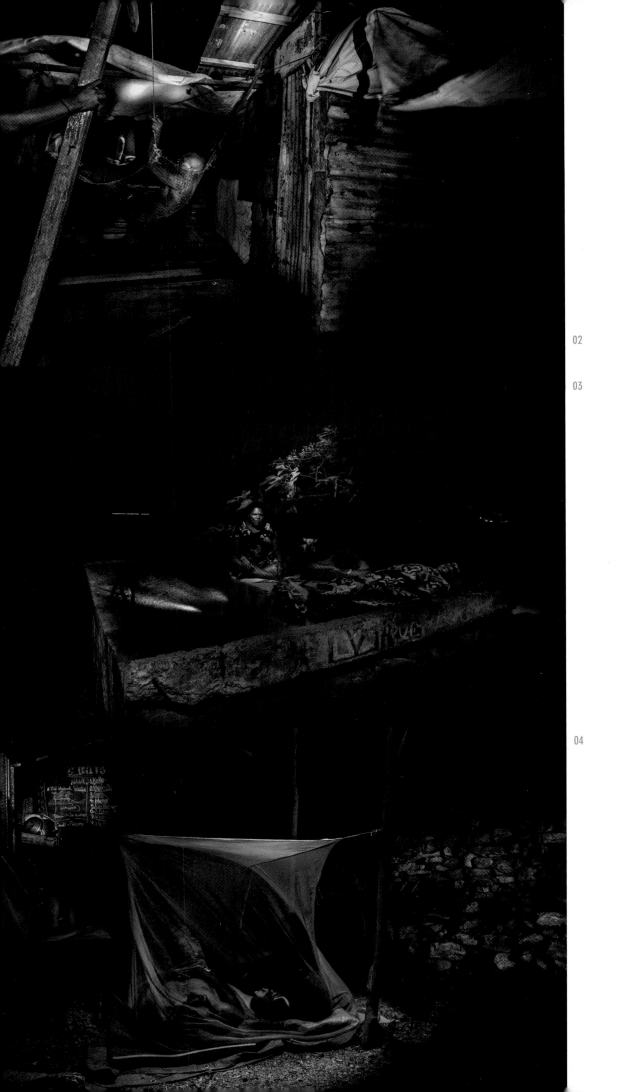

02

03

04

02 Frank, who has been jobless for the last few years, relaxes in a hammock made from a fishing net.

03 On a hot night, a family sleeps on the roof of their home, an abandoned second world war bunker.

04 Allan, a community youth leader at Paga Hill, and his friend, Frank, share a mosquito net. The police demolished their family homes during the May 2012 raid.

ABAIANG, KIRIBATI

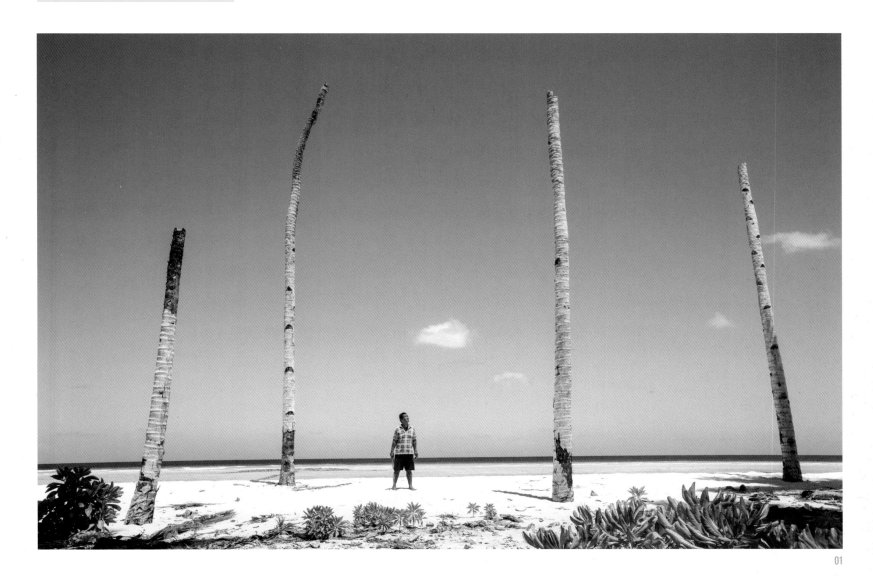

Climate change is affecting South Pacific communities. In Kiribati, an island nation of 32 coral atolls scattered across 3.5 million square kilometres, but whose highest point is just a few metres above sea level, high tides are already a major threat to crops. Water supplies are slowly declining as the underground bubbles of freshwater beneath the atolls are consumed. And in some locations, including one village on Abaiang, villagers are uprooting their homes and moving them to slightly higher land.

01 At Tabontebike on Kiribati's Abaiang island, Tawaa Tebunang, 46, stands besides the trunks of four coconut trees that died after sea water inundated the land. About 5,500 people live on the island in 18 villages.

ABAIANG, KIRIBATI

0 4 8km
Tabontebike

Photographer
RODNEY DEKKER

01

Fiji is a tropical island chain synonymous with blue skies, palm trees and white sandy beaches. It is also a place of political upheaval. Since taking power in a military coup in 2006, its current ruler, Josaia "Frank" Voreqe Bainimarama, has ruled through an emergency decree of his own drafting. Opposition to his leadership is limited by laws forbidding large groups meeting in public and media censorship. The scheduling of elections for 2014, which has already resulted in Australia and New Zealand restoring diplomatic ties, could signal the start of a return to less rancorous times.

01 On a rugby oval in the small coastal village of Vatukarasa, young men and boys use coconut husks and an oily tar mixture to paint line markings before a game of rugby. The sport is Fiji's greatest obsession: of the country's 950,000 people, 85,000 are registered players.

02 School children, mainly from Kalekana Village on the outskirts of Suva, the Fijian capital, await their morning school bus. With only one company servicing the route instead of the usual two, the buses on this day are particularly full.

03 As dusk falls, a couple sit at the water's edge of Suva Harbour.

04 Young men take a break from work at a fresh-food market in Suva. These men carry fruit and vegetables from the markets to buses for shoppers from out of town.

Photographer
ANDREW QUILTY

02

03

04

WILCANNIA, AUSTRALIA

In Wilcannia, a rural district in eastern Australia's state of New South Wales, traditional culture and the rituals of contemporary life intermix. Many members of the Barkindji Aboriginal community depend upon hunting kangaroos and wild boar to supplement their diets.

A key community figure is Gordon Mitchell, usually known as Sunno, a hunter and mentor to young people who also works at the local school liaising between students' families and the school board. To encourage others to eat healthy, traditional foods, he often takes young men from the community out into the country, showing them how to track and shoot animals and live off the land. He hunts to provide meat for his family and the other members of the community, charging just enough money to cover his fuel and other costs.

01 Sunno sits before his home in Wilcannia, one of the most remote communities of New South Wales.

02 In preparation for winter, Sunno hauls firewood to his home with his nephew and a friend.

Photographer
DAVID MAURICE SMITH

David Maurice Smith/Oculi 02

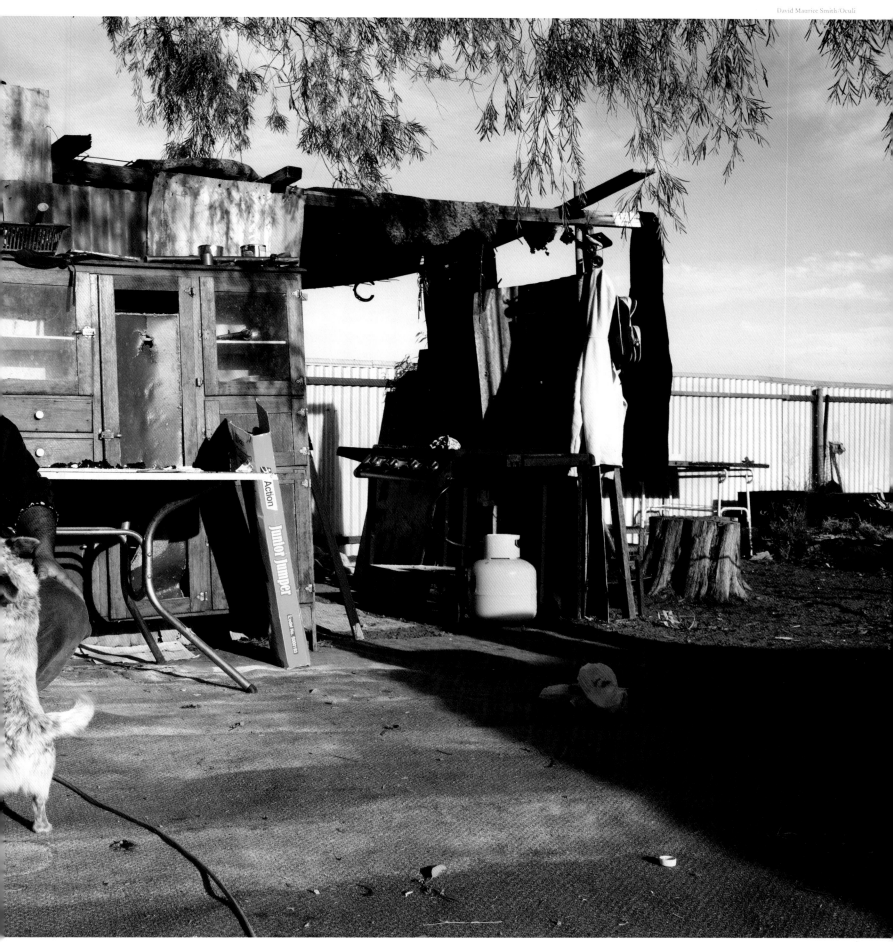

DILI, TIMOR-LESTE

Timor-Leste is a young country with a young population. Colonised by the Portuguese in the 16th century and invaded by Indonesia in the 1970s, it finally claimed control of its own territory in 1999 after a long and bitter war. Formal establishment of the new state followed in 2002.

At least half of the country's population of 1.17 million has been born since it regained its sovereignty, giving the country a median age of 18.4 years, and making education a priority.

One of the country's biggest post-independence successes is an 85 percent primary school enrollment rate, especially considering that around nine-tenths of Timor-Leste's education infrastructure was in ruins by 1999.

But much remains to be done. Most children don't start school until six or seven, and nearly two-thirds suffer from malnutrition. Only 37 percent go on to secondary school.

The country is home to a host of languages – five Papuan and 22 Austronesian. While that's good for diversity, it's not good for schooling. Many children find themselves with teachers who speak another language from them. Four out of ten can't read a single word after two years of primary school.

01 A young girl outside her village home near Dili.

Photographer
SCOTT A WOODWARD

YOUNG NATION, YOUNG PEOPLE

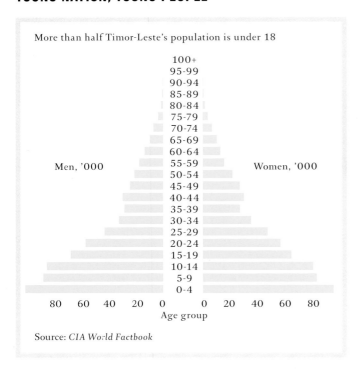

More than half Timor-Leste's population is under 18

Men, '000	Age group	Women, '000
	100+	
	95-99	
	90-94	
	85-89	
	80-84	
	75-79	
	70-74	
	65-69	
	60-64	
	55-59	
	50-54	
	45-49	
	40-44	
	35-39	
	30-34	
	25-29	
	20-24	
	15-19	
	10-14	
	5-9	
	0-4	

80 60 40 20 0 0 20 40 60 80
Age group

Source: *CIA World Factbook*

01

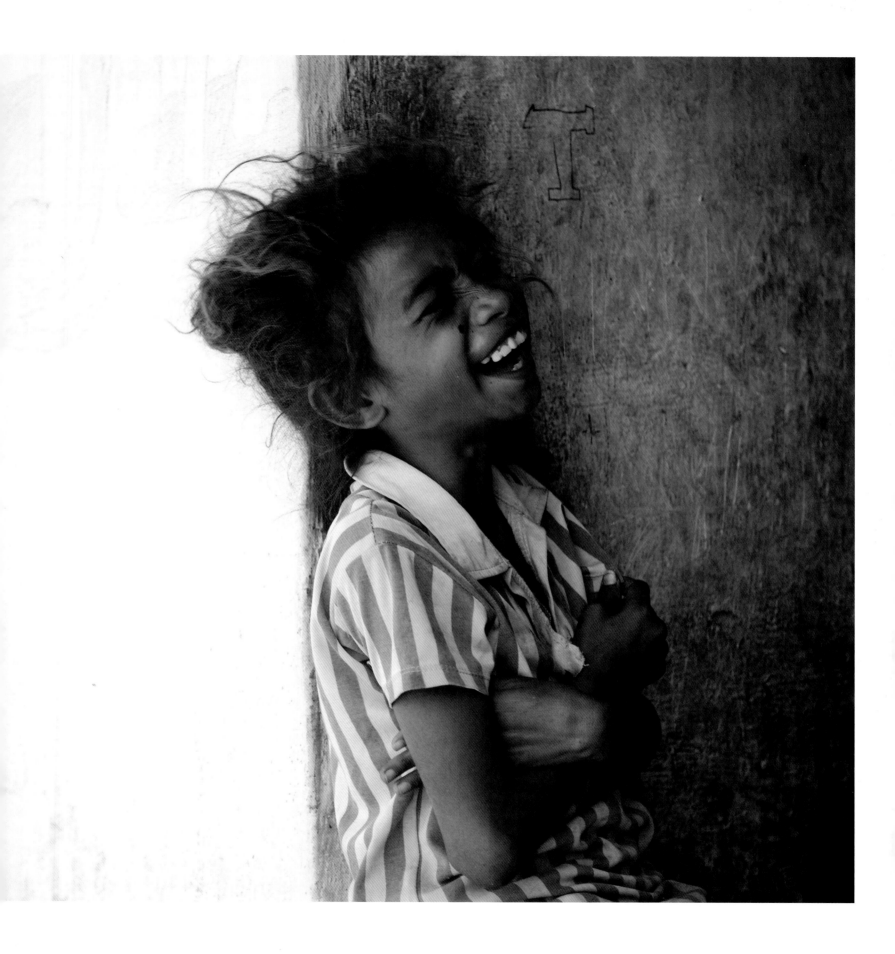

JAVA, INDONESIA

In 1933, Java was the world's leading sugar producer, with more than 200 factories processing sugar cane and selling their output to the world. A product of colonialism, the industry had got its start in the early 19th century after the abolition of slavery in the Caribbean led to European sugar firms looking for new locations for plantations in Asia.

After failing in India, the Dutch found success in Java, expanding output throughout the 19th century. In 1945, Indonesia regained its independence and nationalised the industry. Today, only just over ten factories remain in operation, all using steam-powered machinery installed over a century ago. Although wages are low in Indonesia, productivity is poor, and production costs in Brazil and Suriname are lower. Most of the sugar consumed in the country is now imported.

Despite the industry's decline, for those who still work in them, the factories are an important part of their life. Shuttered for much of the year, they awaken when the cane is harvested. Casual workers are hired, and the towns around the mills fill up with peddlers and travelling fairs.

01 Loading sugarcane into trucks at Kendal plantation in central Java.

Photographer
TOMASZ TOMASZEWSKI

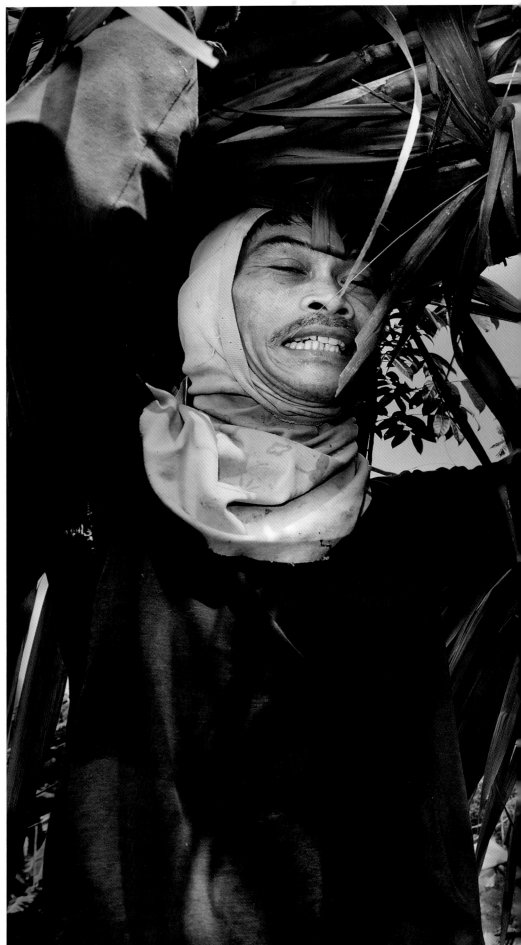

01

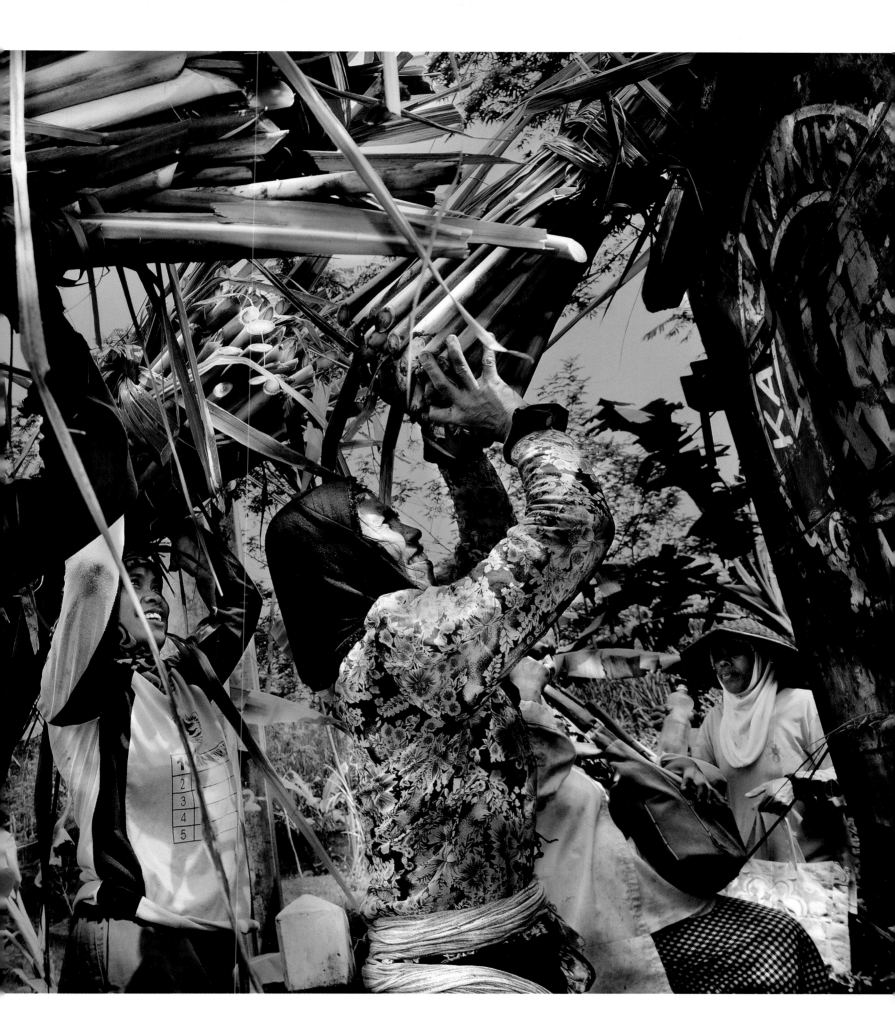

02

03

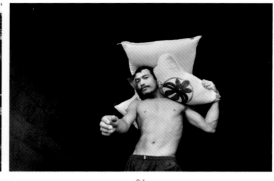

04

05

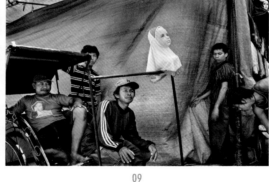

06

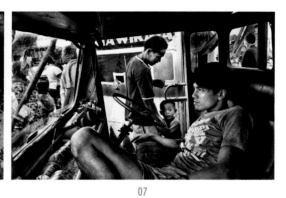

07

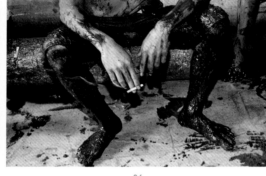

08

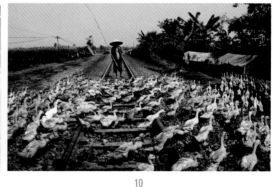

09

10

02 Workers repairing steam-powered machinery installed more than a century ago at Pangka sugar factory in the central Java city of Tegal.

03 Local people relax during the weekend at the Comal Baru sugar plant's swimming pool, built during the industry's golden age for use by the factory's Dutch staff.

04 A labourer at Tegal's Pangka sugar factory.

05 A mechanic tightens a bolt just before the milling season starts at Sumberharjo sugar factory in Pemalang.

06 A worker takes a cigarette break while carrying out maintenance work before the start of the milling season at Tegal's Pangka sugar factory.

07 Entertainers from a travelling funfair rest in their truck at Sumberharjo sugar factory in Pemalang on central Java's north coast.

08 A child lies down in an abandoned warehouse at the now defunct Banjaratma factory, home of the first sugar mill in central Java.

09 At Jatibarang sugar factory in Brebes city, travelling entertainers put on a daytime show during the Buka Giling festival.

10 A farmer drives his flock of ducks across a disused railway line at the now shuttered sugar factory in Comal, central Java.

YOGYAKARTA, INDONESIA

Born and raised in Aceh, at the far western end of the Indonesian archipelago, Mahdi Abdullah has had much of his adult life shaped by the three-decade war fought between separatists from the province and government forces.

Now 53, he came of age as the conflict started in 1976. Three years later, after graduating from high school in 1979, he moved to Yogyakarta to study art. He returned to Aceh in 1984 shortly before the war reached its peak through the late 1980s and early 1990s. Its violence remains a major influence on much of his work.

Through the following years he continued painting and also working as a journalist, lecturer and cartoonist contributing work to both national and Aceh magazines and other publications. In 1990 he held his first solo exhibition, paying for it by selling his motorcycle. He now exhibits both in Indonesia and other countries, most recently with a show titled "Picturing Pictures" held at the Ho Chi Minh City Fine Art Museum in Vietnam.

The early 2000s saw two brief pauses in the Aceh insurgency. But the final catalyst for peace came from nature, and the devastation caused by the Indian Ocean tsunami of 2004, after which both sides declared a ceasefire. The tsunami, however, also devastated Mahdi's home, killing his parents and two younger siblings, and destroying his entire collection of 40 paintings along with many sketches, drawings and photographs.

Since 2009, Mahdi has lived in Yogyakarta, enrolling at the Institut Seni Indonesia, the country's leading art school, and opening a studio. He paints daily for around eight hours, sometimes longer.

01 Mahdi in his Yogyakarta studio.

02 "Ibu, Ibu, Ibu" ("Mother, mother, mother"). "The model for this picture is my wife when she was pregnant with our fourth son. The title comes from a tale about the Prophet, Muhammad. A friend asked him who was the most worthy person in the world. 'Your mother,' Muhammad replied. 'Then who? asked the friend. 'Your mother,' said Muhammad. 'And then?" asked the friend. 'Your mother.' Asked a fourth time, Muhammad paused, then said, 'Your father.'"

Photographer
SANTO UMBORO

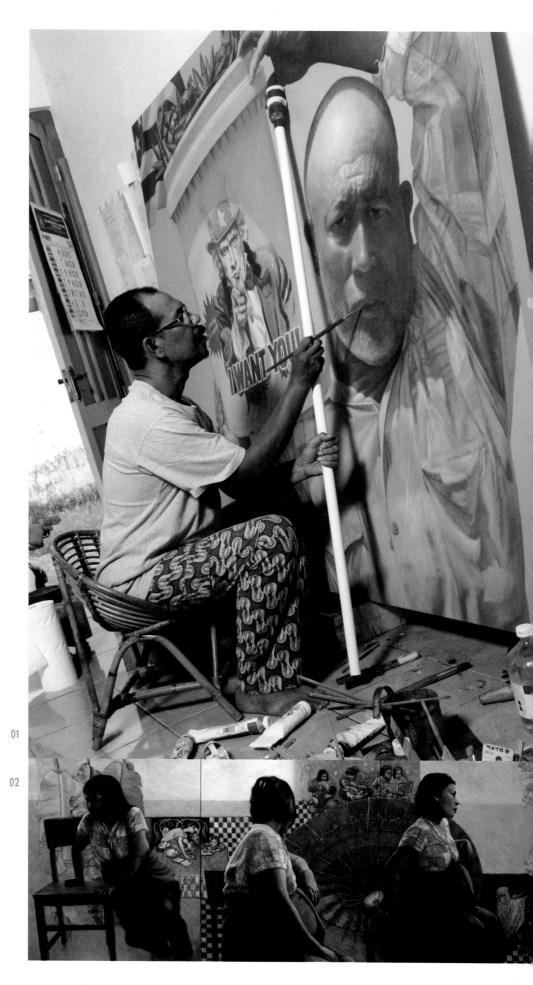

01

02

MALABON, THE PHILIPPINES

At the heart of Malabon, a low-lying district next to Manila Bay, stands Artex village, a one-hectare compound of two-storey houses. Once owned by one of the Philippines largest textile companies, it has been permanently flooded for nearly a decade.

Artex Yupangco Textile Mills Corporation built the compound in the late 1970s to house the work force of an adjacent textiles plant. But within a few years, both the factory and the compound started running into trouble.

A series of labour disputes left relations between workers and management in poor shape, while at the same time, drainage of water was becoming more and more of a problem. When it was built, the compound was surrounded by fishponds through which water would naturally drain into the sea. But one after another, the ponds were filled in and houses built on them. Road construction further blocked drainage channels.

Eventually, in 1989, after a severe strike and a major flood, the company surrendered and closed down. Overnight, the workers living in the 150 households in the compound found themselves without jobs but in possession of their homes.

At first, they were able to keep the water at bay using pumps, but eventually they too were defeated, and since 2004, the compound has been permanently flooded.

Normally, the water is around five feet deep, but after heavy rain it can double to 10 feet or more. Residents, mostly too poor to consider leaving, have long since adapted, buying or building boats to travel between homes, and even enjoying their status as a minor tourist attraction.

01 Long used to living in a permanent flood, a lack of proper sanitation has become the biggest threat to the well-being of residents in the Artex compound. A study by the Department of Environmental Engineering at the University of the Philippines found high levels of bacteria attributable to human and animal faecal matter in the compound's water.

02 Travelling by boat is the only way to move around the compound. With the water permanently five feet deep, residents are confined to the top floor of their two-storey homes.

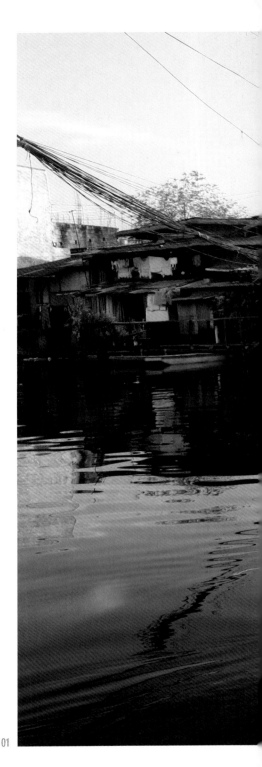

02

01

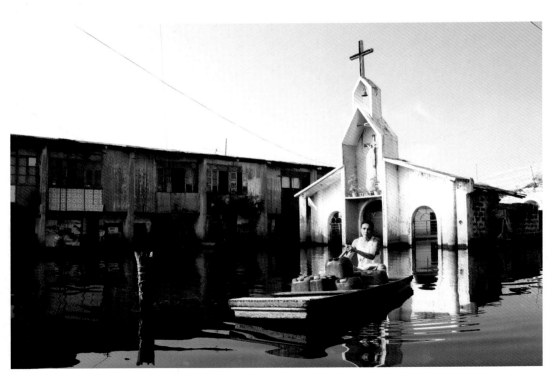

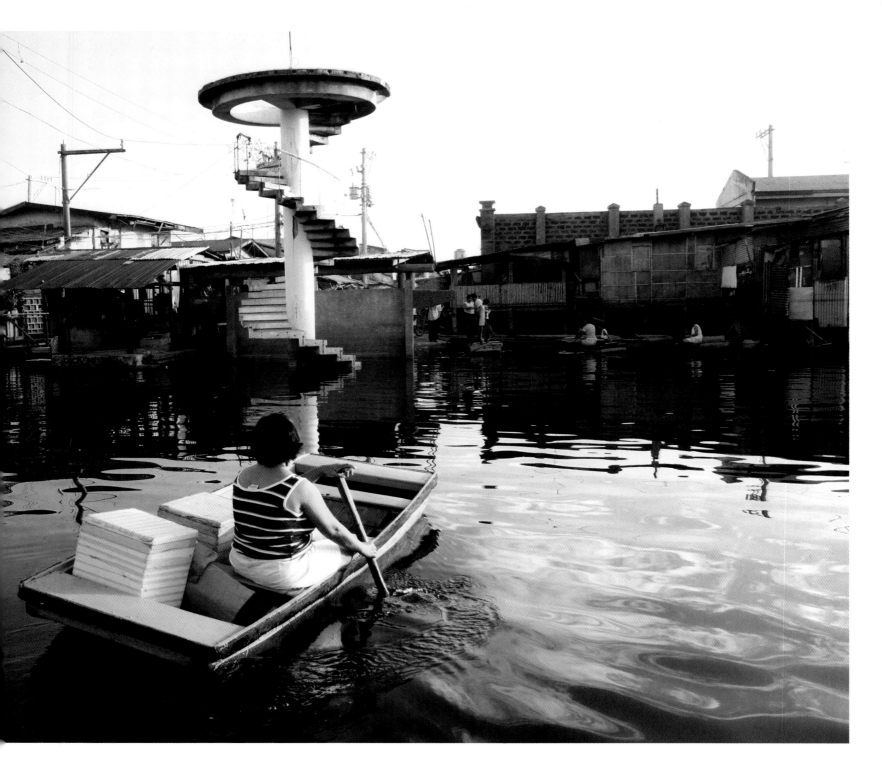

NATURE'S WRATH

PHILIPPINE NATURAL DISASTERS, 1980–2010

Storms	**197**
Floods	**94**
Landslides	**27**
Volcanoes	**14**
Earthquakes	**12**

Source: *OFDA/CRED International Disaster Database*

Photographer
GREGORIO B DANTES JR

"When I wake up in the morning, there are only seven things on my mind – my children. I know they depend on me. I am their only pillar," says Mila. Earning less than US$800 a month as a washroom cleaner, Mila has to support her family in one of the world's most expensive – and most unequal – cities.

An extensive social welfare system helps to some extent: some 85 percent of Singapore's resident population lives in public housing. But income equality, albeit less than in Hong Kong, its Asian rival, is greater than in the US or UK, and widening. In 2011, Singapore had 188,000 millionaire households – about 17 percent of the total, a higher proportion than anywhere else in the world.

Photographer
EDWIN KOO

A DIVIDED CITY?

In Singapore, despite taking a 30 percent paycut in 2012, government ministers earn nearly nine times more than senior managers, and 100 times more than the city state's bottom earners.

MONTHLY SALARIES

Government ministers	US$71,600
Senior managers	US$7,950
Bottom earners	US$650

Source: *Yahoo! Finance Singapore, Bloomberg*

KELANTAN, MALAYSIA

Malaysia is the world's second largest producer of palm oil after its larger neighbour, Indonesia. Logging and palm oil plantations, however, have cost an indigenous Malaysian people, the Batek Negritos, much of their rainforest homeland.

The Negritos were probably part of the first migration of humanity out of Africa, around 10,000 years ago. Small in stature, they may be one of the last few remnants of a people once widespread throughout southeast Asia, and even as far north as Taiwan. Now there are only tiny pockets of Negrito peoples in Peninsular Malaysia, Thailand, the Andaman Islands and the Philippines.

In Malaysia, their territory has been under a relentless attack for the last few decades. Between 1990 and 2005, palm oil plantations more than doubled in area to 3.6 million hectares, while forests shrunk by around 1.5 million hectares.

In the most common sequence of events, logging companies obtain concessions from state governments with little or no say from indigenous peoples. Indeed, many communities have been unaware that a logging concession had been granted until heavy equipment arrived to start felling the forest on their ancestral land.

Loggers claim they log sustainably. This is rarely the case. Opening up logging roads and dragging out felled trees devastates the thin tropical topsoil. After the second or even third pass to harvest all valuable tree species, the forest is ravaged. The soil erodes in tropical downpours; animals leave or starve to death; silted rivers become devoid of fish. Then, once the loggers are finished, the oil palm plantations move in.

01 Towering primary rainforest overshadows Sam and Dolah, two Batek Negrito men, on a muddy logging road in the core of their homeland just outside Taman Negara National Park. The road will offer loggers access to the giant trees of this virgin forest near Kuala Koh in the state of Kelantan.

02 Sam navigates from the bow of a bamboo raft on his way back to his home down the Pertang river. near Kuala Koh. Silt from the logging road built to extract the biggest trees in this sliver of old growth rainforest already clouds the river.

03 Batek Negrito women rest beside a muddy logging road. Surveyed and marked for logging, this area is the last narrow strip of old growth rainforest between Taman Negara National Park and massive oil palm plantations that less than a generation ago were also old growth rainforest and the homeland of the Batek.

04 Sam follows a group of women off on a fishing expedition past a camp being set up for a logging company.

05 A palm oil processing plant set up in what a few years ago was rainforest.

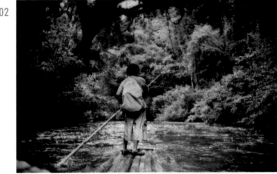

02

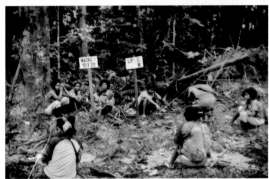

03

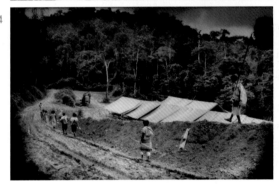

04

Photographer
JAMES WHITLOW DELANO

THE NEGRITOS' JOURNEY OUT OF AFRICA

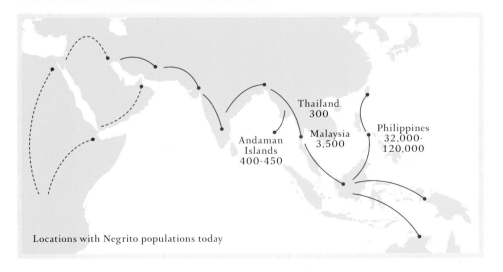

Thailand
300

Andaman
Islands
400-450

Malaysia
3,500

Philippines
32,000-
120,000

Locations with Negrito populations today

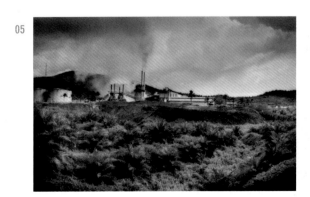

05

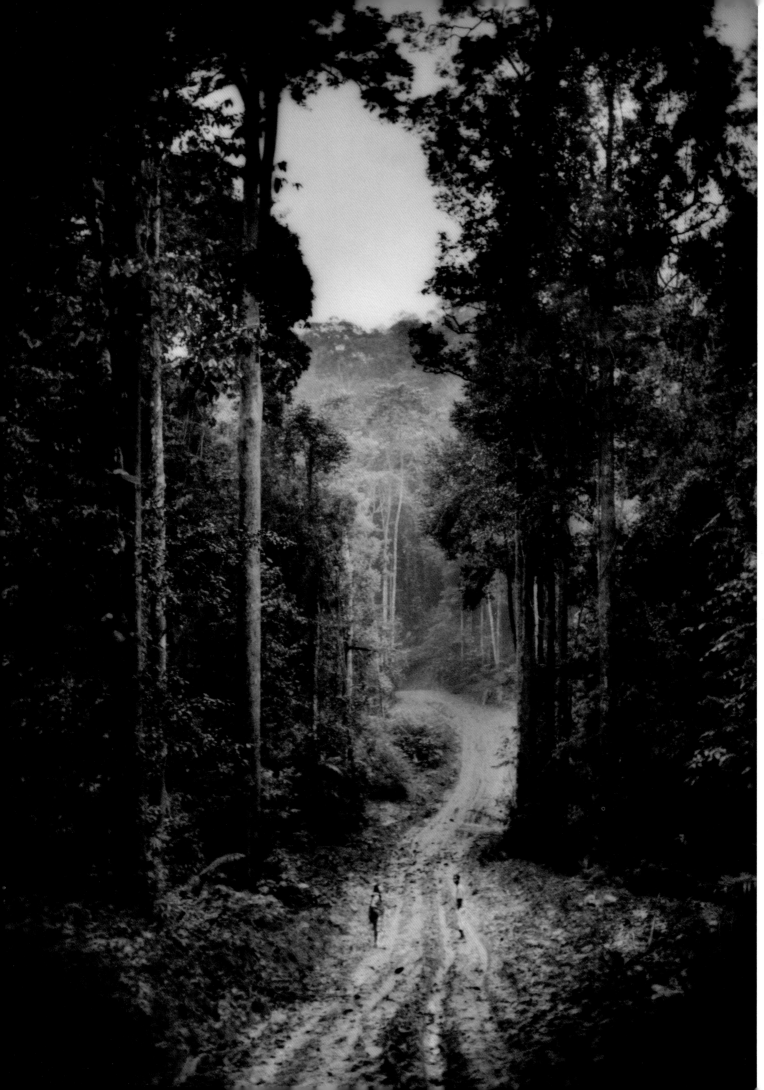

KO LAO, THAILAND

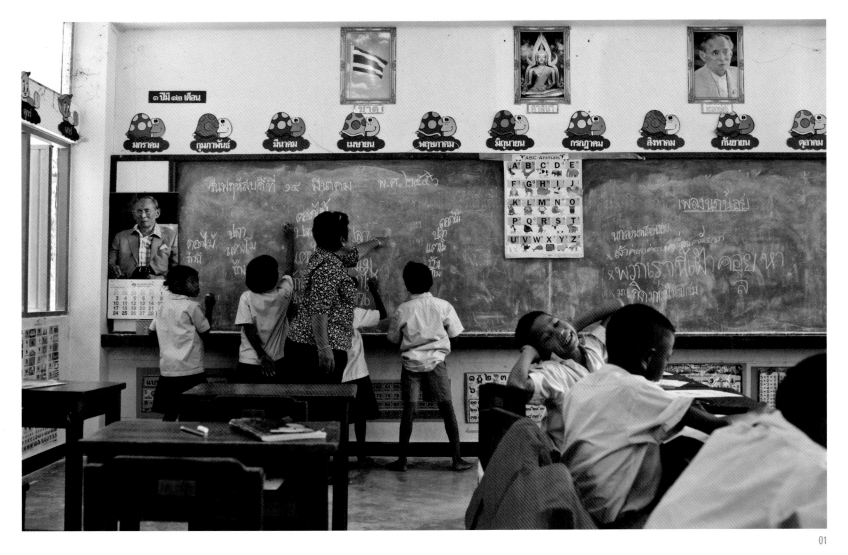

The 2004 Indian Ocean tsunami devastated the way of life of the Moken people, a largely boat-dwelling people who previously had spent two-thirds of the year sailing off western Myanmar and around southern Thailand, only staying on land during the monsoon season.

Numbering around 2,000 to 3,000 people, they have struggled to return to their boats. Lacking passports or other identity papers, those who try to work at sea often find themselves harassed or arrested by coastguards. Their plight has attracted the attention of non-governmental organisations and faith-based bodies. Such aid, however, has left many of the Moken unable to resume their traditional way of life.

The Moken community of Ko Lao island in southern Thailand is now largely land based. Few of its adults fish or dive much, and its children, instead of learning how to live off the sea are educated in a school on the other side of the island, 10 minutes away on a long-tail boat.

Photographer
BERNICE WONG

02

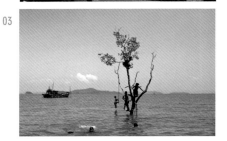

03

01 At their school on the Thai island of Ko Lao, two classes of Moken children share a single teacher.

02 & 03 The Moken's former life as a nomadic, sea-based people may be a thing of the past, but their children remain thoroughly at home in the water.

SHAN, MYANMAR

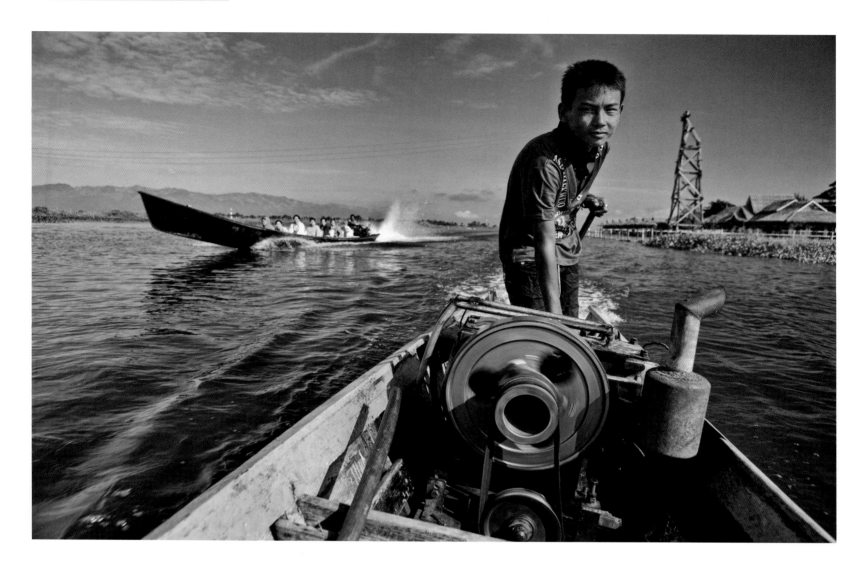

Sin Ko Ko Oo, 13, at the helm of his father's long-tail boat on Shan state's Inle Lake in central Myanmar. His father, tired after nearly a month of non-stop early morning work ferrying visitors around the lake for the Phaung Daw Oo Pagoda Festival, is dozing in the bow of the boat.

Photographer
RICHARD KOH

AN OPENING DOOR

After years of isolation, Myanmar is starting to awaken to the possibilities of international tourism.

In 2012, more than a million visitors arrived – a record high. Forecasters expect the number to reach 7.5 million by 2020, creating 1.4 million jobs. Most visitors are from Thailand, followed by China.

The country's challenge will be how to receive more visitors without damaging its cultural heritage and environment.

TOURIST ARRIVALS, 2012

Thailand	**22 MILLION**
Myanmar	**1 MILLION**

Source: *National tourism associations*

XIENG KHOUANG, LAOS

Between 1964 and 1973, during the Vietnam war, the US dropped more than 2 million tons of ordnance on Laos, making it, per capita, the most heavily bombed country in the world. An estimated 30 percent of these bombs and other explosives failed to detonate – leaving the country with approximately 75 million unexploded items when the war ended.

UCT6 is an all-female clearance team, one of seven in Xieng Khouang province working for Mines Advisory Group, a United Kingdom-based humanitarian organisation that aims to reduce the terrible effects mines and other remnants of conflict can have on people even after wars end. From 2004 to 2012, UCT6 and the other teams organised by MAG destroyed nearly 162,000 bombs and other unexploded ordinance.

The women of UCT6 know the tragedies that unexploded ordnance can unleash. One of them lost her husband when he stepped on a bomb while foraging for food, leaving her with five children to look after by herself. Another farms on family land that has not yet been cleared. "We don't have another place to grow rice", she says.

01 Team UTC6 on its way to a clearance site. Deputy team leader Manixia Thor, 25, dressed in green, is responsible for monitoring the team on site.

Photographer
TESSA BUNNEY

THE BOMBING OF LAOS

Kilogrammes of munitions dropped per person from 1965-73, by region

- ○ <2.5kg
- ○ 2.5-50kg
- ● 50-1,000kg
- ○ 1,000-2,500kg
- ○ >2,500kg

Source: www.peterslarson.com

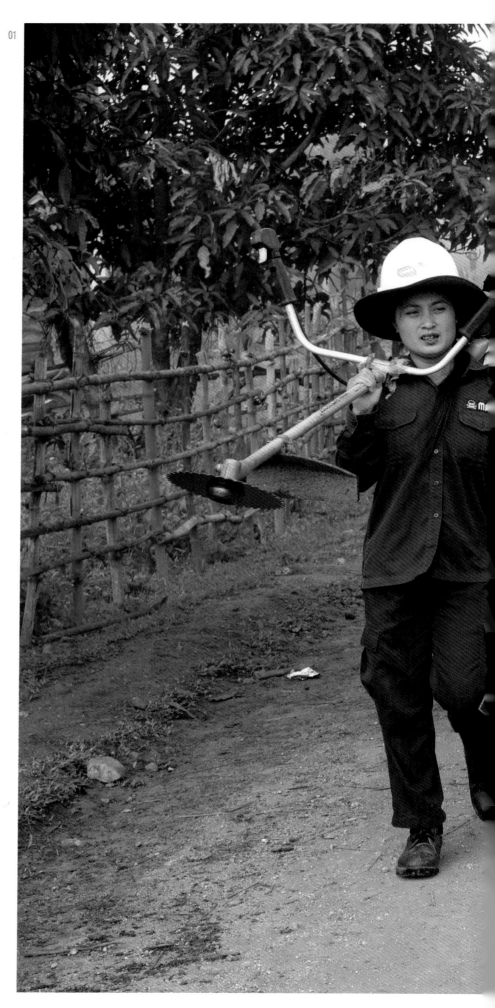

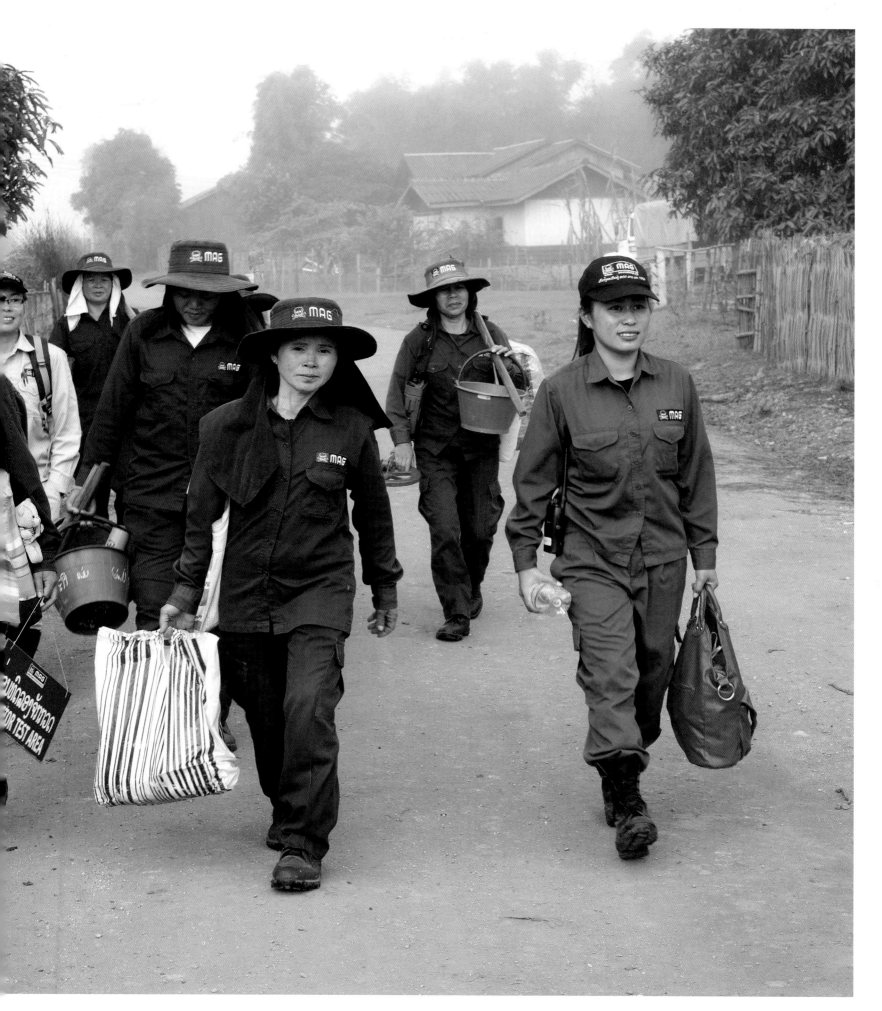

NINH THUAN, VIETNAM

The Champa, a Muslim community of some 39,000 people, lives from Ninh Thuan to Binh Thuan provinces along the coast of central Vietnam. At the age of 15, Champa girls, usually in groups of four or five, undergo a Karoh (maturity) ceremony, one of the most important ritual events of their lives.

The ceremony's preparations start with the girls' families choosing a place, such as a courtyard, where two tents can be set up, a larger one for the priests, aligned east to west, and a smaller one for the girls.

On the selected date, the girls gather in their tent. First, they undergo a purification ritual. An old woman, the most respected in the community, takes them to a fountain and bathes them by pouring water over their heads.

Returning to their tent, the girls prepare for the main ceremony. Two or three women take care of each girl, first dressing her in a white dress, then adorning her with bronze, copper and sometimes gold jewelry. The girls' hair is brushed and put up into a bun. Finally, each girl is given a traditional yellow robe and her head covered with a red woven cloth.

One after another, they step into the main tent. There, the priests sit in a circle. The head priest places his hand on the first girl's head, recites a prayer and then cuts a small lock of her hair. When all the girls have undergone the same set of rituals, they return to their tent, take off their traditional robes and have a short rest.

A few minutes later, they return to the main tent to thank the priests. The head priest says one more prayer and wishes each girl a good future. The ceremony completed, their families and relatives congratulate the girls and give them gifts and money. Each is now regarded as an adult in the community.

Photographer
LY HOANG LONG

01

02

03

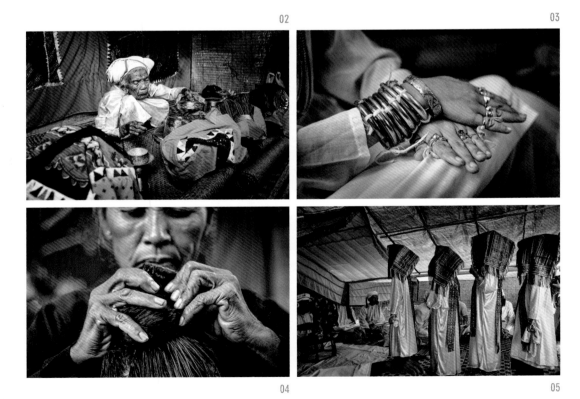

04

05

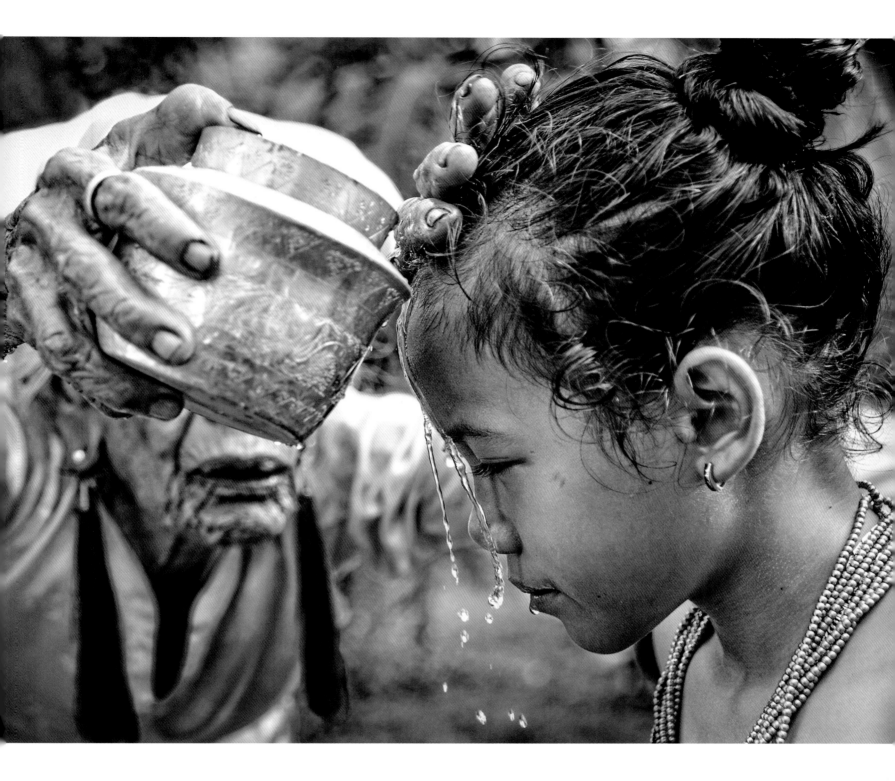

01 In preparation for her Karoh (maturity) ceremony, a girl is ritually purified by having water poured over her head.

02 In the girls' tent, a woman checks the offerings prepared for the ceremony.

03 Bronze, copper and gold bracelets and rings adorn the hands of one of the girls.

04 Each of the girls has her hair carefully brushed then put up into a bun.

05 Their heads wrapped in red cloth, the girls enter the priests' tent for the main ceremony.

SIEM REAP, CAMBODIA

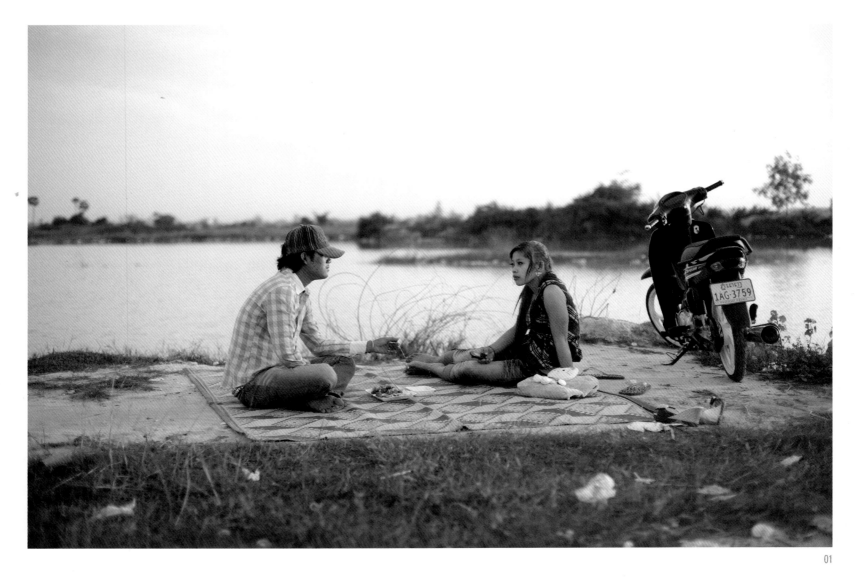

Siem Reap is one of Cambodia's fastest-growing cities, filled with bustling hotels, shops and markets. But along its outer edge, away from the tourist attractions and hectic commercial districts, lie natural, dry, unkempt grasslands, still untouched by development.

Scrubland and lakes lie along the sides of Plov Lek 60 Road. At its end, the road abruptly turns into a field. Early each day, local people gather on the road to exercise. As dusk falls, traders set up stalls and impromptu restaurants along its pavement. Local people come out to picnic, date or just enjoy the scenery.

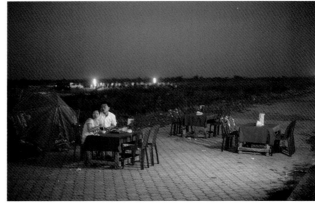

02

01 A young couple enjoy a picnic besides Plov Lek 60 Road on the outskirts of Siem Reap.

02 Every evening, pop-up restaurants appear along the side of the road.

Photographer
MITI RUANGKRITYA

MASTER AND APPRENTICE

Bei Dao

MASTER AND APPRENTICE

Bei Dao

Threads of light pierced the sheet metal roof with the plink-plonk of rain in a bucket. Against the murky darkness of the work shed there was only one small window, its filthy glass like a single blind eye. Freshly sprinkled water settled the dust on the packed earth floor. With the flick of a switch, the fan roared into motion; smoke billowed up from the coal stove, glowing fiery red in an instant.

This was my five years as a blacksmith.

Master Yan was in his 50s, a small, wiry man, his faded work clothes mottled with burn holes and sweat stains, his sweat-drenched hat brim crumpled. He commandeered the peen hammer, where the real craft lay.

Xiao Wang and I were apprentices, and our main task from morning till night was brandishing 14-pound sledgehammers. In terms of seniority, I had been smithing for two years longer, which made Xiao Wang my junior. He was built like a bear, having worked as a scaffolder until a fall from a height fractured his spine and occasioned his change of professions.

Once the steel ingot glowed red, Master Yan turned it with iron tongs in his left hand while fullering it with the peen hammer in his right. Almost magically, the peen hammer wrought its transformation in strokes hard, soft, slow and fast, drawing in blows from the sledgehammers as sparks arched out in all directions

Master Yan was a man of few words, occasionally muttering to himself in a shower of spittle to express his satisfaction or lack of same. The peen hammer was the language of power, while the sledgehammer was the language of attending and repetition. On the anvil, Master Yan was an orchestra conductor beating a multifarious tattoo, a whirlwind of fathomless mystery.

Breaks brought quiet. Master Yan would roll himself a newspaper stogie and brew strong tea in a bottle; when other masters struck up conversations in passing, baring his teeth to mumble a few words was considered a concession to friendship. Master and apprentice communicated little beyond blows to the iron. I would chat and arm-wrestle with Xiao Wang; he was exceptionally strong, able to lift a 300-pound anvil – I lost, wrenching my back in the process.

Finishing my turn at the sledgehammer, I would slip off, sweat-soaked, to the nearby workers' dormitory to read, write in my journal and compose poetry – my secret passion of many years, those stolen moments a source of delight. My books reaching a tacit agreement with his peen hammer, Master Yan gave me this privilege – for an hour in the morning and in the afternoon, he turned a blind eye, waving me over when my turn came again.

Perhaps Master Yan's taciturnity was another expression of his peen hammer. I pounded away at my poetry, that rhythm, that silence, that heartbeat, that passion. All, to some extent, resembling forging on the anvil – the ineffable, in this sense, the pursuit of unattainable perfection.

Translated by *Stacy Mosher*

北島

一线线阳光穿透铁皮屋顶，若下雨漏水，小桶里叮当敲响。在工棚昏暗的背景中，仅有一小窗，玻璃污浊，如盲目的独眼。在夯实的泥土地面，刚洒过水，尘埃落定。合闸，鼓风机轰鸣，烘炉灶头的烟煤升起浓烟，转瞬间呈火红色。

这是我五年当铁匠的生涯。

阎师傅五十多岁，个头儿小，精瘦，工作服褪了色，到处是火花飞溅的破洞和汗碱的印记。浸透汗水的帽檐皱巴巴的。他主管小榔头——这是技术的关键所在。

我和小王都是学徒，从早到晚，主要工作是抡14磅大锤。按辈份儿，我多干了两年铁匠，小王是我师弟。他虎背熊腰，当过架子工，不小心从高处掉下来，摔断脊椎，愈合后改了行。

待铁块烧红，阎师傅左手用铁夹转动，右手用小榔头指点。那把魔术般的小榔头，落点多变，轻重缓急，引领两把大锤轮流击打，火花飞溅，划出弧线。

阎师傅不爱说话，偶尔自言自语，嘟囔，啐口唾沫，表示满意与否。小榔头是权威的语言，大锤是聆听与重复的语言。在铁砧上，阎师傅如音乐指挥，击打的力量瞬息万变，深浅高深，风卷路转，神秘莫测。

工间休息静下来。阎师傅用报纸卷"大炮"，在玻璃瓶沏好浓茶，别的师傅路过搭讪，他咧嘴呲牙，语义含混，权当友好的表示。在师傅和学徒之间，除了打铁，语言极少沟通。我和小王一边聊天，一边掰腕子，他精力过人，双手抬起三百斤的铁砧——我败下阵来，扭伤了腰。

刚抡完大锤，满身是汗，我溜回附近的工人宿舍，读书做笔记写诗—— 这是我多年秘密的爱好，偷走时光，汲取愉悦的源泉。我的书和他的小榔头达成默契，阎师傅给了我特权——上下午各一个小时，他睁一只眼闭一只眼，快到时候了招招手，我继续抡大锤。

阎师傅默默寡言，或许是小榔头的另一种表达方式。我抡着大锤写诗，那节奏，那沉默，那心跳，那热情，多少与铁砧的锻造相仿，所谓言说不可说，在这个意义上，追求的是不可能实现的完美。

BIOGRAPHICAL NOTE

During China's Cultural Revolution
of 1966-76, Bei Dao was sent to
work in the countryside of Hebei
province. It was during this
period that he spent five years as
a blacksmith.

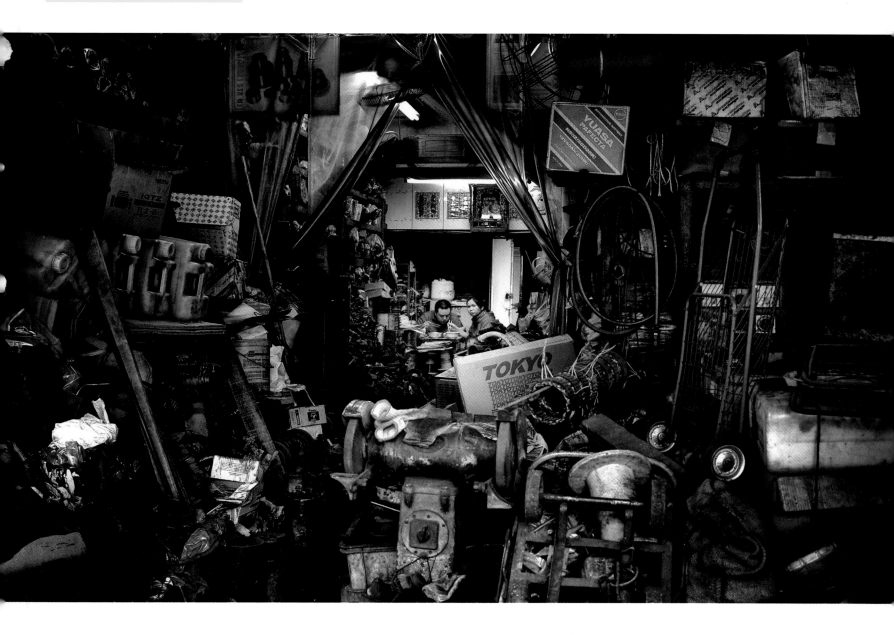

From 9 o'clock in the morning to 7 o'clock in the evening, Mr and Mrs Lau, both in their early 40s, collect batteries, electric motors, wire and other waste materials to recycle and resell. At their tiny warehouse space in Mongkok, one of Hong Kong's most crowded districts, Mr Lau repairs whatever equipment he can, then sells it along with the other materials the couple have gathered to nearby hardware stores and garages.

Despite the smell and the dirt, every day the couple make an effort to find time to eat and watch television together in what after 20 years has become their sanctuary. "Sometimes life is hard, but I'm the big boss of our 'cozy' cave, and here we can live our lives in our own way," says Mr Lau.

Photographer
LEO KWOK

NOT OUR PROBLEM

Each year, Hong Kong produces nearly one tonne of municipal solid waste for each of its 7 million citizens. Although more than half of this waste is disposed of in three landfills, much of the rest is recycled – just not in Hong Kong. Only 1.5 percent of recovered waste is processed by people like the Laus; the other 98.5 percent is sent for processing elsewhere in Asia, mainly in China.

HONG KONG'S RECYCLED WASTE, THOUSAND TONNES*

	Recycled in Hong Kong	Exported for recycling
Paper	0	1,278
Plastics	4	839
Ferrous metals	0	667
Non-ferrous metals	10	106
Electronics and electric equipment	11	56
Other	20	29
Total	45	2,975

*2011
Source: *Hong Kong Environmental Protection Department*

MOGANSHAN, CHINA

A little more than an hour's drive from the city of Hangzhou, 60 kilometres away, and only 200 kilometres from Shanghai, the hills of Moganshan are known both for the quality of their tea and as a place of respite from the heat of east China's summer.

Here, the tea picking season starts in spring, usually around the time of the Qing Ming festival in early April, and lasts for two to three months. In keeping with tradition, the pickers are all women, most of them in their 40s or 50s. The rest of the year, they help their husbands with their farms or look after their homes.

Starting at 8 o'clock in the morning and working through until 3 or 4 o'clock in the afternoon, a skilled picker can collect more than 10 kilogrammes of leaves in a day. Most of these women live in small communities or villages nearby. Although their work starts early in the morning, their mid-afternoon finish allows them time with their families at night.

01 A tea picker stands on the slopes of Moganshan. Although tea likely originated in plants from southwest China, almost all China's best tea comes from the three eastern provinces of Zhejiang – home to Moganshan – Anhui and Fujian.

02 Three tea harvesters enjoy a break with lunch boxes brought by their boss.

Photographer
RACHEL GOUK

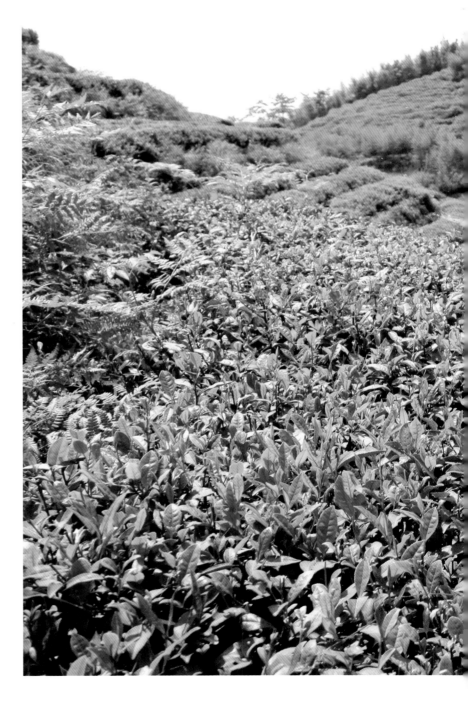

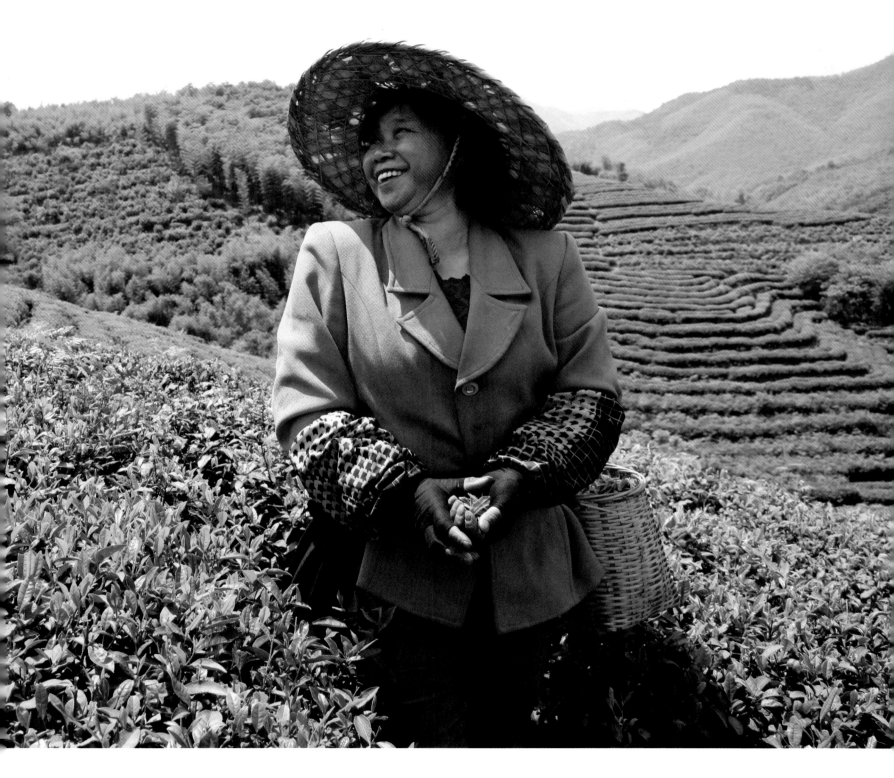

SHENZHEN, CHINA

The city of Shenzhen in south China is primarily known for its spectacularly successful economic achievements. In just over three decades, it has grown from being an insignificant village on the border with Hong Kong into one of the country's richest cities, home to 10 million people.

Most of Shenzhen's population are incomers who have moved to the city from other parts of China. But now there is also a group of young people born in the city since the start of its economic lift-off whose entire outlook on life is shaped by their experience of hyper-growth – people known as the "80s generation".

Photographer
CHEN JIANHUA

01 Xiao Lang, 25, dances at a karaoke club near his college. The son of a successful Shenzhen-based businessman, he expresses little concern about how life may turn out after he graduates. With dyed hair and tattoos, his friends say he behaves more like a gangster than a college student.

02 Zhen Peng, 25, wears his favourite luxury sunglasses on the way to a friend's wedding in Shenzhen. A physical education student at college, after graduating he launched a furniture company. Finding business not to his liking, he gave it up and now teaches physical education at an elementary school.

03 Li Guanhao, 23, kisses his girlfriend during a graduation trip. A year later, the couple split up after the salary at Li's first job proved not enough to keep their engagement going. Wei Ran, behind Li, joined an investment bank after graduating and is now preparing to marry his fiancée, the daughter of a successful local businessman.

01

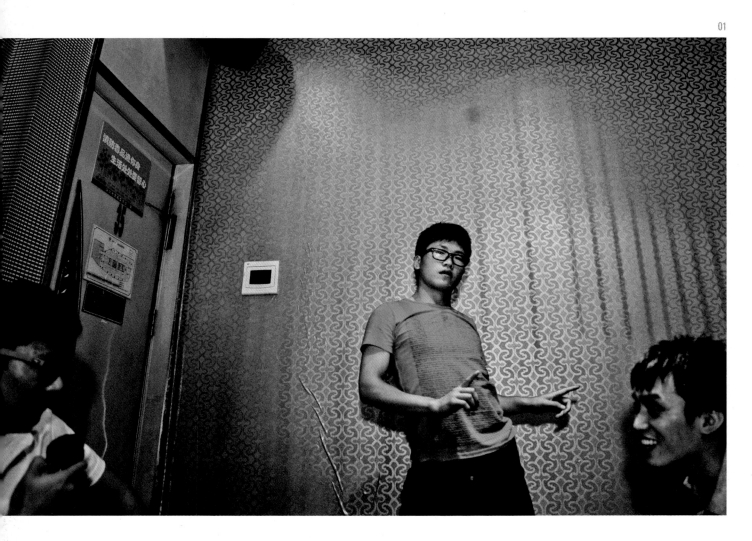

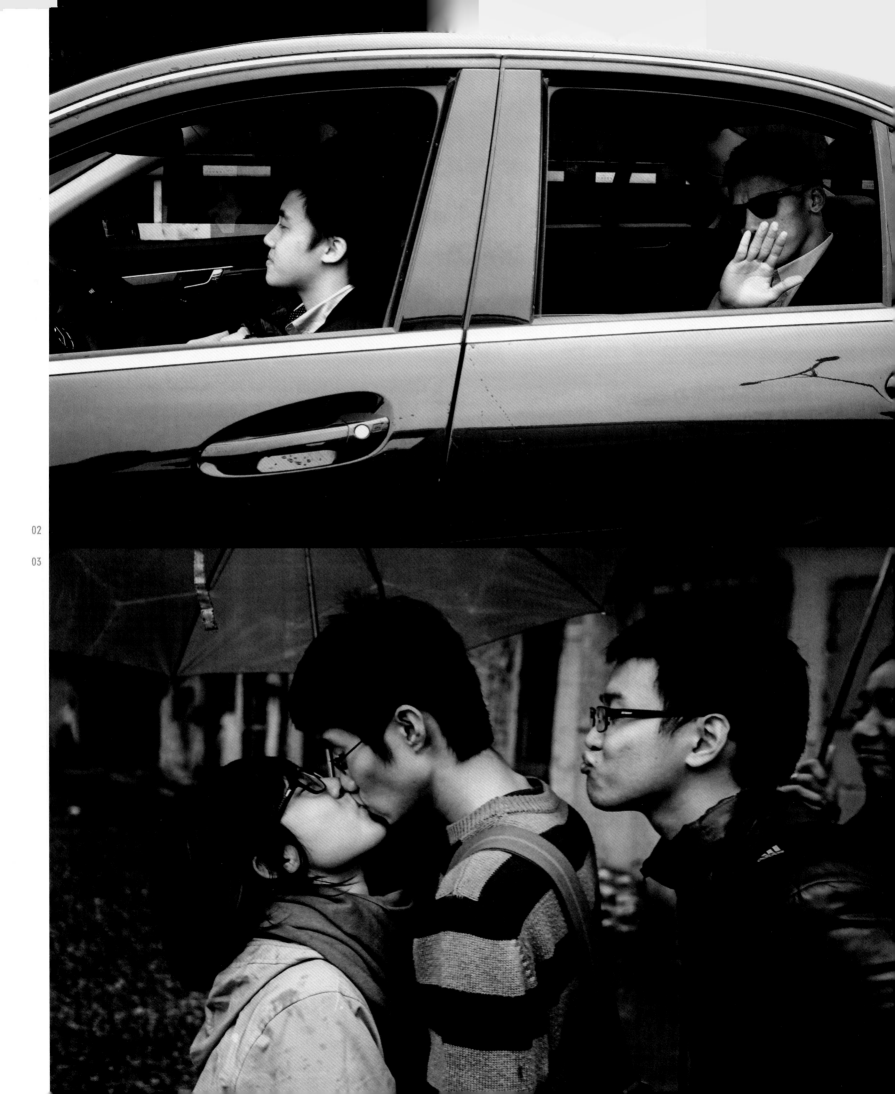

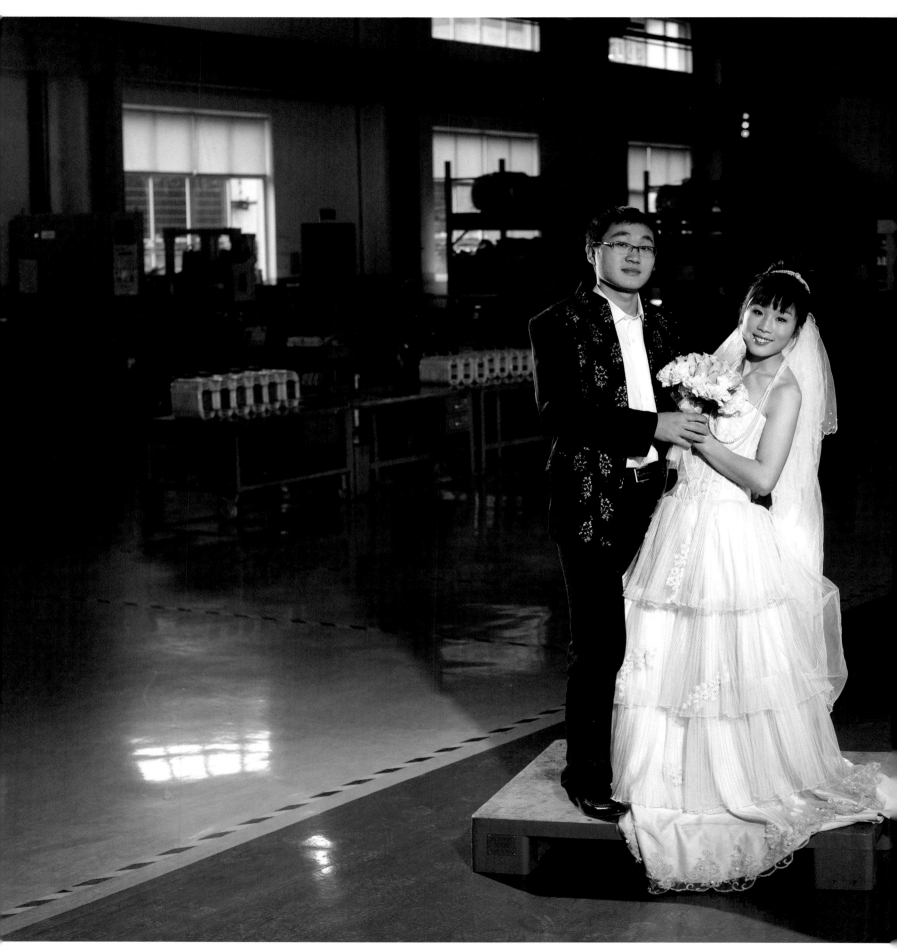

In the last two decades, countless thousands of factories have sprung up across Shanghai's outlying districts and suburbs. The majority of the young workers who fill their assembly lines are migrants from other parts of China. Despite being young – typically in their early 20s – many are already married when they arrive.

These couples face many challenges living in the city. On low wages and denied the social benefits granted to native Shanghainese, they live squashed into dormitories, single rooms or tiny flats. If they have a child, she or he is often left behind with their parents or other relatives in their hometown or village.

Unable to afford the cost when they married, most of them don't have wedding photos. Jia Daitengfei offered to take pictures of a few of them for free if they would pose in the factories where they worked. Six months later, he returned to take follow-ups and see if the lives of these couples had changed in any way.

01 Du Lijun and Li Hongbin were born in Nanchong, a city in west China's Sichuan province. They now live at Songjiang, a suburb of southwest Shanghai. The couple were introduced to each other by mutual acquaintances, married and had a child, who is living with relatives in their hometown.

02 Six months later, the family is reunited. The three of them have to sleep squeezed together on one double bed, but are happy to be together again.

Photographer
JIA DAITENGFEI

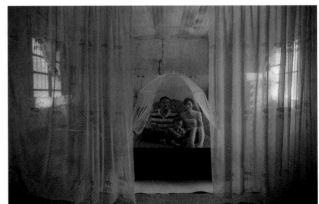

03

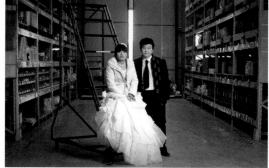

04

05

06

07

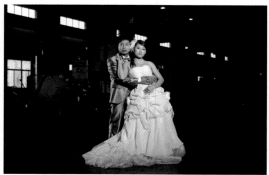

08

03 Both Xia Guang and Li Qianqian were born in east China's Anhui province in 1990, Guang in Haozhou, and Qianqian in Buyang. They married in May 2010 and shortly after Qianqian gave birth to a son. After the son died of pneumonia in October 2011, the couple decided to sue the hospital.

04 Six months later, Qianqian is pregnant again and the couple have withdrawn their lawsuit against the hospital.

05 Chen Guanfu was born in Heze in north China's Shandong province in 1983. Lin Zhimin was born at Guangan in Sichuan in 1987. After being introduced to each other by classmates, they married in 2012. Their plan is to move to Sichuan at some point in the future.

06 Six months later, Guanfu has started working at a new factory. Although his salary is higher, the couple now have to live apart.

07 Wang Hong, from Yunnan province, and Niu Yun, from Anhui, have been together for four years. They come from very different parts of China: Hong is from Yunnan province, in the country's remote southwest, while Yun is from Anhui, adjacent to Shanghai. Because of the distance between their hometowns, both sets of parents object to their relationship, which has prevented them from marrying.

08 Six months later, the couple have made no progress in resolving the uncertainty in their relationship.

JUNG PYONG RI, NORTH KOREA

"Everywhere I go, I try to show the human side of a country. What's behind the headlines that you see or read in the media," writes Eric Lafforgue.

"I've been six times to North Korea. Every time they've opened new places to visit, and I've kept on meeting local people.

"My contact with them has always been good. On my first visit in 2008, they wanted to see the pictures on my camera screen. Nowadays, especially in parks and at funfairs, they often ask me to pose for them and take a picture of me with their camera.

"In Jung Pyong Ri, a small seaside village, tourists are allowed to share food and sleep in the homes of local fishermen. For sure, these people are more privileged than many, and propaganda may be everywhere, but they have kept a warm side if you make the effort to discover it.

"North Koreans aren't the robots they are often portrayed as in Western newspapers and magazines."

01 In his uncle's house in Jung Pyong Ri village, beneath the portraits of North Korea's first two leaders, Kim Il-sung, and his son, Kim Jong-il, a boy plays his guitar before going to school. He had stayed overnight in the house to play music with his twin cousins who live there.

Photographer
ERIC LAFFORGUE

LIVE IN KOREA

To see brief footage of the boy playing his guitar, Google "Eric Lafforgue North Korea guitarist video".

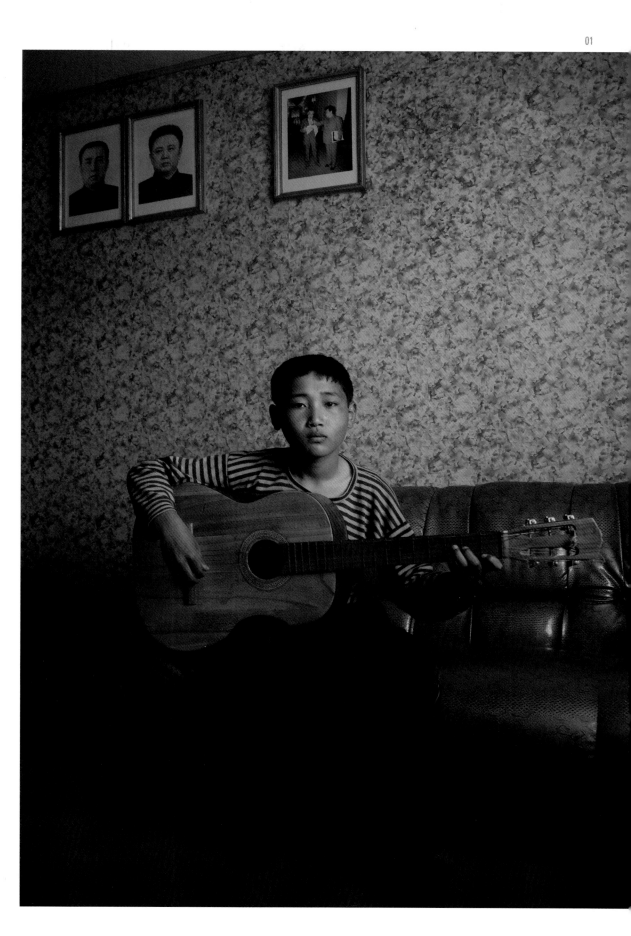

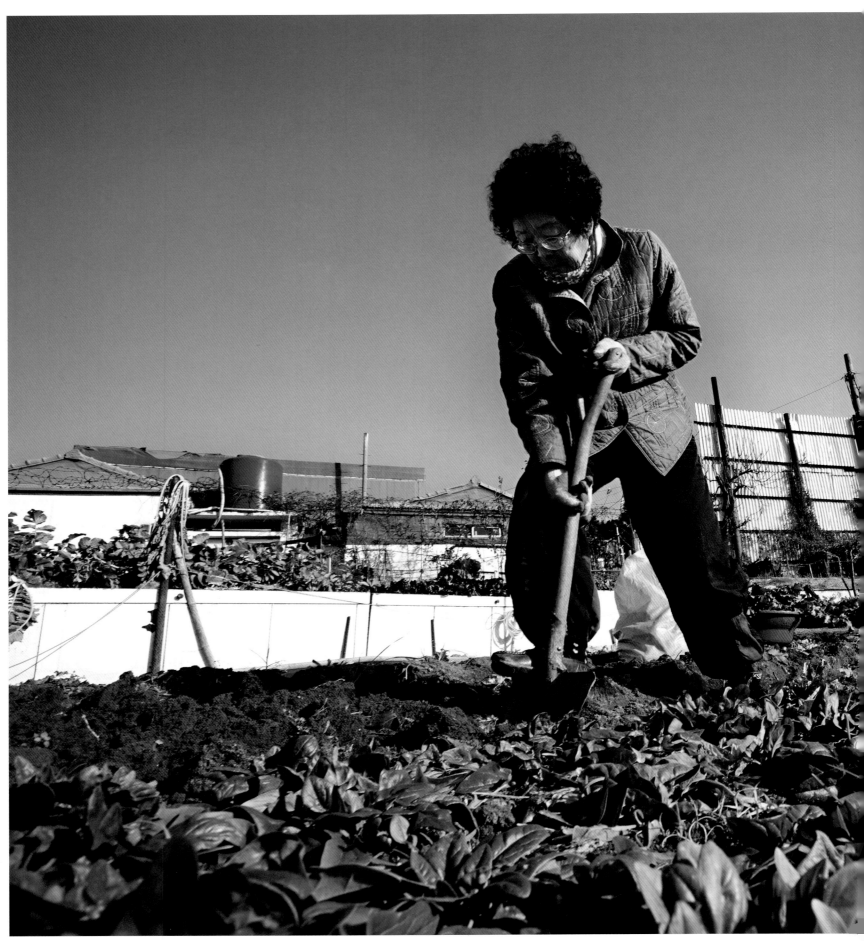

South Korea is a mountainous country with a scarcity of flat land for agriculture. Even in large cities such as Busan, people carve out small farms and gardens along terraced hillsides, often next to their homes and apartments. Produce from these plots feeds families and is also sold in traditional street markets. The growth of mega supermarkets, as well as the unrelenting pace of urban development, threatens these farmers, their land and their markets. Few farmers are young – 40 percent are over 60 years old – and most have seen their children and grandchildren move to other professions.

01 A farmer harvests produce from her small hillside plot in Sasang, a working class neigbourhood of Busan. More than half of South Korea's farmers are women.

02 A farmer pauses while spreading manure on his plot, also in Sasang. South Korean farms are small, averaging just 1.4 hectares, or 3.5 acres.

Photographer
BEN WELLER

02

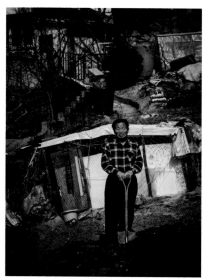

TOKYO, JAPAN

At the heart of central Tokyo's Shinjuku district stands the 235-metre-high Tokyo City Hall, one of the city's most famous buildings, designed by star architect Kenzo Tange and home to the Tokyo metropolitan government. Every morning, as hundreds of suited officials enter its doors, another local community sets off on its daily commute. From Shinjuku Central Park, literally in the shadow of City Hall, a community of homeless people dismantle their shelters made of blue plastic sheeting and cardboard, pack them and their other belongings into trolleys, and head off to their work – collecting plastic bottles from around the district.

Every evening, after a hard day's work, these communities pass each other again. As the homeless return to put up their temporary shelters for the night, the formally dressed bureaucrats hurry through the park to Shinjuku station and the trains that will take them back to their homes and families in the Tokyo suburbs.

In the mid 1990s, the city government tried to banish the homeless from the district. Their efforts failed as it proved impossible to stop people returning each night to sleep wherever they could find a spot to lie down. Officials have been more tolerant since, accepting that while office workers can relax and eat their lunch in the park during the day, at night it belongs to those with no homes.

Photographer
SAMUEL ZUDER

01 Besides the main street outside Shinjuku Central Park, a man sleeps oblivious to traffic and the all-night glare of street lighting.

02 A homeless man eats dinner next to his shelter. Officials put Tokyo's homeless population at around 3,400 and Japan's at 16,000 (aid groups put the national total much higher, at 25,000-50,000). More than 90 percent of these people are single men, and most are over 50.

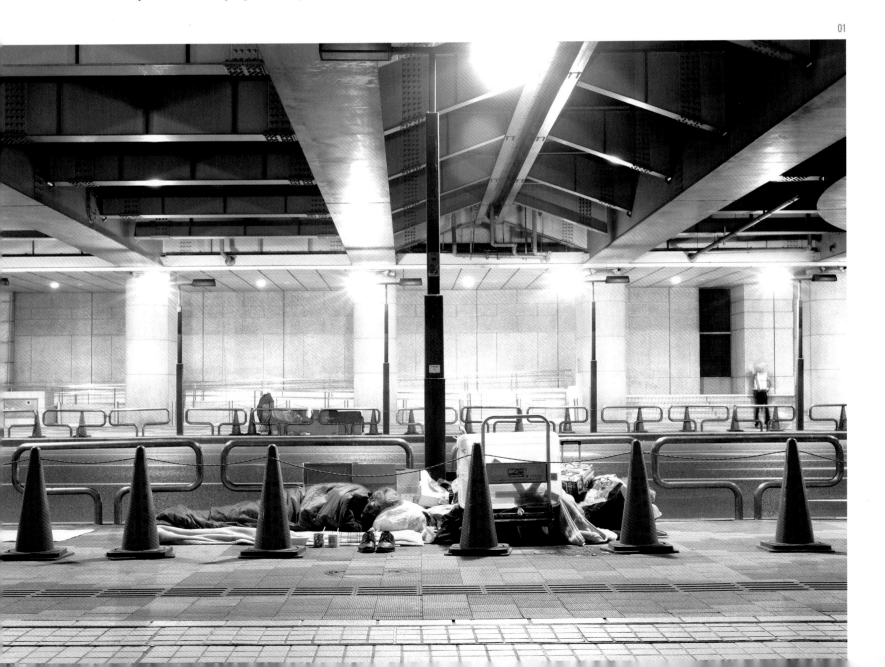

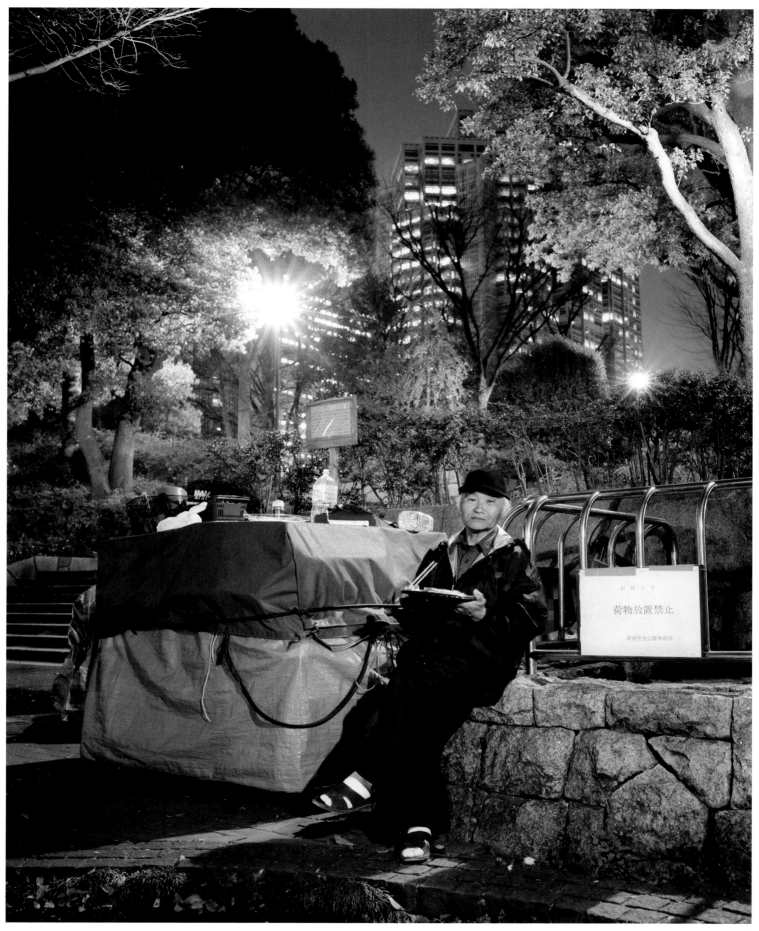

KHUVSGUL, MONGOLIA

Muugi, one of Mongolia's transgender population, was raised as one of seven children in a herding family in Khuvsgul aimag, a province in the north of the country. She left her home, first to study at university at Erdenet, Mongolia's second biggest city, and then for Ulan Bator, its capital, where she now lives with the family of one of her sisters.

Unable to afford the medical procedures for gender reassignment surgery, her papers still identify her as a man. This makes it impossible for her to be a teacher, the job she was trained for. Instead, she works for an LGBT (lesbian, gay, bisexual and transgender) non-governmental organisation.

To celebrate Tsagaan Sar, Mongolia's new year, Muugi returns home to Khuvsgul, where her family welcomes her home as warmly as ever.

01 Muugi's family mixes *shar tos*, a form of butter, with sugar and flour to make a traditional sweet for eating during new year celebrations at their home in Khuvsgul aimag, northern Mongolia.

02 Muugi tries on her sister-in-law's deel, a traditional long coat still widely worn in Mongolia, especially in the countryside.

Photographer
MAREIKE GÜNSCHE

02
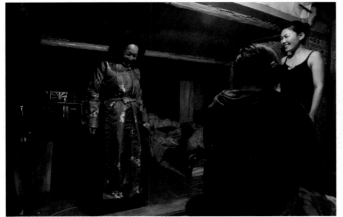

01
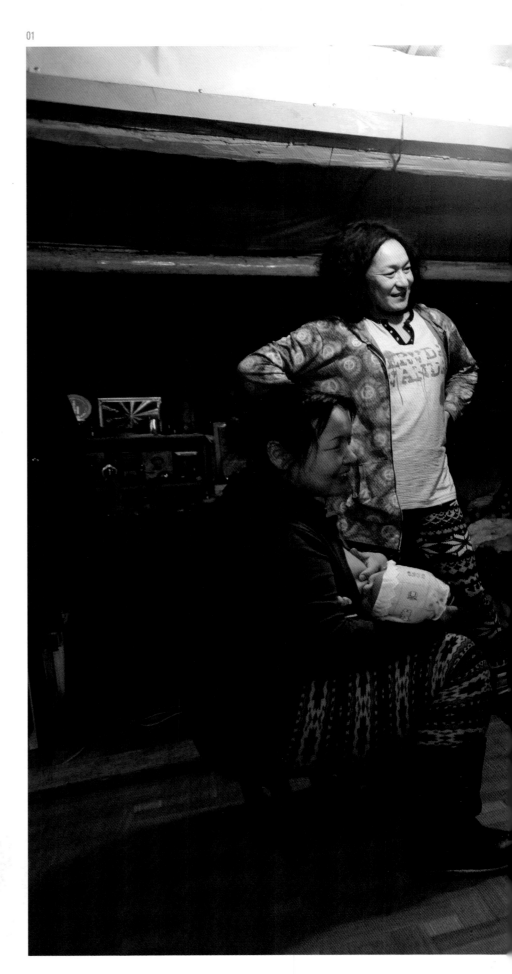

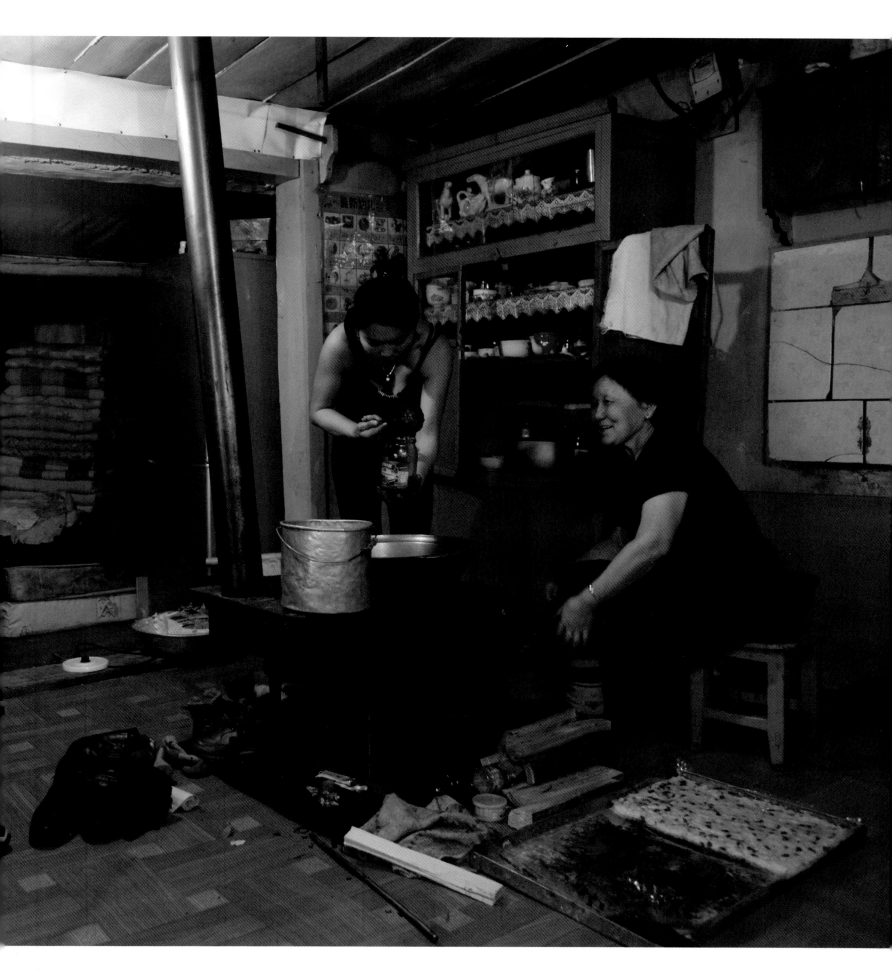

ASTANA, KAZAKHSTAN

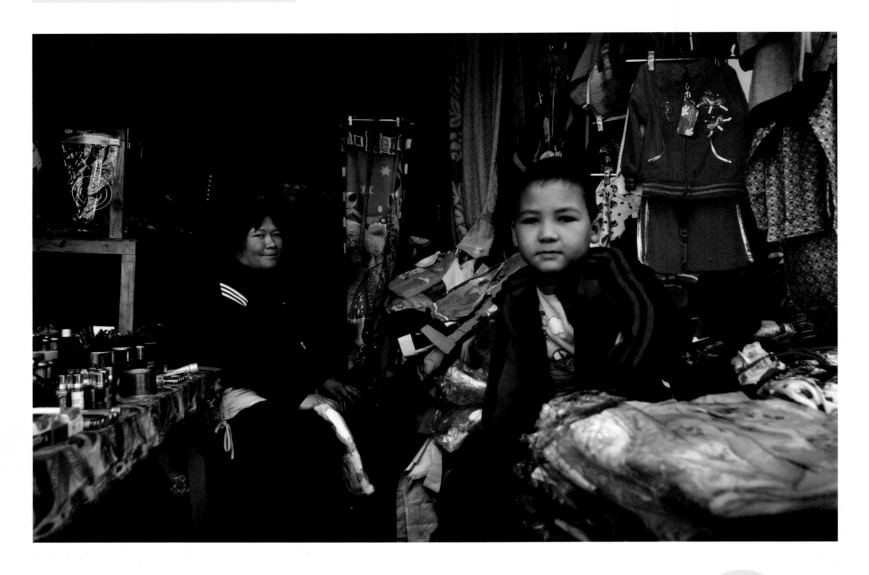

Astana is the boldest statement of any post-Soviet country – an entire capital city built on the whim of a single man, Kazakhstan's President Nursultan Nazarbayev.

Since Nazarbayev moved the Kazakh capital from its old location at Almaty to Astana in 1997, the country's oil wealth has funded an extraordinary construction programme.

The late Japanese architect Kisho Kurokawa laid down a masterplan for the entire city, paving the way for other star designers, architects, including Britain's Norman Foster and Italy's Manfredi Nicoletti to fill it with a grandiose collection of monuments and monumental buildings.

Like Myanmar's Naypyidaw, Canberra in Australia and other capitals built from scratch, much is hyper-ordered. Traffic drives along enormous boulevards lined with carefully trimmed hedges. Huge public squares are geometrically delineated with footpaths and fountains. And despite the city's extreme climate – summer temperatures can rise as high as 35° centigrade, plunging to minus 30° centigrade in winter – manicured lawns abound around its showpiece buildings.

And yet not everything is conducted to a plan. The city's population has soared from less than 300,000 to at least 775,000, many of these arrivals from poorer parts of the country looking for casual work on its construction sites or in service jobs.

For such people, the markets that have sprung up around the city are a godsend. In what has become by far the most expensive city to live in in Central Asia, traders bringing low-cost imports from China and other parts of Asia are a key link. Masterplans may feed the egos of rulers, but when it comes to the needs of ordinary people, the informal sector's ability to improvise wins out.

Photographer
JULIA STROKINA

DASHOGUZ, TURKMENISTAN

Since Turkmenistan secured its independence after the breakup of the Soviet Union in 1991, Dashoguz has been a backwater. Most of the city's population of just under 200,000 people are either Turkmen or Uzbek, leavened with a sprinkling of ethnic Russians, Karakalpaks, Koreans and Tatars.

In the 1920s and 1930s, Soviet engineers built electrical, water, and sewage systems. Hospitals, schools, four-storey apartments and broad avenues followed in the 1960s and 1970s.

Little new has been added in the last two decades, and the city overall retains the atmosphere of a provincial Russian town. In the city's Bai Bazaar, the legacy of Soviet rule remains evident in the dress and demeanour of these Turkmen women, in its décor and – especially – in its cakes.

Photographer
DAVID STANLEY

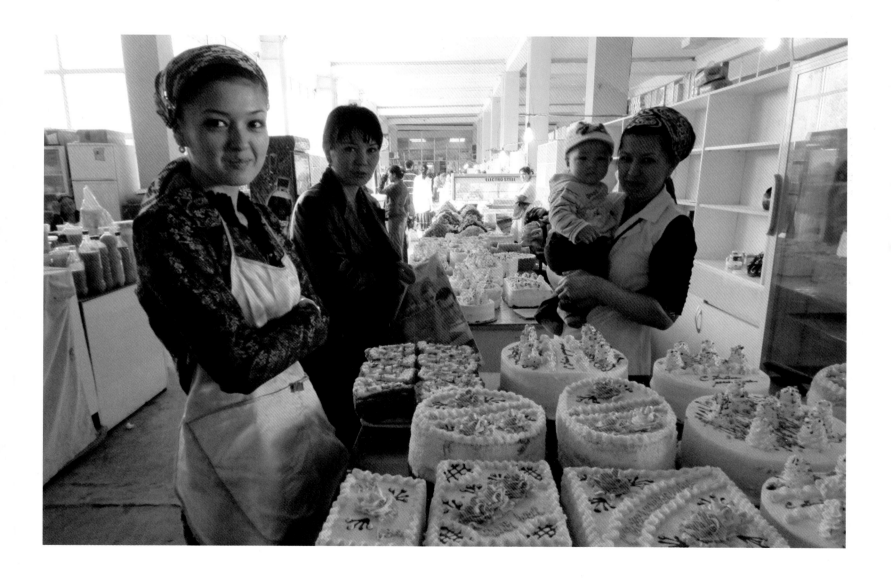

01

In the decades before the collapse of the Soviet Union, many of Uzbekistan's 13,000 Luli population were forced to abandon their ancient nomadic ways and work either on state farms or in factories.

Since Uzbekistan's establishment as a separate nation, most have switched to more casual work, such as collecting and reselling scrap metal and other waste materials, while the women raise food crops on small patches of land.

Followers of Sunni Islam, they have maintained a strong clan and sub-clan organisation, and usually live in small but tightly knit communities.

01 To save money, these four cousins shared the price of a bolt of fabric to make their colourful dresses. Their families share a common courtyard in Bukhara, the capital of Bukhara province.

02 Two Luli brothers (far right and with rooster) pose with two friends against a backdrop of posters featuring their heroes, among them Bruce Lee.

Photographer
ANZOR BUKHARSKY

02

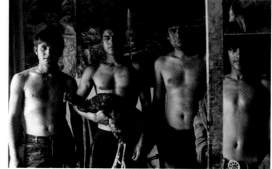

DUSHANBE, TAJIKISTAN

Khurshed and his three brothers live on the outskirts of Dushanbe, the capital of Tajikistan. Their family passion, stretching back at least three generations, is the Central Asian sport of *buzkashi*.

Played by Afghans, Uzbeks, Hazaras, Kazakhs, Kyrgyz, Turkmens and Pashtuns, as well as Tajiks, *buzkashi* has few rules. Up to a hundred or more riders fight to seize a headless goat carcass then carry it to a goal. In games that can last up to several hours, almost anything goes in this free-for-all sport.

As is common in the *buzkashi* world, rather than riding their own horses, the brothers ride a string owned by a wealthy individual – in their case a businessman-banker.

During the off season, the brothers get by on side jobs. Khurshed sells cheap cellphones in a bazaar, and the family also does some farming. But their primary work involves caring for horses, for which their backer pays them a salary.

01 On the hills near his home, Suhrob exercises one of the brothers' team of horses.

02 Ahliddin discusses the weekend's *buzkashi* matches with a friend on his cellphone.

03 Rustam takes a break during a foggy *buzkashi* match.

04 Khurshed prepares a horse for its daily exercises near his home on the outskirts of Dushanbe.

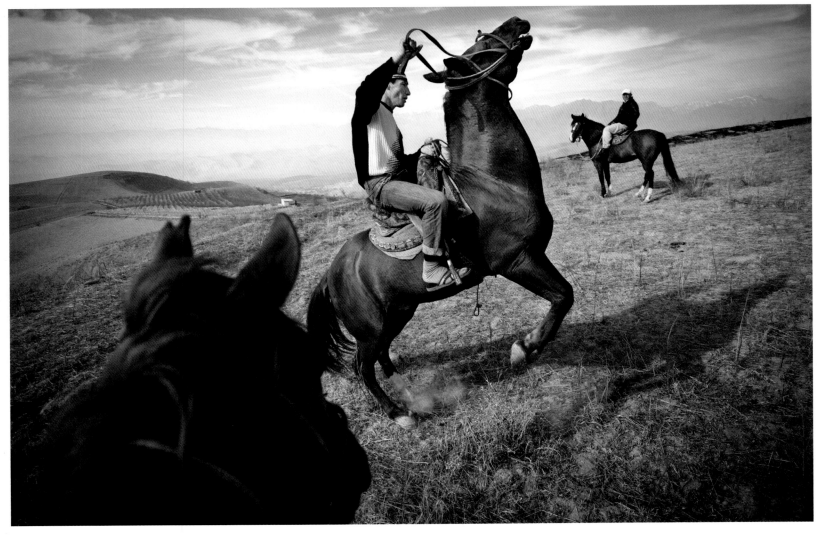

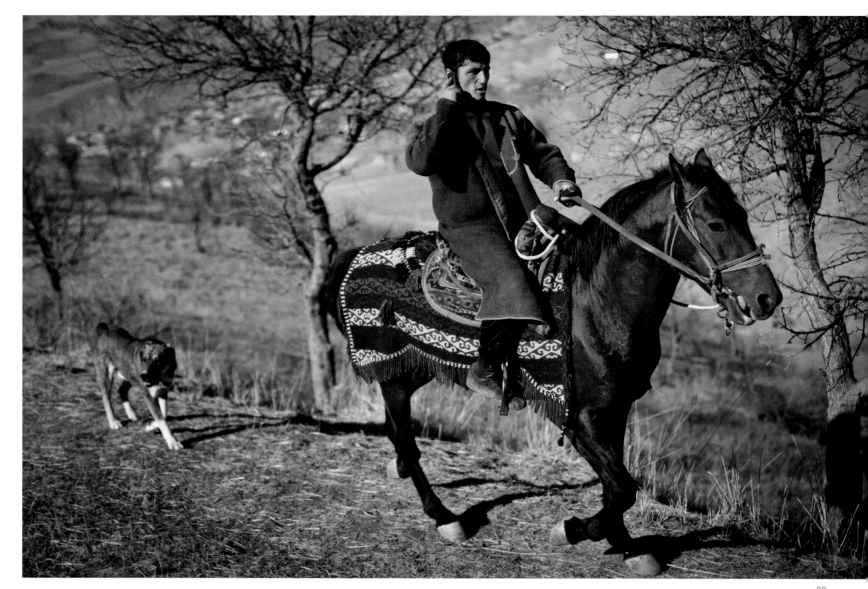

02

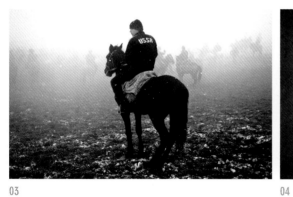

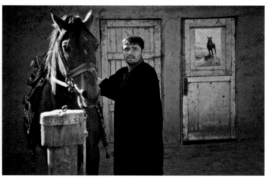

Photographer
THEODORE KAYE

03

04

HORSEY PLACES

Buzkashi may be one of Tajikistan's passions, but its horse ownership is surprisingly low. With just 75,000 horses and a population of some 6 million, that's just one horse for every 80 people.

By overall total, the USA is the world's horsiest nation with around 9.2 million horses – one horse for every 35 people – followed by China with around 7.4 million – one for every 180 people.

But by who has the most horses per person, the easy winner is Mongolia, with one horse for every 1.5 people, far ahead of second place Argentina, with one for every 11 people.

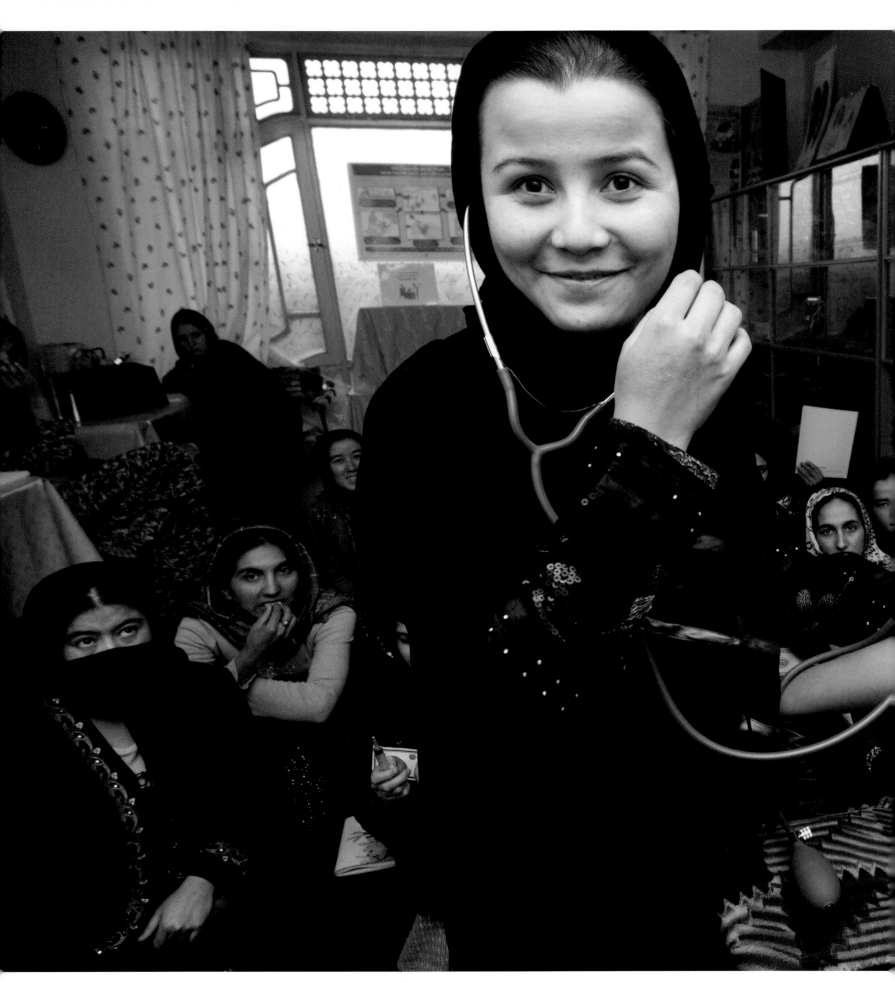

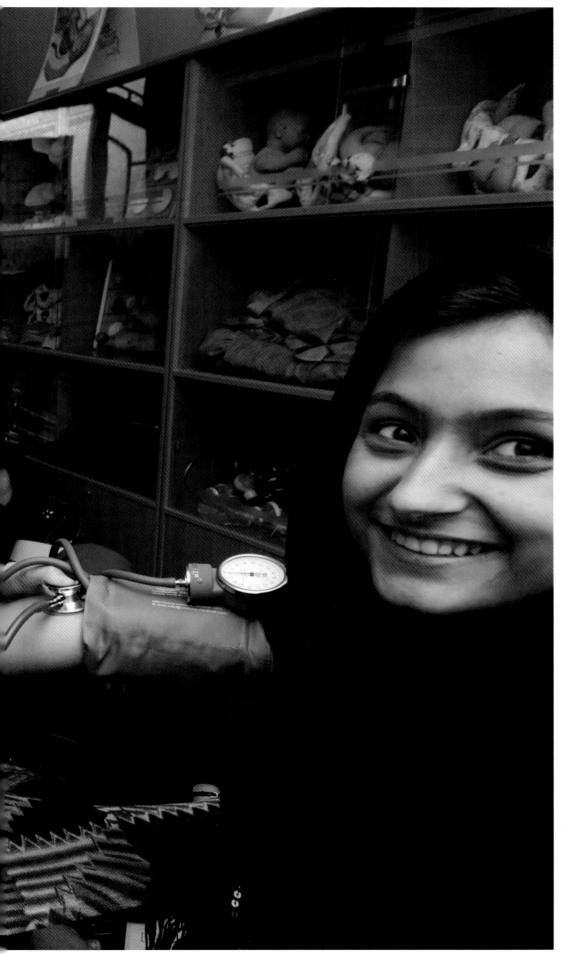

In Taloqan, in the north of Afghanistan, a class of 20 young village women are being trained to be midwives at the Afghan Turk clinic. They spend 18 months studying and practicing in the town's local clinics. After qualifying, they return to their remote villages, where they are often the only health worker for miles. In a country whose child mortality rates are the highest in the world and where many women die in pregnancy, their skills will save lives and enable women to deliver babies safely.

01 Soliha practises measuring blood pressure.

02 Fawzia gives a talk on family planning.

Photographer
JENNY MATTHEWS

ALL TOO MORTAL

CHILD DEATHS PER 1,000 LIVE BIRTHS, 2013*

Afghanistan	119.4
Somalia	101.9
Angola	81.8
India	44.6
Bangladesh	47.3
China	15.2
United States	5.9
France	3.3
Japan	2.2

*Estimated
Source: *CIA, The World Factbook*

KABUL, AFGHANISTAN

In the tiny alleyways of Ka Farushi, Kabul's bird bazaar, a merchant from one of Afghanistan's Tajik population sells everything from spices and flower seeds to bird food and shampoo. The Johnnie Walker Red Label bottles at the front of his stall, however, are not quite what they seem, being filled with cooking oil not Scottish whisky.

In 2012, to bring the country into line with Sharia law, Afghanistan's parliament passed a bill stipulating fines, imprisonment or whipping for anyone caught buying, selling or consuming liquor or other alcohol.

But with non-Muslim foreigners largely exempt from this ban, a black market for spirits and other drinks flourishes, albeit discreetly. Once emptied, the bottles are collected, cleaned and recycled with other liquids inside. It is unsurprising that bottles with Johnnie Walker labels often turn up – the brand is the most widely distributed and best-selling Scotch whisky worldwide, with annual sales of more than 130 million bottles.

Photographer
MARTIN MIDDLEBROOK

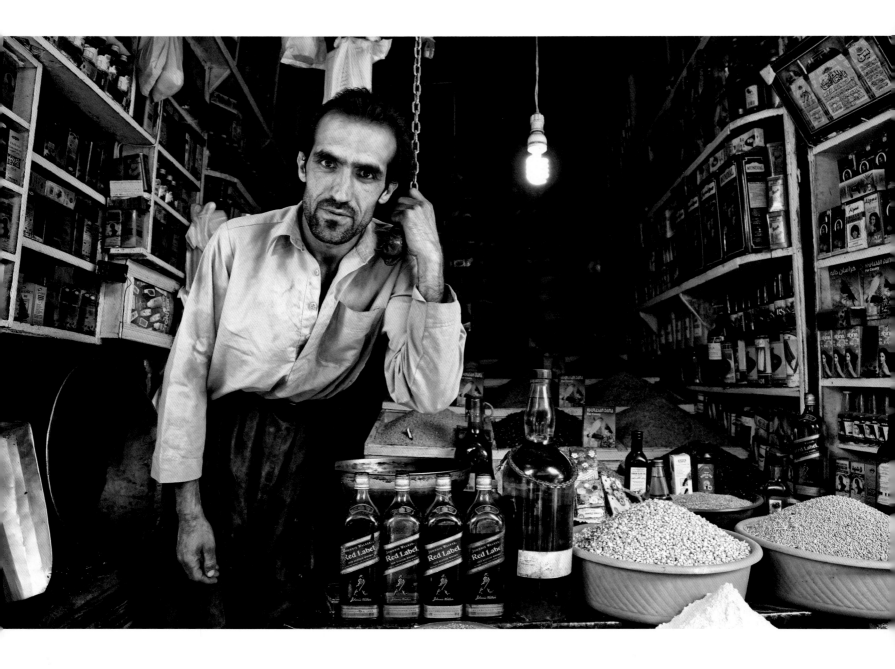

PRAKASHPUR, NEPAL

Teeka Paudel, 54, lives with her husband and children on a small farm in Prakashpur, a remote village in southeast Nepal. She was born on the same farm, and has had six children there. The furthest she has ever travelled is to the nearby town of Inaruwa, about 15 minutes journey by bus.

Every morning after waking, Teeka performs a Hindu ritual *puja* – a welcoming of blessings from the gods into her home. She then prepares a breakfast of rice, lentils and potatoes for her family. Once breakfast is over, she works through the day until the early evening on the family's patch of land, then returns home to prepare the evening meal. After dinner, she and her family sit outside their home on straw mats, chatting and socializing with friends and neighbours.

The family lives on less than US$10 dollars a day. Their income comes from her husband's army pension of US$30 a month and the small sums they make from selling crops they have grown.

In early 2012, her eldest son, a soldier in the Indian army, suggested that the family should move to the Nepalese capital, Kathmandu, where they could have an easier life. Teeka had none of it, telling her son she wanted to spend the rest of her life in the village she had always called home.

Photographer
JAMIE MITCHELL

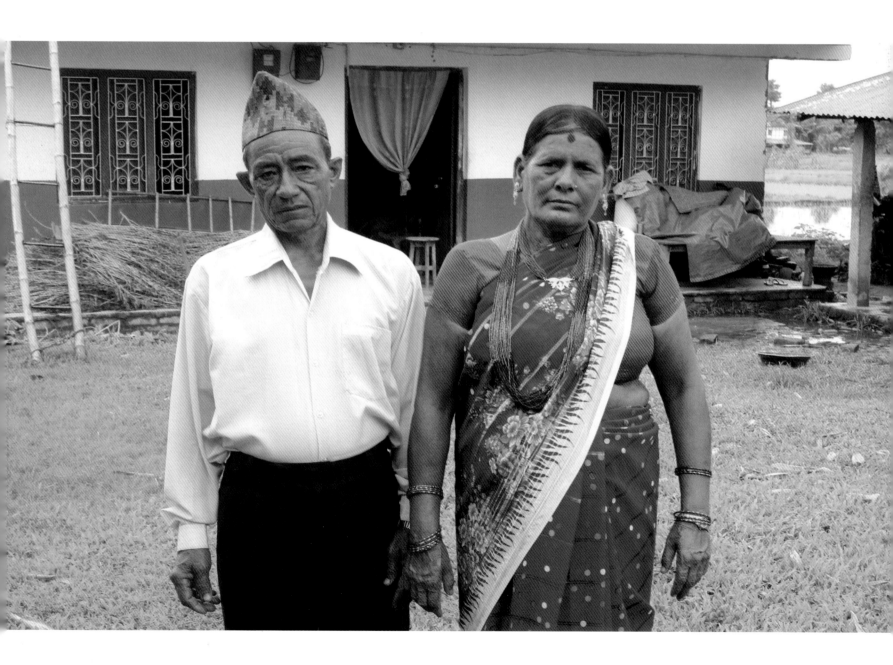

KHYBER MAIL, PAKISTAN

Taking 35 hours for its journey, the Khyber Mail train service – named after the famous pass linking Pakistan to Afghanistan – runs daily from Peshawar in northern Pakistan's Khyber Pakhtunkhwa province, south through Punjab province, to Karachi, Pakistan's largest city, at the southern tip of Sindh province on the Arabian Sea. The line, 1,069 miles long, has operated continuously since 1947, when Pakistan established its independence.

01 Brothers Mairaj Hassam, 7 years old, Siraj Hassam, 3, and Shabbir Hassam, 10, travelling with their sister, Tatheer Fatima, 4, between Rawalpindi and Karachi. The children are returning with their mother, father and 18-month-old brother to their home in Karachi after visiting relatives in northern Pakistan's mountainous Baltistan region.

Photographer
SAM PHELPS

KHYBER MAIL

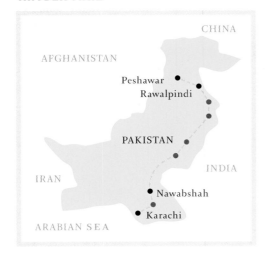

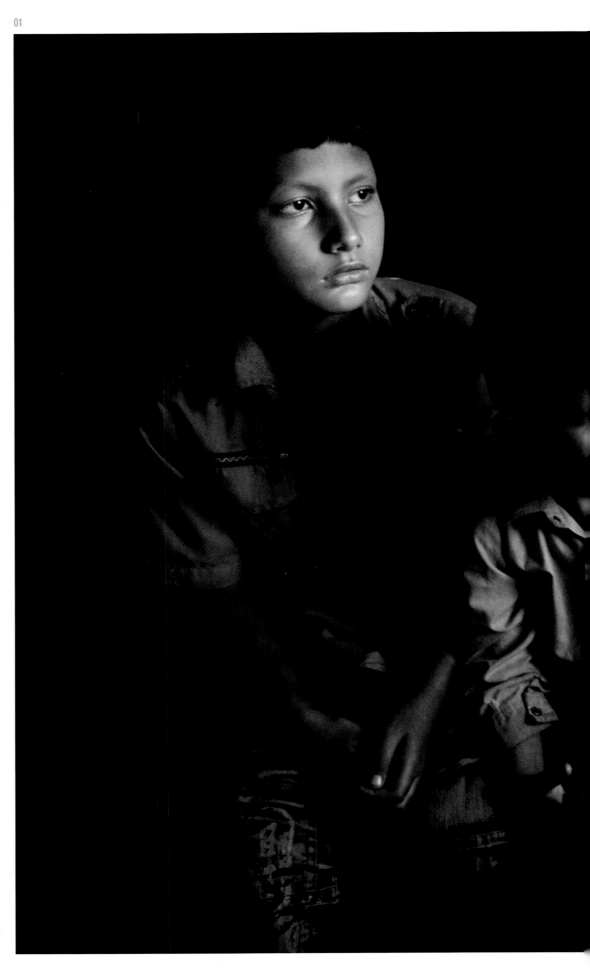

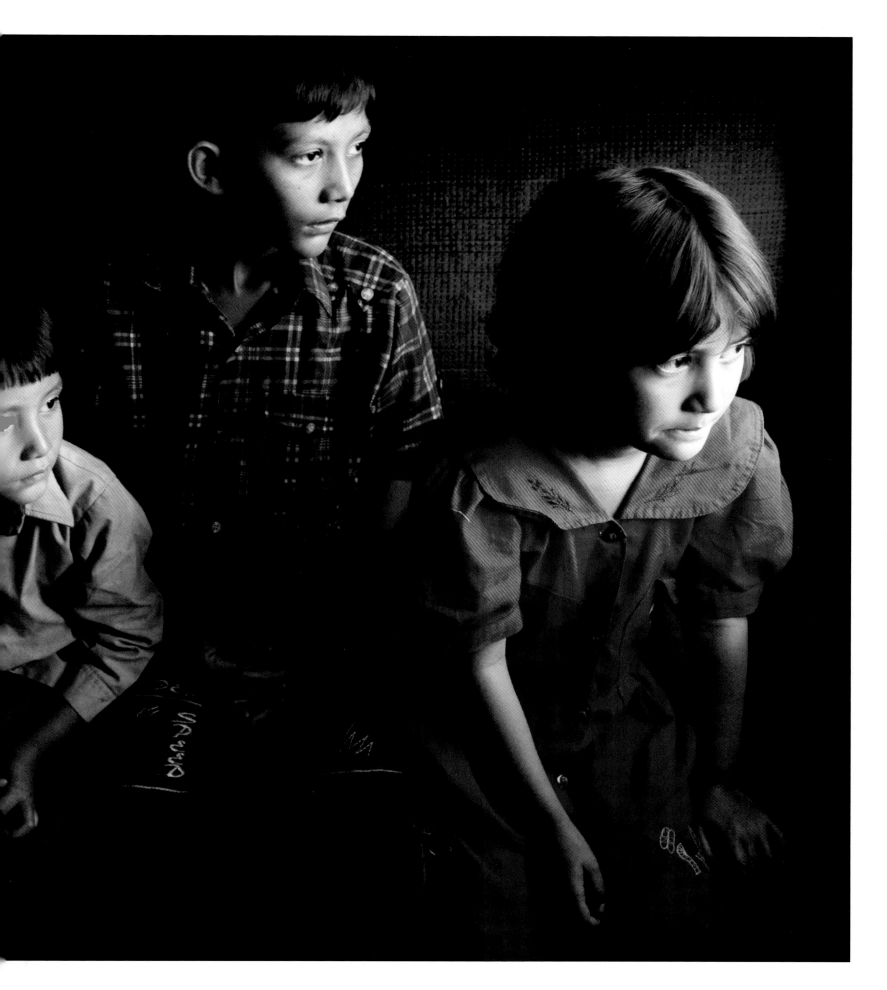

02 Sufi beggar Joman, 80, travelling from Rawalpindi to Karachi. Born in Nawabshah in Sindh province, he has two wives and 12 children, and has been a beggar all his life.

03 Poultry farmer Sadiq Hussain, 50, travelling from Rawalpindi to Karachi, on his way home to Sahiwah after visiting a friend. He has four children – two sons and two daughters. His leg was cut off at the knee in 1999 because of cancer. "The government cannot help us. We are poor people and have always been poor people. Nobody can help us."

04 Quran teacher Muhammad Ali Johari, 22, and his 18-month-old son, Murtaza, travelling from Rawalpindi to their home in Karachi, along with his wife and his other four children – the quartet of the previous two pages. "This country is like the train system – inefficient and poorly managed."

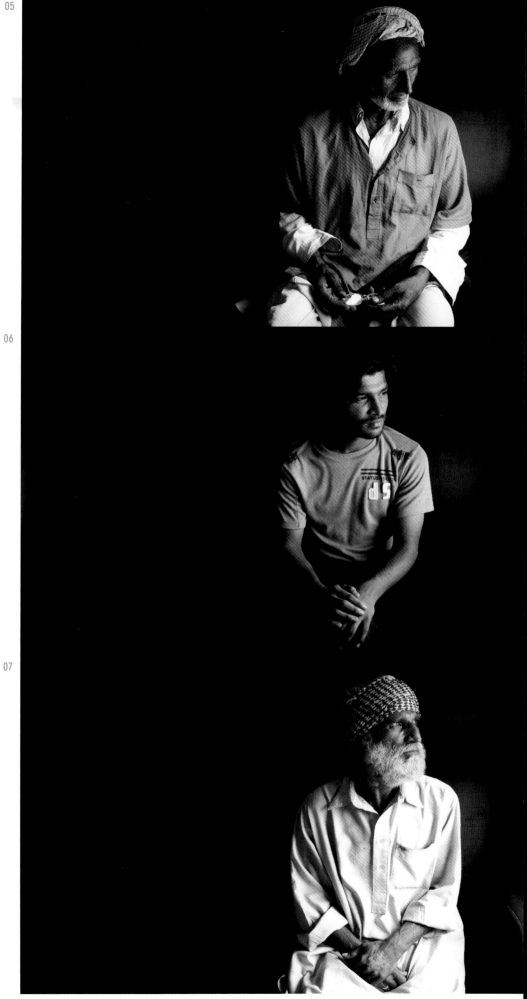

05 Ghulam Farid, 60, travelling from Karachi to Peshawar. The father of six daughters, he has worked as a porter in Multan for the last 40 years. "Corruption is a big problem in Pakistan. I don't believe that the government can help us."

06 Muhammad Ali, 24, travelling from Karachi to Peshawar to visit his hometown, Sahiwal. Muhammad's father died recently aged 45 of a heart attack. Muhammad, the eldest of eight siblings, is searching for work to support his family. "I am the eldest child. Sometimes I borrow money from relatives and do odd jobs for a little money. I was working in a shop but was only paid 2,000 rupees (US$25) a month."

07 Haji Ghulam Abbas, 70, on a journey from Dera Ghazi Khan to Hyderabad. He has worked as a station beggar for his entire life.

DHAKA, BANGLADESH

In Bangladesh, a society where marriage is still regarded far more as a merging of two families than as a union of two people, love can be a complicated, even dangerous thing.

Religious, economic and social factors are the conditions that count – hard terms for young people who dream about love and freedom of choice.

Many sweethearts meet in secret to escape the disapproving eyes of their parents or even their friends. Parks are a favoured location for their encounters.

01 Arif Mahmud, 26 and Rashna, 21, both students at the University of Liberal Arts, have been together for two years. Their families are aware but do not approve of them dating. The couple hope that given time their families will eventually accept and support their relationship.

02 Masum, 29, and Sopna, 20, have been married nearly a month. The couple had never met before their wedding, but have no qualms about revealing that their marriage was arranged. Advocates of arranged marriages maintain that the wedding is just the starting point on the path to love; other factors – religion, status and economic well-being – should be the real determinants of who marries who.

03 Dhaka's Chondrima Uddan Park is one of the most popular meeting spots for clandestine lovers. Just a few years ago it was impossible for couples to meet in public places without the risk of being harassed, but times are changing and now they can hold hands and talk undisturbed.

04 Lakhi and Firoz knew each other for four years before they married. In keeping with tradition, after the wedding Lakhi will move to live with her husband and his family. Tears to mark the bride's separation from her family are an expected part of the ceremony.

Photographer
TOBIAS SELNAES MARKUSSEN

01

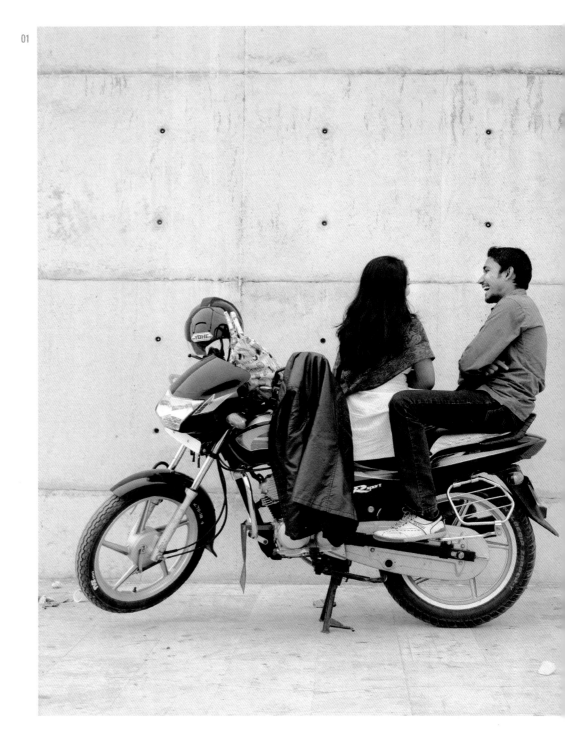

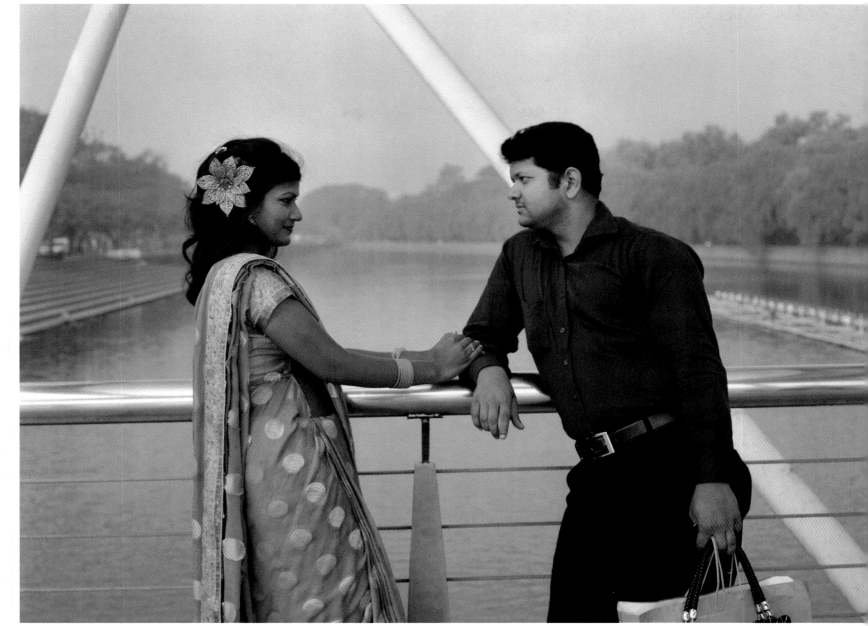

02

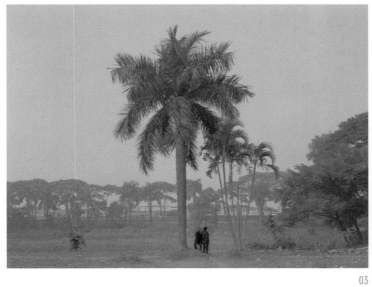

03

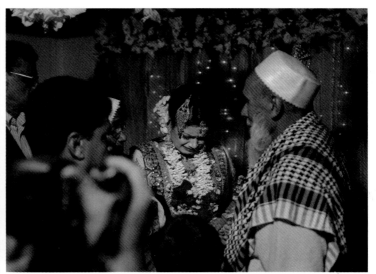

04

MONGAR, BHUTAN

Karma Choden, 28, from Drepong village in east Bhutan's Mongar district, is a member of the Puengu Detshen farmers' group, one of the district's leading growers of vegetables.

Puengu Detshen, which means nine brothers, takes its name from its nine member households.

Karma and the group's other members work seven days a week growing a host of different vegetables, among them cabbages, broccoli, peas, radishes, carrots and mustard greens.

The group sells vegetables to the local community. Its biggest customer is a nearby secondary school which buys around 100 kilogrammes of vegetables daily. Every year, each household in the group earns around 100,000 ngultrum – about US$2,000 – from sales of the vegetables.

Karma's husband, Cheten Norbu, 30, is the group's leader. His main responsibility is coordinating work to maintain a smooth supply of vegetables to the school. The couple, who are from the same village, have a five-year-old son and a three-year-old daughter.

As well as growing vegetables as a cash crop, Karma and the other farmers in her group also grow maize and rice.

Photographer
AIDAN DOCKERY

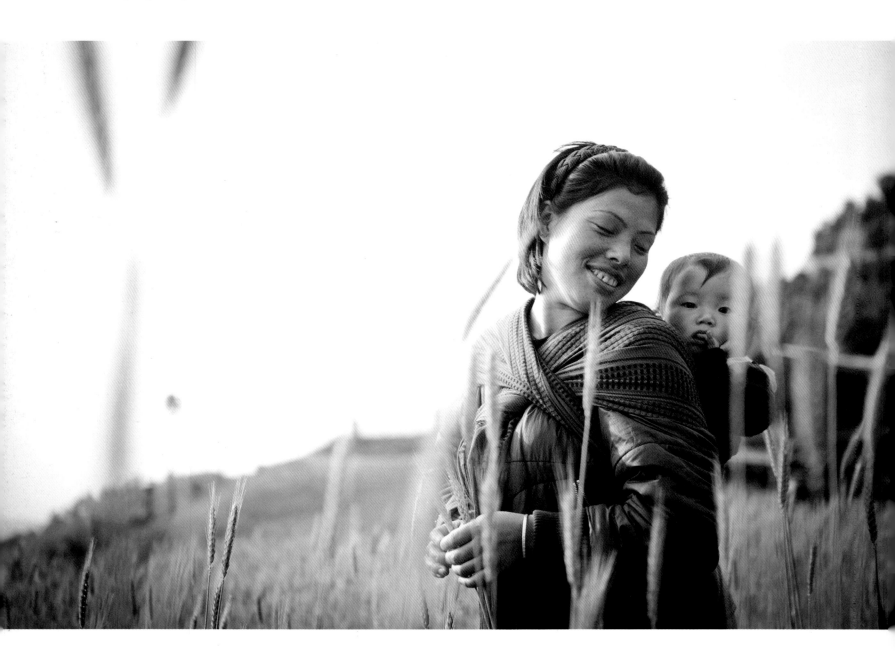

ODISHA, INDIA

Mount Niyam Dongar is a sacred place for the Dongria Kondhas, a people living in the Nyamgiri Hills of east India's Odisha state. But it also holds a huge deposit of bauxite, valued at US$2 billion by Vedanta Resources, a United Kingdom-based metals company that wants to open a mine on the mountain.

Since 2005, Dongria Kondh villagers have resisted Vedanta's efforts to develop the mine using demonstrations, court cases and – where necessary – direct action. Along the way they have enlisted the support of other local peoples, lawyers and international non-governmental organisations.

Odisha, known as Orissa until 2011, is home to 62 different tribal peoples, more than any other Indian state. Together they account for 22 percent of Odisha's population.

Here, four men from villages around Niyam Dongar stand atop a jeep they helped destroy after it was found bringing engineers hired by Vedanta to the mountain.

Photographer
ROBERTO CACCURI

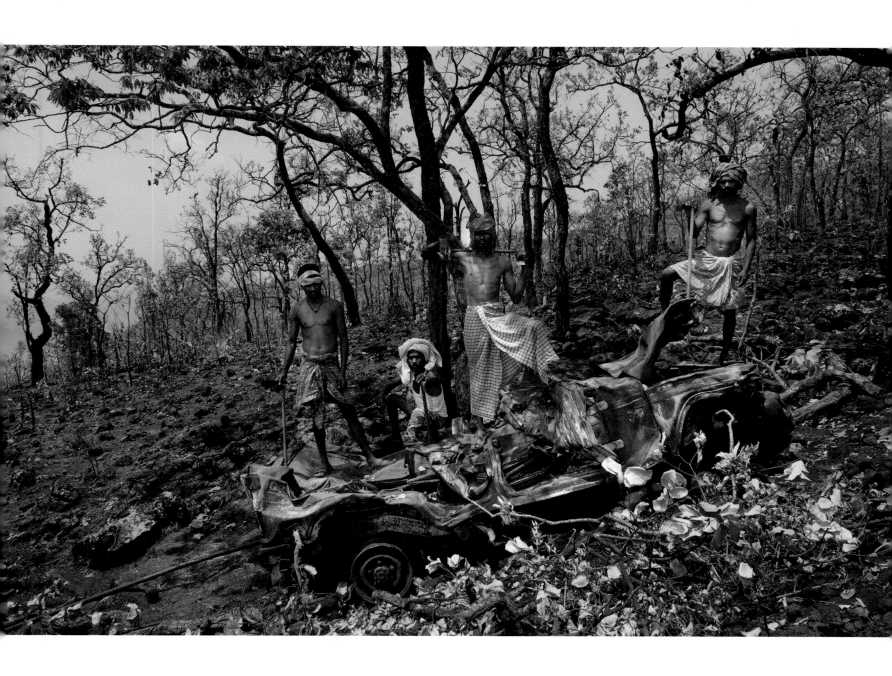

KOLKATA, INDIA

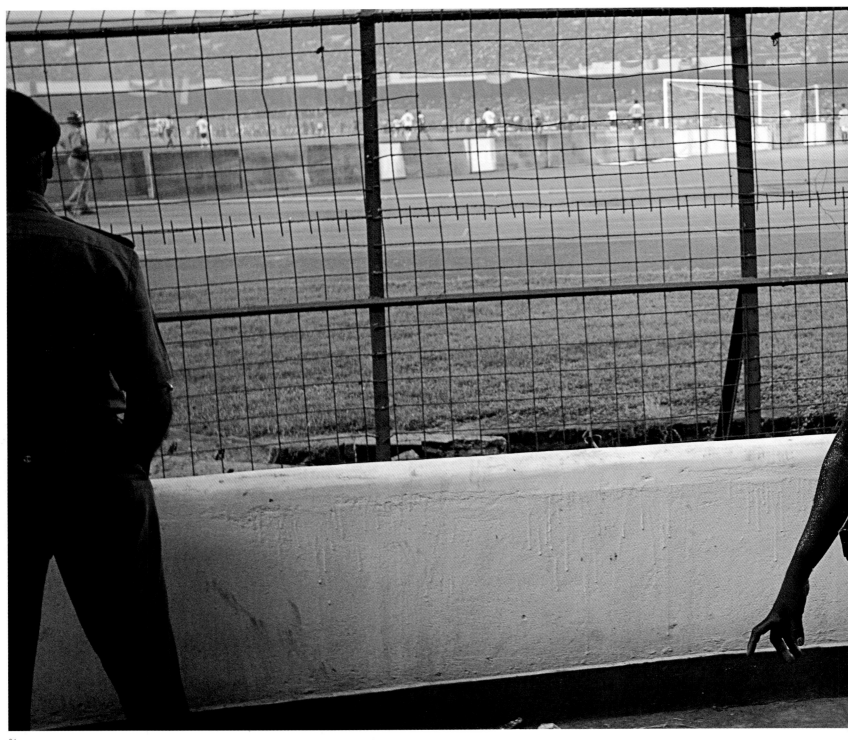

01

NEAR THE TOP OF THE LEAGUE

Mohun Bagan Athletic Club is one of world's oldest football clubs. Founded in 1889, it is outranked by Manchester United (1878) and Arsenal (1886), but can claim seniority on most of football's other contemporary giants: Liverpool (1892), Juventus (1897), Barcelona and AC Milan (both 1899), Bayern Munich (1900), River Plate (1901), Real Madrid (1902), Chelsea and Boca Juniors (both 1905), Inter Milan (1908), Corinthians (1910) and Santos (1912). East Bengal, founded in 1920, is a comparative youngster.

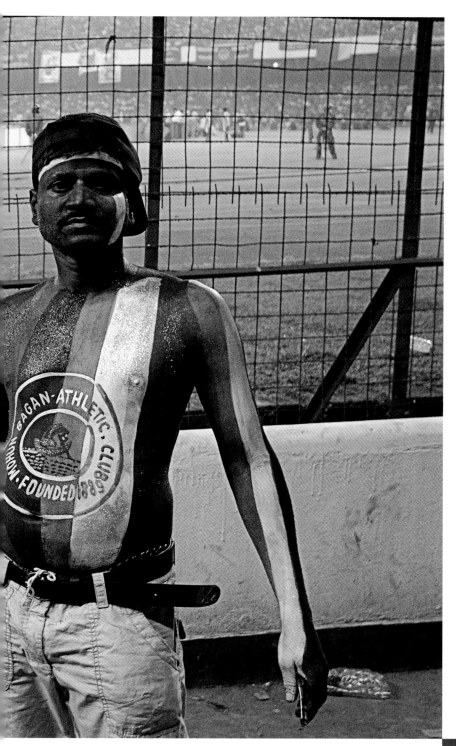

East Bengal against Mohun Bagan at Kolkata's Salt Lake Stadium is the biggest derby in Indian football, attended by up to 100,000 people.

The two teams meet at least four times a year in league encounters – more if they clash in cup competitions. Their supporters care little about a new low FIFA ranking for India's national team or news from Real Madrid or Manchester United. All that matters is their next derby.

The sides first played in 1925, and have clashed more than 300 times since. According to the most recent count, East Bengal has won 115 games, Mohun Bagan has won 85, and 105 have been drawn. A 1997 Federation Cup semi-final between them drew India's largest ever football crowd: in front of 131,000 spectators, East Bengal won 4-1.

Both Kolkata-based, the two teams originally drew on different segments of society. Mohun Bagan was followed by people from western Bengal, while East Bengal's supporters came from the east, in what now is Bangladesh.

Those distinctions have weakened over the decades. What hasn't is that both team's fans come from the bottom ranks of Indian society, working as labourers, rickshaw pullers, security guards or small-shop owners. Most live below the poverty line, but hard as it may be to make ends meet, they still happily pay the US$0.50 entry fee for a game, where over 90 minutes, and despite tight security, they drink illegally brewed country liquor, let off fireworks and scream the foulest slang at opposition supporters.

01 A Mohun Bagan supporter at his team's 299th meeting with East Bengal in November 2011. Mohun Bagan won 1-0 thanks to a first-half penalty goal by their Nigerian striker Odafa Onyeka Okolie.

Photographer
SASWATA KAR

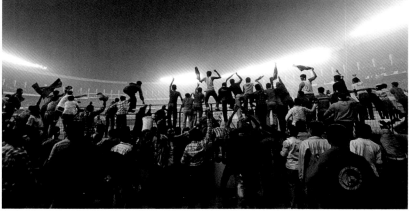

KOLKATA, INDIA

Mohammed Komrulhoda, 57, works as a rickshaw puller in the streets around Kolkata's New Market area, starting before dawn and usually carrying on until nine o'clock at night.

From Purvi Champaran, a small village in northern India's Bihar state, he averages around six or seven customers a day, each paying between 10 rupees and 30 rupees for a journey – US$0.15 to US$0.50. His total daily earnings range between 50 rupees and 100 rupees, from which he has to pay 30 rupees for the rental of his rickshaw. At night he sleeps in a room shared with a dozen or so other men, paying 90 rupees a month for his bed.

Two or three times a year he travels by train to visit his family in Bihar, journeys which each cost him around 5,000 rupees. Any money he has left after paying for food and his other living costs he sends to relatives in Bihar. He has five children, two of whom – his youngest daughters – remain unmarried because he cannot save enough money to give them dowries big enough to attract suitable husbands.

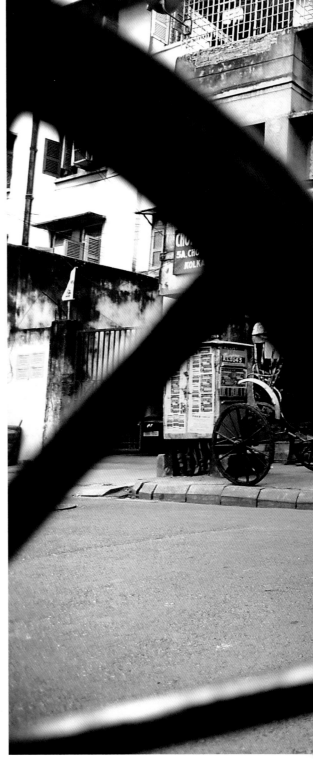

01

02

03

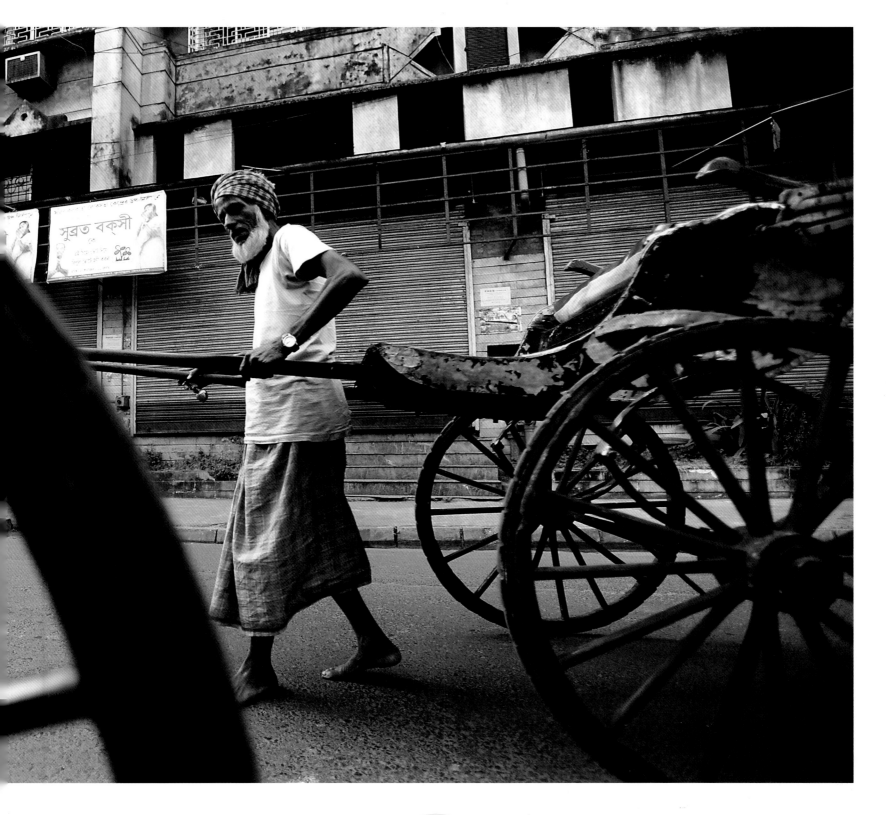

Photographer
OLAF SCHUELKE

01 On the streets for around 15 hours a day, most of Mohammed's time is spent waiting for his next customer.

02 Mohammed takes an afternoon break with a cup of tea.

03 Eating lunch at a street-side restaurant. Most days, Mohammed can only only afford a few chapati (unleavened flat bread), some dhal (lentils) and a bowl or two of rice. Occasionally he treats himself to a little chicken or mutton.

AHANGAMA, SRI LANKA

For 30 kilometres along Sri Lanka's southern coast, between the towns of Unawatuna and Weilgama, fishermen such as Sunil Nishanti sit motionless on wooden stilts a few dozen metres from the shoreline.

The technique may be unique, but it is a fairly recent innovation, first adopted just after the second world war when fishing spots on rocks and cliffs along the coast became too crowded. Men started fishing from the wrecks of boats and aircraft left behind by the war, then some of them moved to stilts erected at fixed locations, which they then passed on to their sons.

The practice is unlikely to last much longer other than as a tourist attraction. Local fisheries are in decline, particularly following permanent alterations to the shoreline brought about by the Indian Ocean tsunami of 2004. The returns from fishing, never good, are worsening, and few fisherman pass their stilts to their sons, instead renting them to other men who find it easier and more lucrative to pose for photographs.

For now, Sunil still earns his living from fishing. He and his family lost almost everything when the tsunami of 2004 flooded the bay where they lived. He declined a government offer to give him a new house on higher ground – the bus commute would have been too expensive, and anyway he wanted to live near the sea. For most of the year, he sells what he catches from his stilt. During the monsoon season, when fish tend to avoid shallow waters, he buys fish caught by trawlers which he then resells in his village. Other fishermen spend the period working as fruit and vegetable vendors or as seasonal agricultural workers.

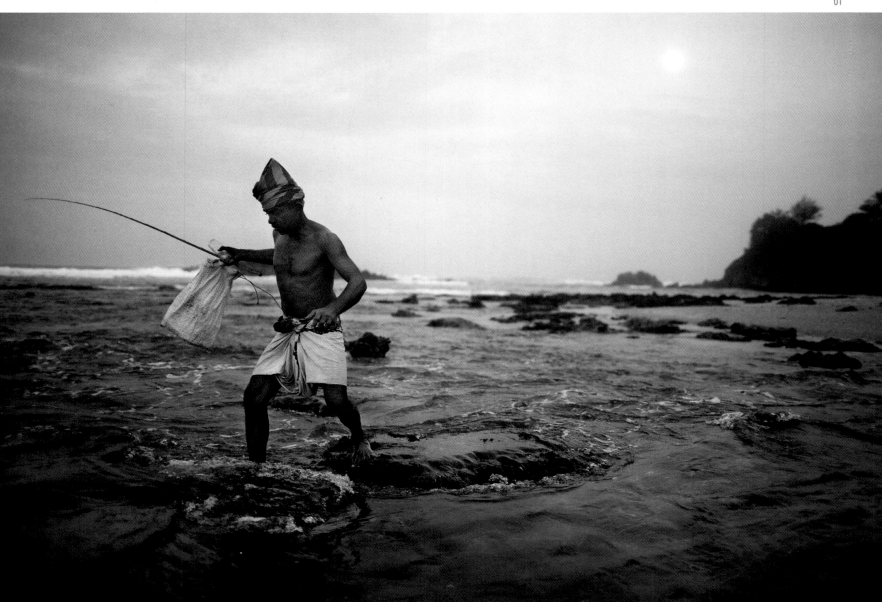

01 Before sunrise, Sunil walks across coral and rocks in the bay of Ahangama on the way to his stilt.

02 Shamila Nishanti, Sunil's daughter, prepares fish caught by her father. His catch is often small – just a few fish, each just a few centimetres long, and not enough to feed his family.

03 During the day, when the fish stop feeding, men pass their time at stalls drinking tea or home-brewed liquor made from coconuts.

04 At dawn, Sunil (left) and Anil Madushanka sit on stilts they both inherited from their fathers.

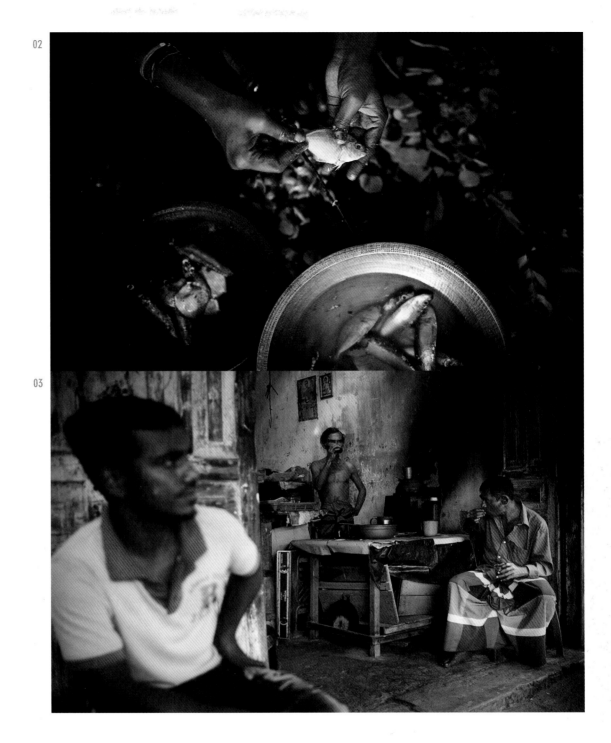

03

Photographer
FLORIAN MÜLLER

04

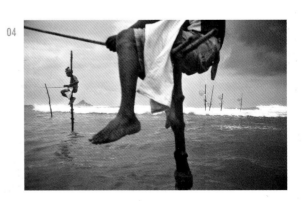

THILAFUSHI, MALDIVES

01 Thilafushi is an artificial island created by filling one of the Maldives' shallow lagoons with garbage. More than 300 tonnes of rubbish are brought to Thilafushi each day. Migrant workers from Bangladesh, such as the one above, burn much of this. Unfazed by the heat and smoke, they scavenge for materials such as copper wire, aluminium cans or other metals which they sell to a Thilafushi company that in turn sells them on to India and other countries. Typically paid less than US$200 a month for their regular job, scavenging can earn these workers another US$100.

02 A plume of smoke rises into the air from Thilafushi. As well as serving as a collection and disposal site for garbage generated in this part of the Maldives, the island is also home to a few small industrial plants and warehouses.

Photographer
MOHAMED MUHA

02

TRASHING PARADISE

Average waste generation in the Maldives per day per capita (kg)	
Locals	**0.55**
Tourists	**3.50**
Local population (2011)	**331,964**
Tourist population (2011)	**931,000**

Source: *Environmental Protection Agency, World Bank*

MIGRANTS

Chika Unigwe

MIGRANTS

Chika Unigwe

As a young child, I was sent to boarding school, a thousand kilometres from home. We were not allowed access to the telephone in the principal's office. There was no internet. We could only receive guests once a month on visiting days, and then only from 10 o'clock in the morning to 6 o'clock in the evening.

A thousand kilometres was a long trip for any relative to make for just a few hours a month. So instead I lived for Saturday – mail day. Receiving letters from home eased the homesickness I felt. I would read and reread my letters until they began to fall apart. I wrote meticulous replies back. Pages and pages filled with the most banal details of my week. My memories of being away from home, or from being "left behind" are tied to letters: receiving them and writing them.

Recently I saw a documentary, Mama Illegaal (Illegal Mother), about Moldovan women who leave their families behind to live and work illegally in richer European countries. It struck me that there was no exchange of letters. Of course these are different times; the mothers speak on the telephone or Skype with their families.

But for all the immediacy of Skype, there is something dishonest about it. It gives a false sense of involvement and control. One of the women had a daughter who was wearing nail polish. First she asked her to remove it, and then she made her promise not to wear any more until she finished high school. The fact that they could see one another made her imagine that she was as involved in her children's lives as if she were there, present with them. Of course her daughter might be the ideal teenager and keep her promise, or she could choose simply not to wear nail polish when she is on Skype with her. I am certain the mother realises this but appearances must be kept up and video calls aid this.

One month is a long time to be away from one's family. Six years is an eternity. Children grow. They change. You change. Yet to go is the choice those Moldovan women make. I use the word 'choice' sparingly, not to mean 'option', but as the only viable alternative they have to remaining at home. I could not watch it at one sitting. The only way I could bear it was to take it in doses, otherwise the darkness would have swallowed me. Even though I am an immigrant, this was not my story. But it comes close to the stories of other immigrants I know.

Illegal immigration is not about choosing a holiday destination, or following your love, as it was in my case. It is about which country one can enter most easily with the minimum bother. It's about sacrificing yourself for a better future, not only for you, but as with the women from Moldova, for the people who are dearest to you, even if those relationships could suffer as a result. Maybe it calls for immunising yourself against thinking how time could wreak havoc on relationships put on hold; for being enthusiastically optimistic; for shrinking time into miraculously short spans so that six years is like six hours. Was it worth it, I asked myself – all that: money, a better life, better opportunities

for their families? Then I remembered interviewing Nigerian sex-workers in Antwerp and the lessons they taught me.

Those women – some of them mothers with children left behind in Nigeria – put themselves in bondage for years paying off tens of thousands of euros to their trafficker just for a chance to provide a better future for their families. There is (or was) an auction house in Brussels where Nigerian women illegally in Europe would voluntarily put themselves up for sale to pimps so they could work as prostitutes and earn some money.

When I wondered how anyone could leave behind everything dear to them and come so far to service the sex industry, one of the women responded by asking me, "If your father had diabetes and could not afford his pills, but you could pay for them by doing this, would you?" It struck me then that for some people the comfort that I take for granted is a luxury. That the reason I could not imagine leaving my children behind to live furtively as an illegal immigrant was because I have always had the luxury of comfort. As a child I had a comfortable lifestyle. As a parent I can offer the same to my children. The mothers in the documentary just want a chance to realise their own dreams: a house with a terrace; a TV with remote control for their aging parents; beauty in their poor homeland. And why not?

Yet seeing the children cry and watching the returnees struggle to rebuild a relationship with their partners, I found it difficult to have any empathy for the women or sympathy for the men who choose to send them away (and who indeed encourage them to stay on until their stays have been legalised).

My heart broke at the sight of those poor children for whom those sacrifices were being made. But being a mother, I know that your heart breaks too to see your children go without. Leaving cannot have been an easy decision for those mothers to take, but they do so, time and time again, so they must feel that the compensation is worth the price they are paying. What love they must have to make such sacrifice.

I cannot begin to comprehend such sacrifice. Perhaps I don't need to. Maybe the documentary is asking that we be grateful for our difficulty in comprehending such a sacrifice as that means we have never been confronted with the need to pay such a huge price for comfort. It wants us to remember that had the accidents of our birth been different, we might have been Moldovan illegal immigrants or Nigerian sex workers, separated from home, yearning for our families but unable or unwilling to return with nothing to show for it. And this remembering helps us not to judge, not to look at the "illegal" with contempt, but to recognise their humanity and appreciate them as fellow human beings trying to get on the only way they (think) they can.

GURUE, MOZAMBIQUE

Eduardo, 22, owns a barber shop
in the hillside town of Gurúè in
northern Mozambique. A single pair
of clippers and a power supply are
all that's needed to run his business
from a small tin-roofed concrete
shop that he rents for US$15
per month. A haircut costs about
US$0.50. On some days he might
have more than 10 customers.

From a family with four brothers
and three sisters, he now has a two-
year-old son of his own. Pictures of
American rap artists decorate the
interior of his shop. He hopes that
one day he will be able to visit the
United States.

Tea is the mainstay of Gurúè
and its 120,000 people. The
plantations that surround the town
account for around 90 percent
of the local economy. Apart from
his work as a barber, Eduardo
occasionally works in the plantations
to supplement his income.

Photographer
PETER GOSTELOW

Contance Bwanali, 29, lives with her three children in Kanengo township of Area 25 in Lilongwe, the capital of Malawi. Contance married when she was 18. After the birth of Chisomo, her third child, now five, her husband went to look for work in South Africa. He hasn't returned.

Her husband left her with a house, but she still had to find a way to support her children. A local development programme taught her garment-making skills, and her brother bought her a knitting machine.

She now makes clothes for local people and schools, earning 8,000-15,000 kwacha a month – about US$50-100. "I work hard but I just cannot earn enough to support my children properly. I want my children to have good education. It's hard to come up with money to pay for their education."

"What if my husband comes back? I think I will accept him, but I will make sure he takes an HIV test first."

Photographer
SHEHZAD NOORANI

SHINYANGA, TANZANIA

Charles grew up in west Tanzania's impoverished Shinyanga region, one of six children. His family were farmers, and so is he.

He has the reputation of being one of the best local farmers, admired for his skills at growing different types of sisal on arid soil. He has eight acres he uses for food crops and five-and-a-half acres for sisal. He has ten oxen, ten goats, six sheep and two bicycles. He also has three mobile phones he uses to oversee his five staff and handle sales, insurance and banking.

Charles is married and has nine children. Four have primary education, four have secondary education and one – who has a master's degree in education – is a lecturer at Saint Augustine University of Tanzania.

Photographer
KECIA BARKAWI

THE STRING OF LIFE

Tanzania is one of the world's four major producers of sisal, along with Brazil, Kenya and China, though demand – and so production – has fallen sharply in recent decades. In 2012, Tanzania produced 35,000 tons of the fibre, less than one-fifth of its output in 1970.

Traditionally, sisal has been widely used to make twine, matting and as a reinforcing material in plaster.

SISAL USE IN AFRICA, TONS

Carpets and matting	11,500
Plaster reinforcing	8,500
Pulp	6,000
Commercial twines	5,000
Polishing cloth	5,000
Handicrafts	1,500
Wire rope core	1,000
Other	1,500

Source: *London Sisal Association*

NYABUMERA & KIGALI, RWANDA

Coffee has been a cash crop in Rwanda since Belgian colonists encouraged widespread growing of coffee plants in the 1930s. Growers, however, never did very well from the crop. For decades, its quality was generally poor and earnings were correspondingly low. A nadir seemed to have been reached in the early 1990s when a worldwide glut caused a sharp fall in prices.

Things, however, soon got far worse. The Rwandan Genocide of 1994, when over the space of 100 days between 500,000 and a million people were killed in a mass slaughter of Tutsis by Hutus, led to a near total collapse of the industry. Many farmers were among those killed or the two million-plus others who fled the country, and coffee output fell 95%.

Once peace was restored, production volume recovered quickly, with output matching the pre-genocide period within a few years. But of more importance was a change that took a little longer to occur.

In 2000, none of Rwanda's coffee was classified as premium. That has changed with the help of a series of internationally backed programmes. Led by the Partnership for Enhancing Agriculture in Rwanda through Linkages (PEARL), organised jointly by Texas A&M University, the US Agency for International Development and Rwanda's Ministry of Education, a generation of young Rwandans has been trained in coffee-related agronomy and quality standards.

Supported by investment in infrastructure and equipment, and the promotion of farmer co-operatives, the output of premium-grade coffee soared. By 2012, it accounted for more than one-quarter of Rwanda's coffee exports and one-third of its total US$75 million coffee earnings.

Around the world, coffee drinkers – including many in the world's biggest coffeehouse chain, Starbucks – are now enjoying the pleasure of beans from a country whose rolling green hills have always had the potential to produce great coffee. But perhaps the biggest winners are Rwanda's 40,000 coffee farmers – who thanks to the transformation of the industry have seen their income double.

Photographer
JONATHAN KALAN

WHERE THE WORLD'S COFFEE GOES

Countries importing up to 200,000 tonnes of coffee annually
Countries importing more than 200,000 tonnes of coffee annually

01 Laetitia Mukandahiro, 28, one of Rwanda's most sought-after coffee experts. The daughter of a poor coffee farmer who started work sifting through coffee drying racks in Gankenke, a small village in northern Rwanda, she is now head of quality control for KZ Noir, a global coffee trading company.

02 Uzziel Habineza, an expert taster and roaster, at a coffee washing station he once managed near his home town, Nyabumera. An orphaned genocide survivor, Uzziel rose through the ranks of Rwanda's coffee industry to become the sole Rwandan representative for Volcafe, one of the world's largest coffee suppliers.

OGONGORA, UGANDA

Dan Opiding, 14, lives in Ogongora village in Amuria district near Soroti in Uganda. The sixth of eight children, after falling ill and missing end-of year-exams, he still attends primary school. His father died of malaria when he was six. When not at school, Dan helps his mother, Grace, 40, with farming, household chores and looking after his siblings.

01 Dan dresses for school. Education at his school is free. The pupils must turn up wearing a clean, unripped uniform and with the books they need, a condition that prevents the poorest children in his village from attending.

02 When he gets to school each day, Dan's first task is to help clean its yard and his classroom.

03 At eight o'clock each morning, the students sing the national anthem and say prayers. Their teacher checks that their clothes and finger nails are clean, and that they have combed their hair. Classes start at half-past eight.

04 After falling ill and missing most of his exams, Dan failed to make it to primary seven. If he can pass his exams next time round, he will be able to start six years of secondary education, assuming his family can afford the cost of his uniform and fees.

05 The school has one break at 10 o'clock and another for lunch, when Dan and his friends play football.

06 Dan's home is 15 minutes' walk from his school. Usually he goes to school six days a week.

Photographer
KIERAN DODDS

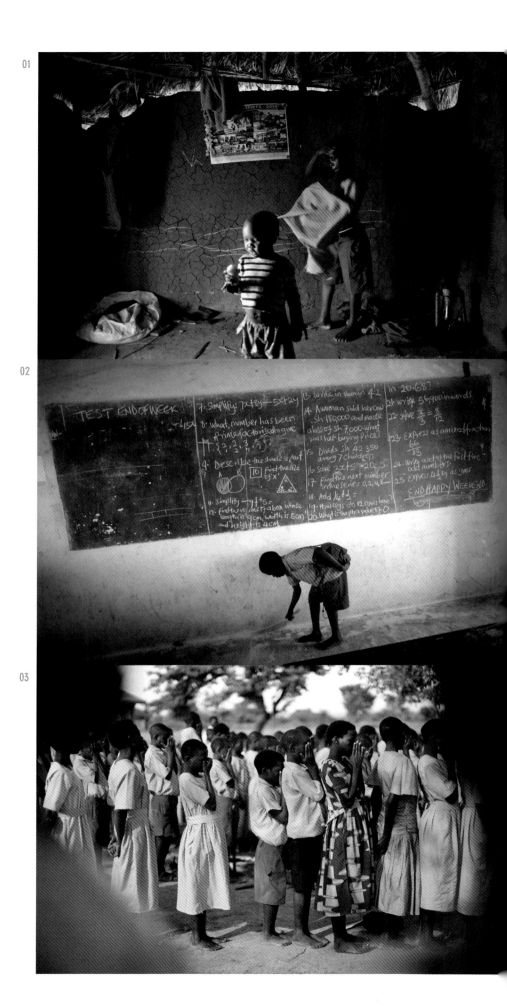

01

02

03

04

05

06

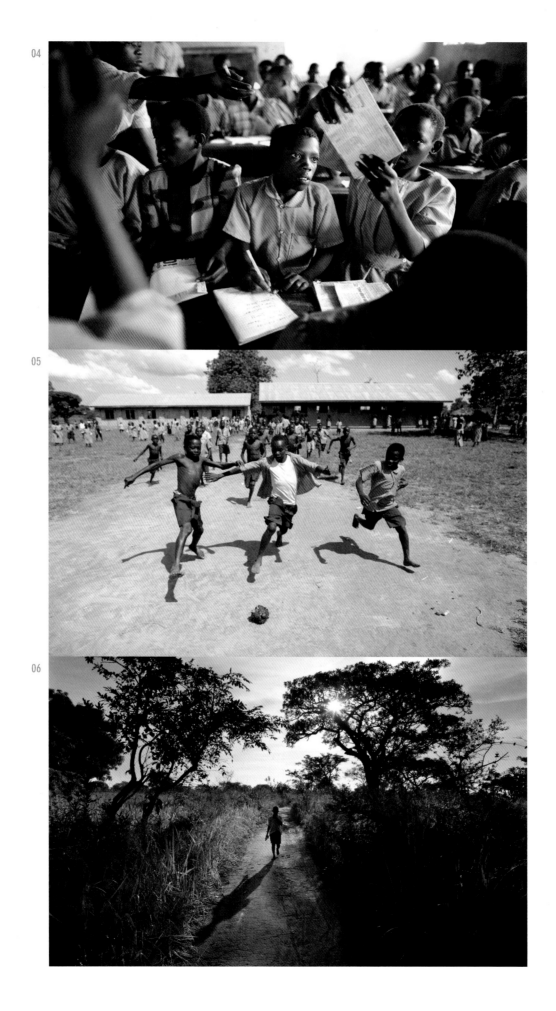

NAIROBI, KENYA

Across one square kilometre of Nairobi's Gikomba district, more than 4,000 people work for 200 businesses that process scrap metal. Known as *jua kali* enterprises – the official term for people who work beneath the open sky (*jua kali* is Swahili for "scorching sun") – these businesses turn empty oil barrels, construction waste, steel pipes, paint cans and other metal items into everything from pans and tools to life-size statues of animals.

Most of the workers are from western Kenya. They work 12-hour days, with no holidays, sick pay or other benefits. The average salary is US$100 a month. Only around one-fifth of their output is sold in Kenya. The rest is exported to other East African countries and – in the case of the animal statues – to Europe.

Recently, the *jua kali* industry has faced a shortage of raw materials. Unable to buy empty barrels in Kenya, businesses now buy them in Tanzania.

01 Most jua kali businesses employ between four and six men, each of whom dreams of earning enough money to start their own business.

02 Oil drums are the main raw material source for Kenya's jua kali industry.

03 A worker takes a break to catch up on the news. The cover of his paper announces the death of Osama Bin Laden.

04 & 05
Moses set up his jua kali workshop ten years ago. At first he made furniture, but six years ago he switched to making animal sculptures for export at the suggestion of a European customer. His business is now one of the most successful in the Gikomba area, and many others have started making identical copies of his designs.

Photographer
SERGEY MAXIMISHIN

02

03

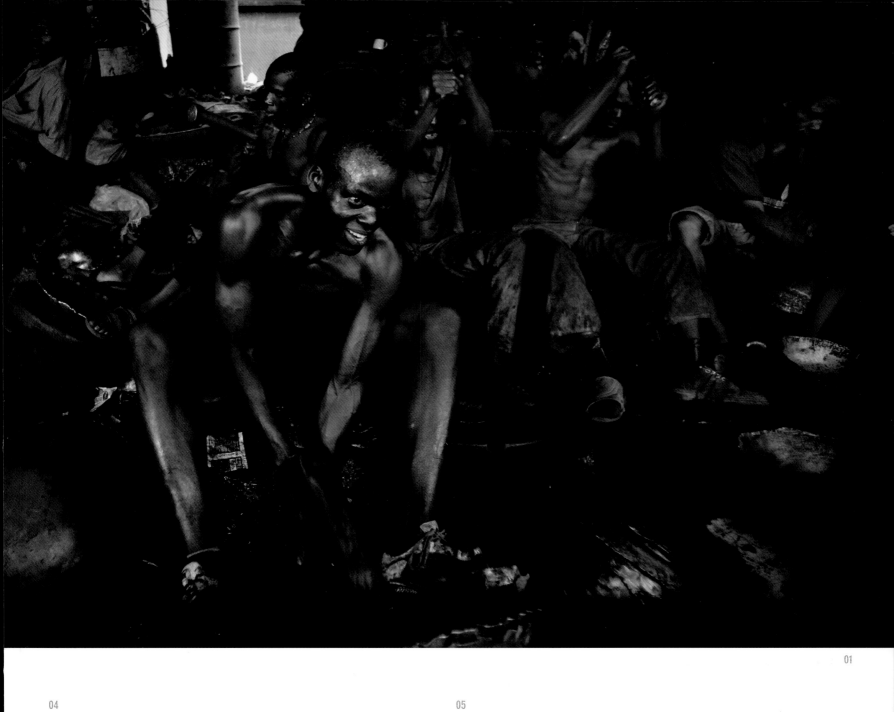

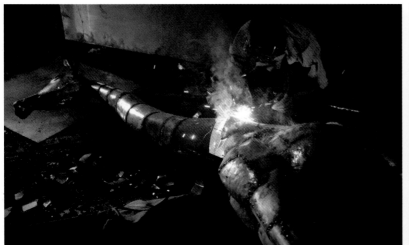

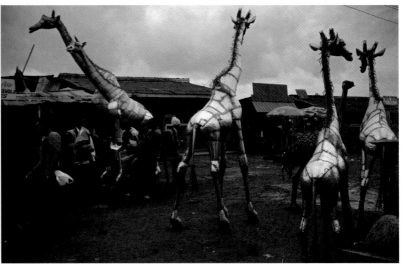

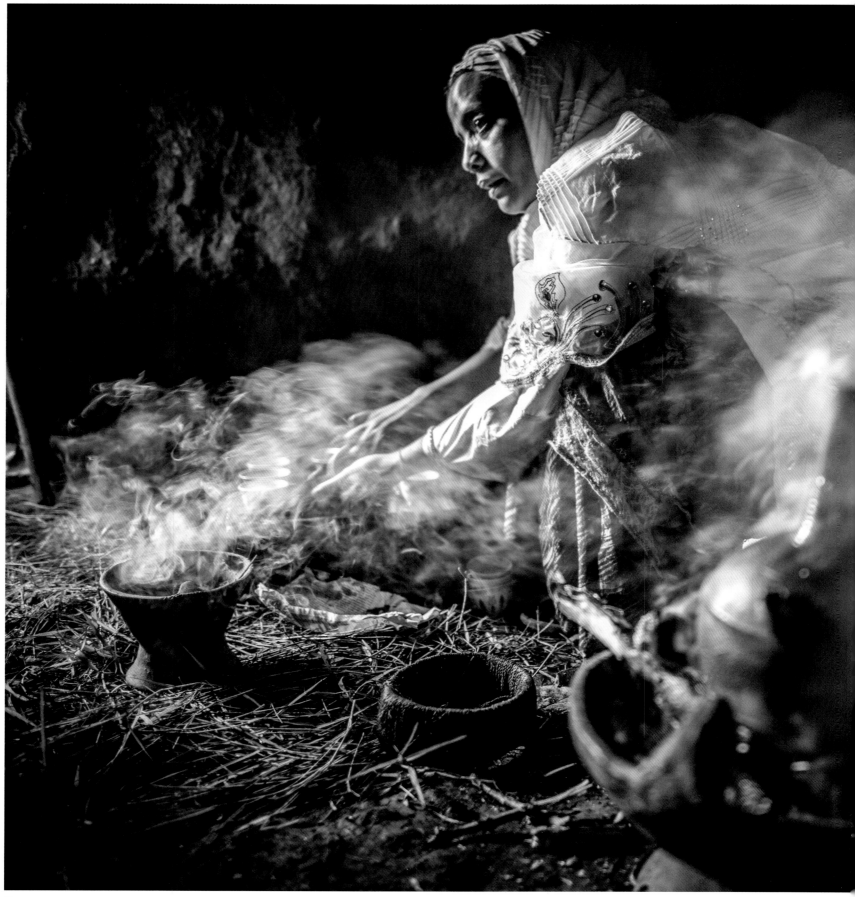

01

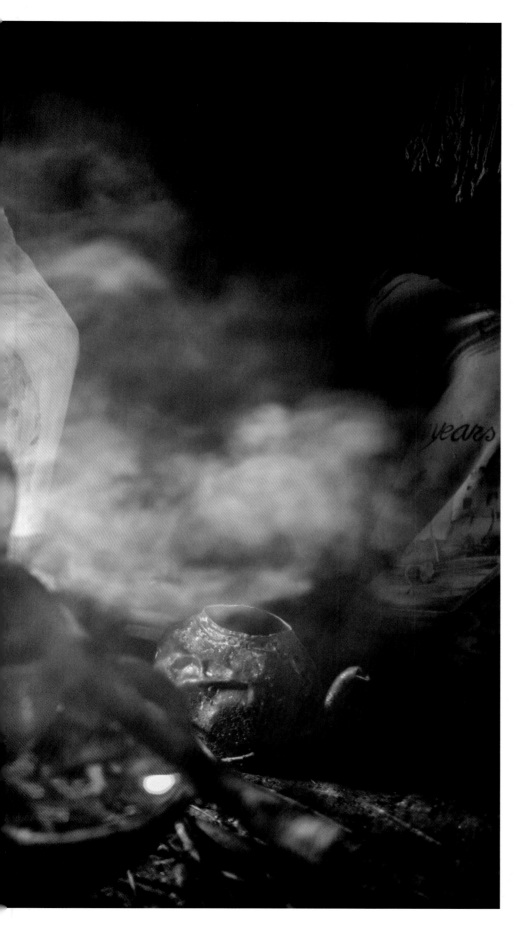

Ethiopians drink around half of the all coffee they grow, preparing it with a set of traditional rituals in a ceremony handed down over centuries.

Usually brewed by women, the process begins with the lighting of a fire on which is placed a jabena – a traditional round clay pot with a short spout and a long neck in which water is boiled. A pan with green coffee beans is put on top of a separate pot of burning charcoal and roasted until the beans become black and shiny. To make sure everything takes place in the right atmosphere, frankincense is lit.

Once the coffee is roasted, it is ground using a wooden mortar and pestle, then put into the jabena. The mixture is boiled again, then sieved and poured into small, handleless cups and drunk in three rounds, starting with abol and tona – first and second in Amharic – then finally baraka – blessing – accompanied by light snacks such as roasted barley, peanuts and popcorn. Preparation alone can take half an hour; the drinking can last for hours.

Coffee is a vital part of Ethiopian life. Directly or indirectly, around one-quarter of the population depends on it for their livelihood. The world's fifth largest producer in 2012, the country earned more than half a billion dollars from exports of beans.

01 Ramla Sharif roasts coffee inside her home at Choche, a village which many claim was where the original ancestral coffee tree was discovered in the 13th century.

Photographer
AMI VITALE

WORLD'S BIGGEST COFFEE GROWERS, 2012–13

MILLION BAGS

Brazil	**56.1**
Vietnam	**25.0**
Indonesia	**10.5**
Colombia	**9.0**
Ethiopia	**6.3**
India	**5.3**
Honduras	**4.6**
Mexico	**4.3**
Peru	**4.3**
Guatemala	**4.2**
Other	**21.2**
Total	**150.7**

Source: *US Department of Agriculture*

ASMARA, ERITREA

Cycling is immensely popular in Eritrea. Every weekend, thousands of amateurs speed along isolated roads, over mountain passes and across deserts. Between them, the country's 6 million people own some 500,000 bicycles.

The sport's event of the year is the "Giro dell'Eritrea", a 700-mile, 10-stage event, that is Africa's oldest cycle race. It was first organised in 1946 by the country's Italian expatriate community, but with local people barred from entering. Political unrest led to the race being cancelled the following year, and it was only resurrected 54 years later in 2001, ten years after Eritrea had secured its independence.

The race has been run every year since then – always along roads packed with spectators. The event is a huge celebration in the country, followed by some one-third of the country's population.

01 Eritrea's Daniel Telehaimanot, the country's most popular cyclist, is mobbed by spectators in front of Asmara's Roma Theatre after finishing second in the Giro dell'Eritrea.

02 Spectators line a road betweenn Dekemhare and Massawa as cyclists of the tour speed past.

Photographer
CHRIS KEULEN

02

01

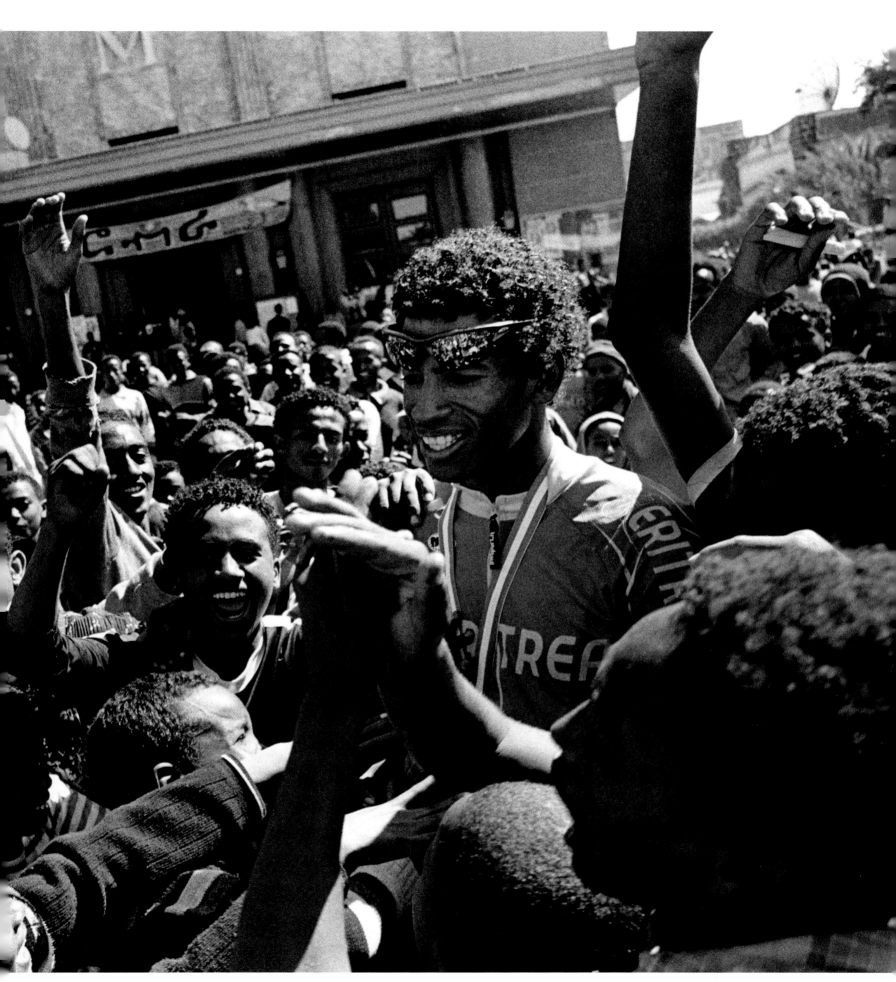

CAIRO, EGYPT

Shaimaa Yehia, 28, is a violinist with the Al Nour Wal Amal orchestra, a 40-strong ensemble of blind women from Cairo. The orchestra, which plays a full range of string and wind instruments, is run by the Al Nour Wal Amal Association, an Egyptian non-governmental organisation that takes in blind girls from Cairo's poor.

The association, founded in 1954 and whose name means light and hope, gives the girls a formal education in the mornings, emphasising literacy and vocational training, and teaches them music in the afternoons. Shaimaa entered when she was seven. In her first year, she was taught to read and write words and musical notes in Braille.

The following year, aged eight, she chose the violin as her instrument. She then spent five hours a day practicing and just one year later became a member of the association's junior orchestra. At 12, she entered the senior orchestra, since then travelling with it across Europe, to North America and to Australia.

Unable to read music as they play, the orchestra's musicians memorise it, typically carrying around 45 pieces in their heads at any one time, among them works by the Egyptian composer, Ahmed Aboeleid, and classical European pieces by Mozart, Brahms, Strauss, Tchaikovsky and others.

01 Shaimaa on her way to vote in a national election. As well as being a violinist, she also has a university degree in English, which she teaches for a living.

02 Members of the Al Nour Wal Amal orchestra take a break during a concert at the Manoel Theatre in Malta's capital, Valletta.

02

01

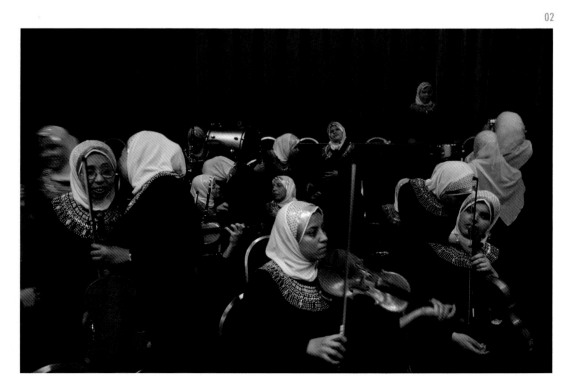

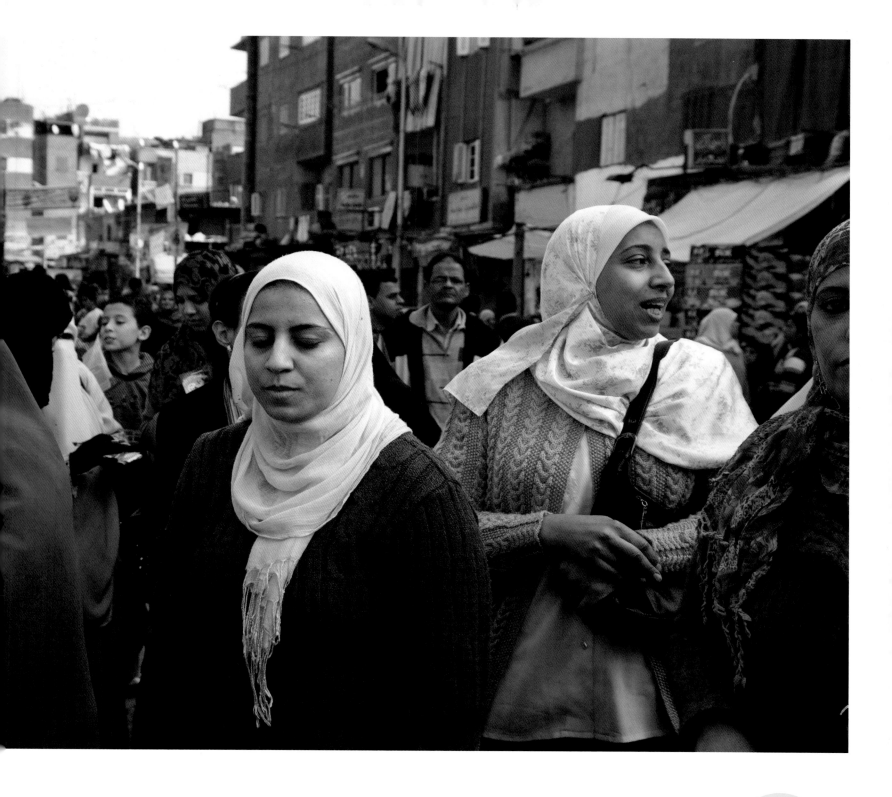

Photographer
FERNANDO MOLERES

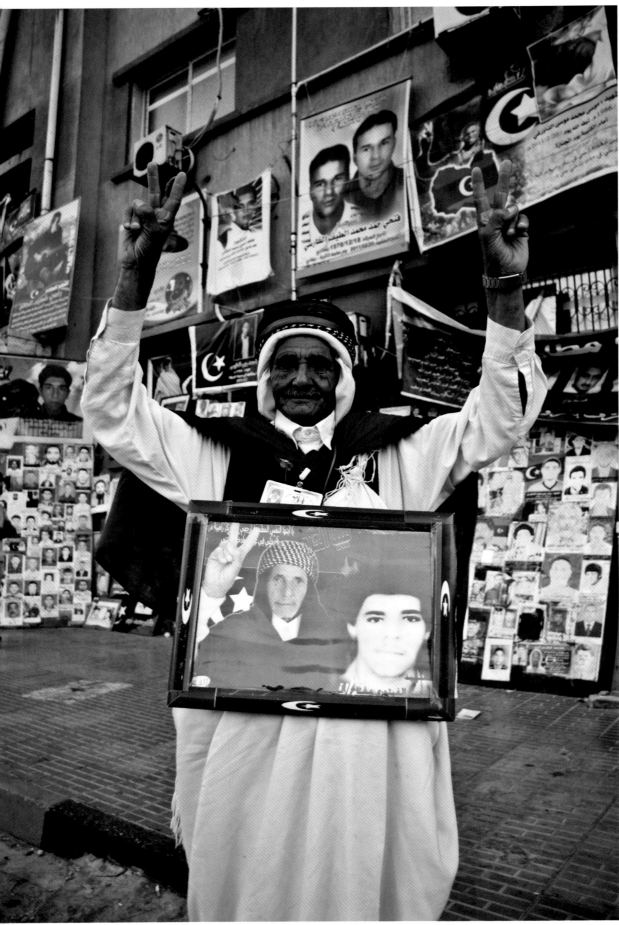

Al Faitouri Bouras Al Werfalli is the father of one of more than 1,200 inmates reportedly massacred in 1996 in Abu Salim maximum-security prison in southern Tripoli.

It was more than 12 years after his son's death, that Al Faitouri discovered his son was amongst those killed.

The families of those incarcerated in Abu Salim prison were responsible for providing them with food and clothing. Every day, from 1996 until 2008, Al Faitouri's wife prepared meals for her son, which her husband then delivered to the jail, along with occasional items of clothing.

At the prison, he was told he was not allowed to see or communicate with his son. But as the guards accepted the deliveries, Al Faitouri presumed they were being passed on. Instead, the guards were sharing the meals and other items out among themselves.

The Libyan government initially denied that any mass killing had taken place, though opposition groups based overseas were soon claiming a massacre had taken place. In the early 2000s, officials told some families that their relatives had died in prison but gave no reason for their death and provided no corpses.

In 2004, the government conceded that some killings had taken place. Al Faitouri, however, didn't receive confirmation about the death of his son until four years later.

01 Al Faitouri carries a composite picture of himself and his son near the Mediterranean seafront in Benghazi. In the background are photographs, posters and banners of others killed in Abu Salim prison put up by their family members and friends.

Photographer
DERICO COOPER

01

NEAR SIDI BOUZID, TUNISIA

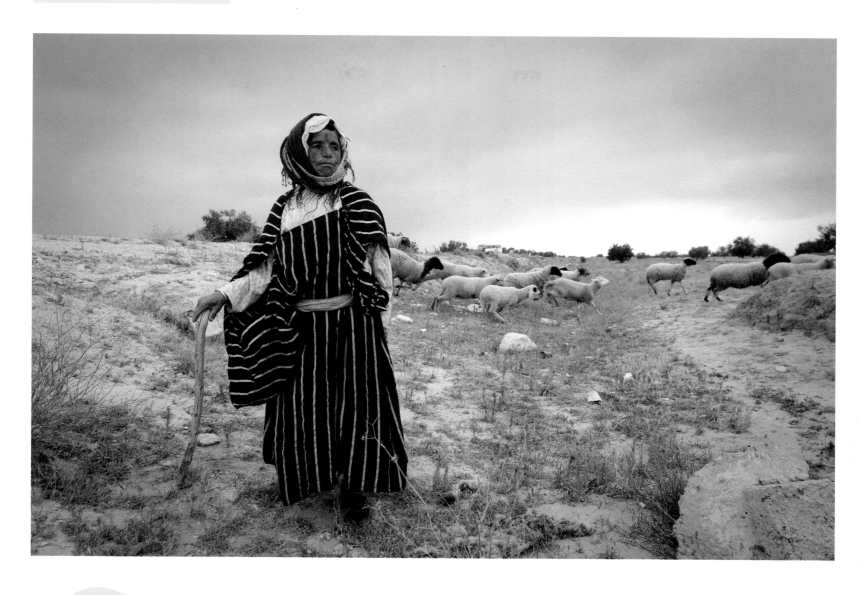

Photographer
CLAUDIA WIENS

Juma, 60, has been a herdswoman all her life. Every day, regardless of the weather, she and a young woman from her family walk miles to make sure her flock of sheep finds enough to eat.

Juma had no opportunity to go to school and has never learned to read or write. Her forehead was tattooed when she married, as used to be the custom among Tunisia's rural population. In Juma's family, hers was the last generation to be tattooed. Notions of what constitutes beauty have changed, she says, and none of her children or grandchildren have tattoos.

Many other women in her area have to work in the fields, spending 12-14 hours a day bending over, carrying heavy baskets and kneeling on the hard land. They are paid US$3-4 a day, or not even that if they are family members of the landowner.

Juma, in contrast, sees herself as a strong, independent woman. In her community, owning a flock of sheep brings prestige; caring for her animals may be arduous, tiring work, but it comes with responsibility and a freedom of its own.

She lives close to where Tunisia's revolution started – just 50 kilometres from Sidi Bouzid, the city where Mohamed Bouazizi, a street vendor, immolated himself in protest against years of official harassment and humiliation. But the only events she witnessed were those she saw on television. She doesn't expect them to change her life. "What could be different? The sheep need their grass," she says.

01

Ten years ago, Senegalese designer Adama Paris created Dakar Fashion Week to highlight local designs and celebrate the country's fashion, art, and self-expression. Since then, the week has grown to become a major platform for Senegalese and other international designers to showcase their talents.

"I want them to be part of a black movement that can showcase black or African designers that don't have the opportunity to show in the big fashion weeks, Paris or London or elsewhere. How many black designers are there in Paris Fashion Week? None. New York is the same. London is the same," says Adama.

01 A model gets her makeup done backstage for Dakar Fashion Week's finale. The 2012 edition featured designers from more than 15 countries, among them Morocco, Pakistan, Haiti, Mali, Egypt and Ivory Coast.

"Everybody is white in this industry: the designers, the buyers, the audience. It's just weird because you have the feeling in fashion that we're so open. And we're not. We're *definitely* not. That's why I thought about having a show that can showcase minorities."

– ADAMA PARIS

Photographer
TANYA BINDRA

01

Photographer
THOMAS ROMMEL

Karate, though not as popular as boxing, is well established in Burkina Faso. Many small towns have their own "dojo" or martial arts training school. Though usually nothing more than a spartan space with no real teacher, they attract young people eager to copy the moves they have seen on action films from Asia at their local video club.

Jeannette Nikiéma watches these films too. As she plays with local boys most of the time, it was no surprise when, three years ago, aged 10, she also decided to try karate. Her school since 2007 has been part of the Sankudo Kikai Karate Do Federation, one of the most popular varieties of karate in west Africa.

01 Jeannette, 13, practices karate at a martial arts school in Ouagadougou. Every week she trains three times: from four o'clock to six o'clock in the late afternoon, as the sun goes down.

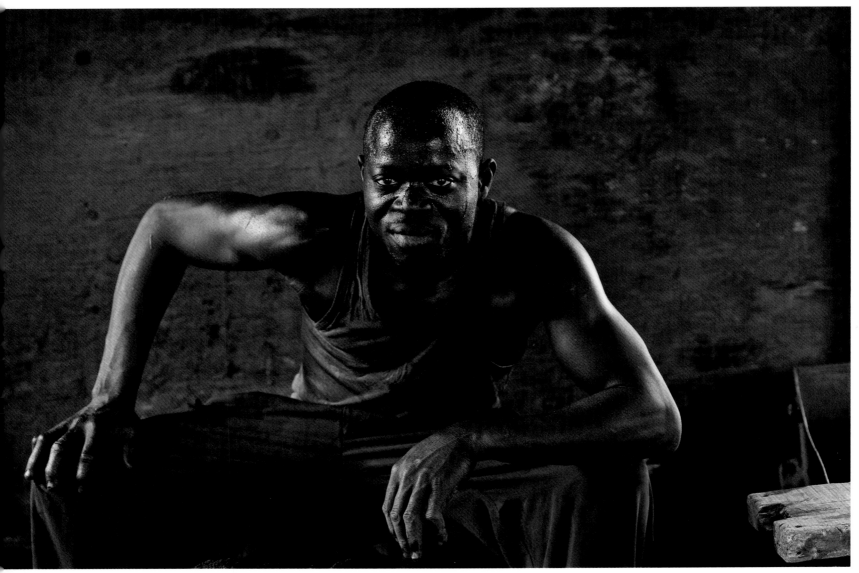

01

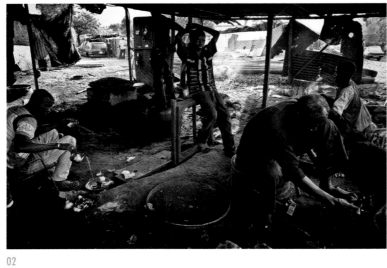

02

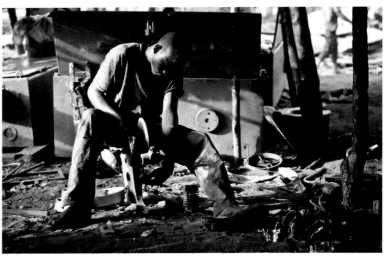

03

In Mali, blacksmiths' associations, such as this one at Médine district in Bamako, the country's capital, recycle scrap metal into all manner of everyday objects, from pots and buckets to pulleys and nuts. Wrecked cars and trucks are a favourite source of raw material. With no electricity to work with, the blacksmiths melt their iron and other metals in furnaces dug in the ground.

01 Seydou works seven days a week, earning around US$7-8 a day. In Mali, blacksmiths are a highly respected caste, often acting as as mediators in local conflicts.

02 Bourama, 47, sitting to the right, is the head of the workshop. His nephew, Soury, 12, standing behind him, is learning to become a blacksmith. Soury's father died last year of meningitis. Bourama, who already had two wives and eight children, followed tradition and married Soury's mother, giving him six extra children to feed. Soury, the oldest boy in his family, knows that he will be a burden on his uncle if he doesn't work. So instead of going to school he spends seven days a week helping his uncle.

03 Mahamadou, 17, grinds metal parts that have just been moulded. Every day he works from 7am to 6pm. He never went to school and, like more than seven out of ten Malians aged 15 or older, is illiterate. His knowledge, instead, came from his father and grandfather, both of whom were blacksmiths.

04 Karim's father is one of Médine's most respected blacksmiths. Unlike most children in the neighbourhood, Karim is lucky enough to go to school, attending classes each day from 7.30am to 12.30pm. When his lessons are over, he goes to the workshop for lunch – white bread and tomato sauce with onions – then works until 6.30pm. Even if he continues with his schooling, he is almost certainly destined to become a full-time blacksmith.

05 Oumar, 16, has been a blacksmith since starting an apprenticeship at the age of 10. Each day he earns around US$7, money that helps feed his parents and seven siblings.

Photographer
VALERIE LEONARD

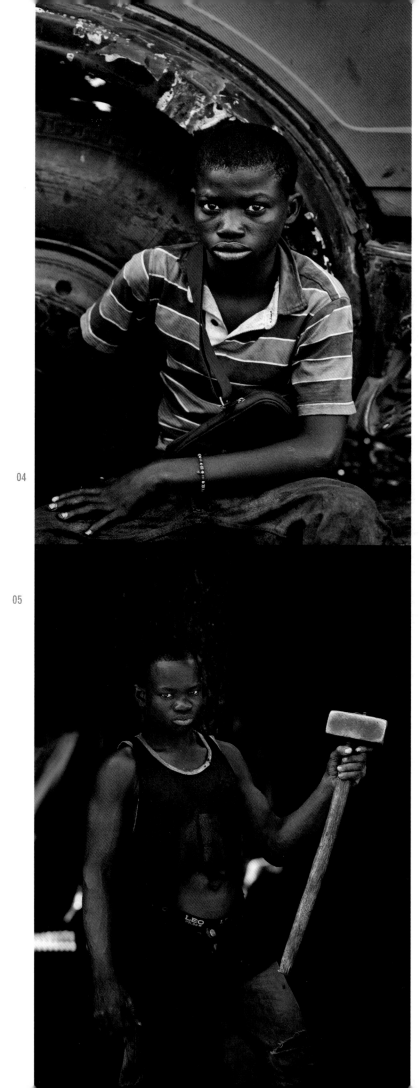

04

05

FREETOWN, SIERRA LEONE

From 1991-2002, Sierra Leone was the theatre of an atrocious civil war. More than 50,000 people were killed and hundreds of thousands were displaced. Several thousand others were deliberately mutilated by forces of the rebel Revolutionary United Front as part of a terror campaign aimed at controlling diamond-rich regions.

Since 2001, a group of amputees, almost all victims of the civil war, have met regularly on the beaches of Freetown, the country's capital, to train and play football. Their team, Sierra Leone Amputee Sports Club, has travelled to international competitions around the world, from Brazil in 2005, where it came third, to Russia, Turkey, Liberia and Ghana. In 2007, it hosted the first Amputee African Nations Cup. It fielded two teams, which finished third and fourth.

01 Mohamed Sisse, centre forward for Sierra Leone Amputee Sports Club, warms up on the beach of Aberdeen, a district of Freetown where the team first played. Mohamed was five when forces of the Revolutionary United Front (RUF) killed all his other family members and left him for dead after shooting him in the leg.

02 Kalon, 35, is the team's captain and a founder member of the club. He lost his leg at 22 after he was shot and wounded. All other members of his family were killed by the RUF.

03 Mussa Manssaray returns home from a match. Mussa lost his leg at 10 after RUF members shot him during an attack on Kabaka, his hometown.

Photographer
GWENN DUBOURTHOUMIEU

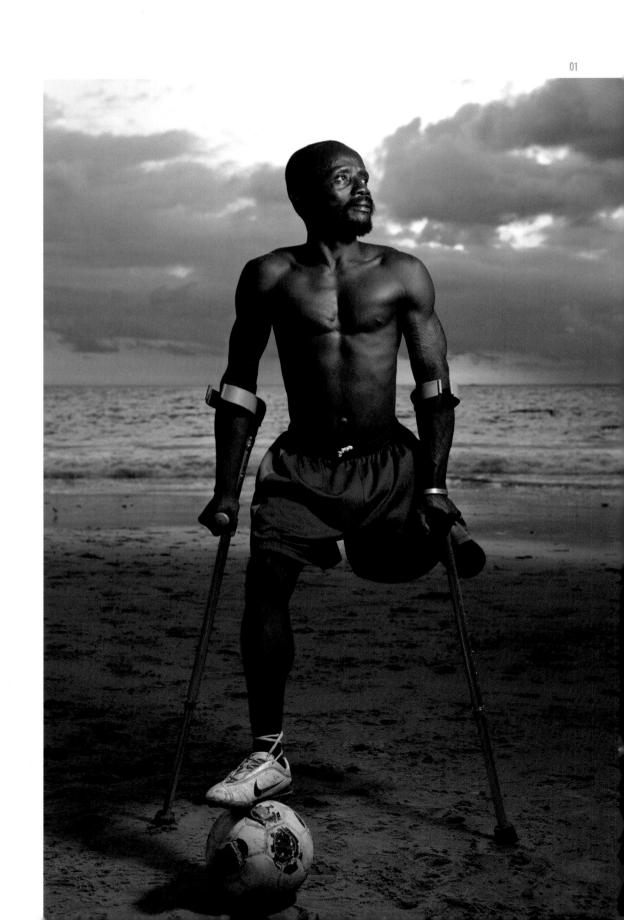

02

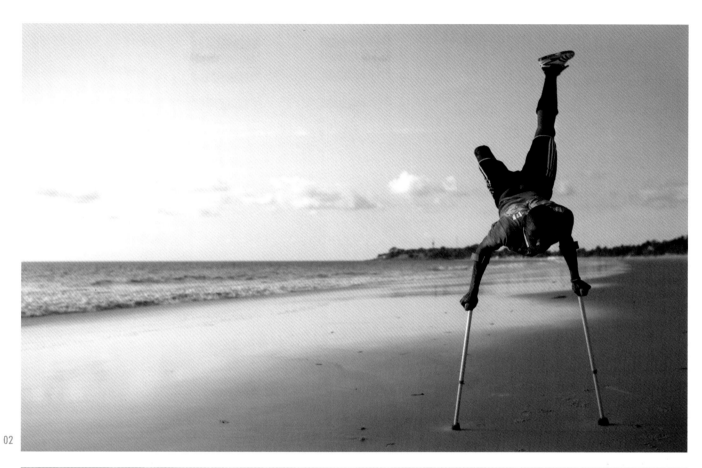

03

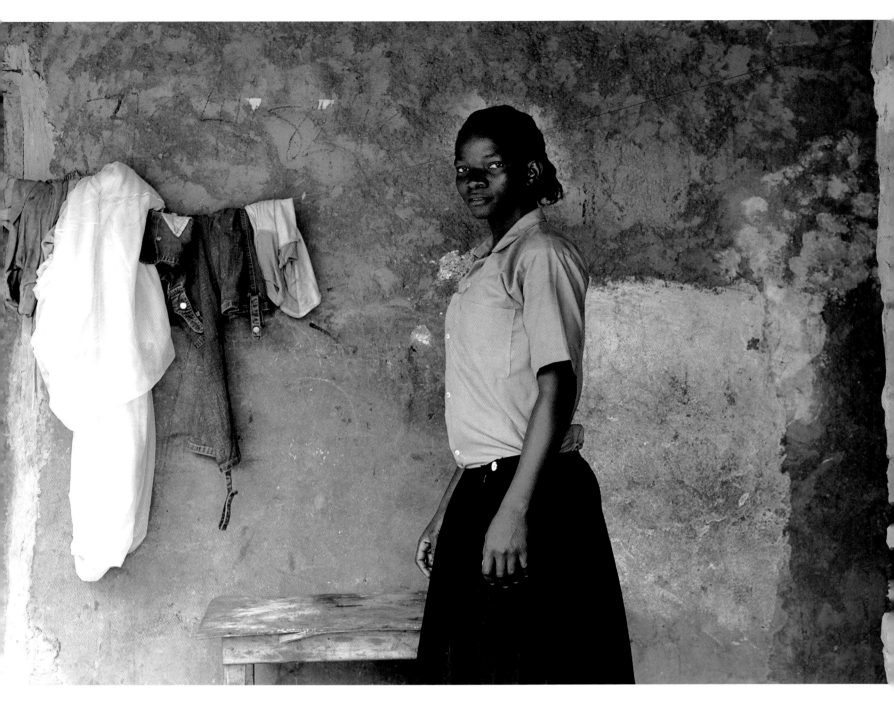

Photographer
ANDREW ESIEBO

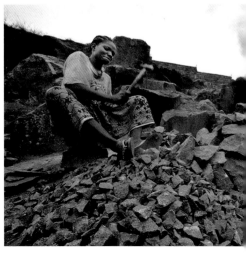

01

Like many Liberians, Mercy Womeh, 18, missed several years of education as a result of her country's civil wars of 1989-96 and 1999-2003.

Three years ago, in a search for work, her family moved from the countryside to a suburb of Monrovia, the country's capital. Mercy is now catching up with her schooling.

She could go to a free state school. But with overcrowded classes, staff shortages and teachers who often fail to show up, she has opted for a private school.

"Yes, the education is free at state schools," she says. "But there are charges like paying for pamphlets and tests, so it is almost as if you are paying. If you don't have money, you have to drop out."

To complete her last two years of schooling, Mercy has enrolled at J Chauncey Goodridge school, where she is now in seventh grade. She earns the money for her fees by crushing rocks.

01 Before Mercy's family moved to Monrovia, none of the children attended school. "My parents didn't have the money to send my brothers and I to school when we lived in the village. They were farmers and I used to help them by driving the birds away from the rice and then beating the rice when it was harvested. I'm happy that my father was able to relocate us to the city to get a better education."

02 Mercy believes getting an education will transform her life: "When you graduate from high school, you understand things that people who did not go to school cannot understand. The way you speak will be different and you will be able to make decisions that will benefit you and your family. If you are not educated, you are like a tea without sugar."

03 The stones Mercy crushes are used in Liberia's booming construction industry, but little of the country's economic growth trickles down to people like her. Although Liberia's economy has grown strongly in recent years, eight out of 10 Liberians still live on less than US$1.25 a day.

04 For each bucket she fills, Mercy earns 35 Liberian dollars – about US$0.50. On a good day, she can fill seven buckets. "How many years I have left in school depends on whether I have the money to continue," she says.

02 03 04

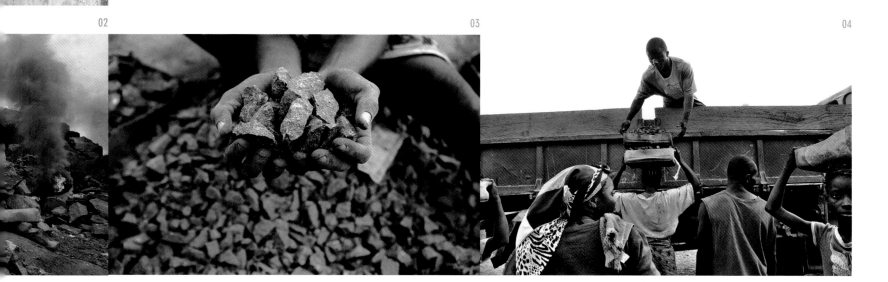

AKWAMUFIE, GHANA

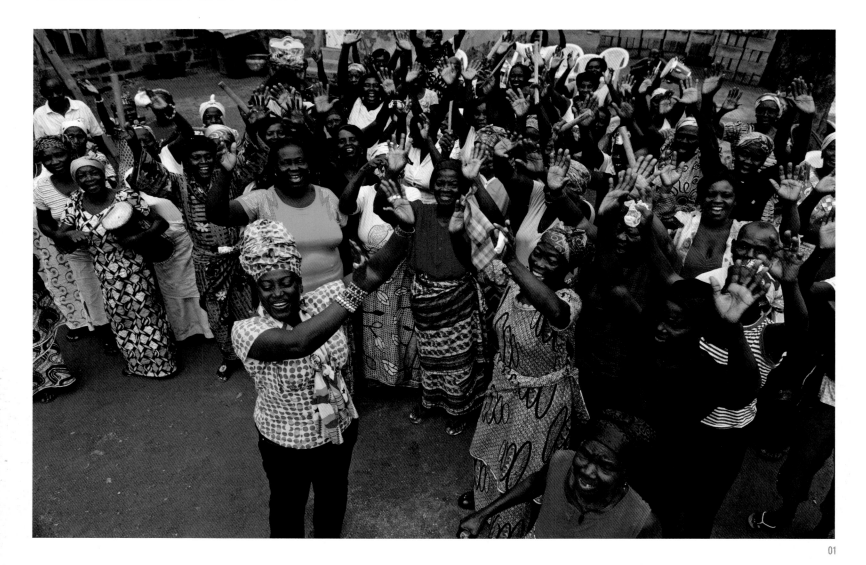

Photographer
REZA

Akumaa Mama Zimbi is a Ghanaian cultural icon. She has starred in
five feature films, hosts television and radio talk shows, and writes a
regular newspaper column. But she is also one of the country's best-known
campaigners for women's rights.

Widows are a big focus of her work. In Ghana, many women who lose
their husbands are pushed to the margins of society. Some find themselves
accused of witchcraft and exiled from their communities. Others, if they
don't have any sons, are stripped of their land.

Through her Mama Zimbi Foundation, Akumaa launched the Widows
Alliance Network (WANE) in 2007. Aimed at strengthening widows'
economic standing, WANE has already organised more than 300
programmes covering everything from career training and agriculture to
reproductive health, sewing and beekeeping.

Akumaa also runs a media production house dedicated to promoting
women's rights through the media and education.

01 Akumaa meets members of the Widows Association of Akwamufie,
 a Ghanaian city that is also home to a palm oil project set up by her
 Widows Alliance Network.

LAGOS, NIGERIA

Culture is one of Nigeria's great exports. During the 1990s and 2000s, the country's film industry – Nollywood – grew quickly to become the world's second largest maker of films in terms of number of productions, just ahead of the United States and only behind India.

Nollywod now releases between 900 and 2,000 productions a year (the estimates vary widely), with budgets ranging from US$40,000 to just over US$200,000 – a fraction compared with the US$140 million Hollywood now averages for a major release. The industry is almost totally digital, with the films released straight to DVD or increasingly watched via the internet, on social networks and on mobile phones. Even the most popular Nollywood stars are paid comparatively little – most are receiving between US$1,000 and US$3,000 per film.

01 On the set of the sitcom "Girls Next Door" directed by Fidelis Duker, one of Nollywood's most prolific film and video makers. Also the founder of the Abuja International Film Festival, now in its 11th year, and president of the African Festival Network, Fidelis has long argued that the only way the rest of the world will respect Nigerian films is if the country's directors make movies about Nigeria and its culture.

Photographer
MARCO GAROFALO

01

01

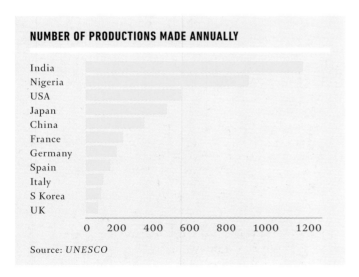

NUMBER OF PRODUCTIONS MADE ANNUALLY

India							
Nigeria							
USA							
Japan							
China							
France							
Germany							
Spain							
Italy							
S Korea							
UK							
0	200	400	600	800	1000	1200	

Source: *UNESCO*

02 Young actors take a dance lesson at Nigeria's National Council for Arts & Culture. The government sees culture as a key means for promoting both unity and an appreciation of diversity in a country home to more than 250 ethnic groups.

03 Frank sells a Nollywood movie to a young woman in his DVD shop at Lagos's Idumota Market. Unlike Hollywood or Bollywood, the majority of Nollywood's revenue comes from DVD sales, making piracy a major concern. According to the World Bank, sales of pirated Nollywood DVDs outnumber legitimate sales nine to one.

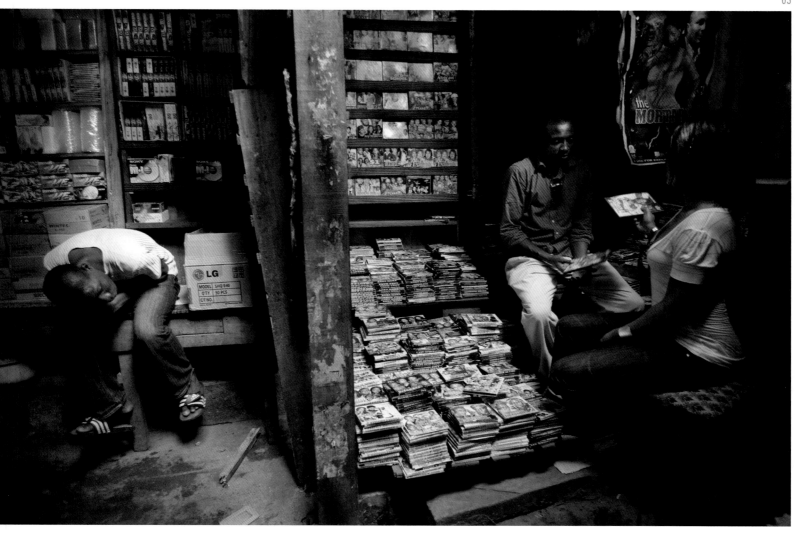

A FILM-FREE MOVIE INDUSTRY

Nigeria's film industry – or strictly speaking, its video industry – has annual revenues of around US$250 million, of which US$100 million comes from exports. It employs around 180,000 people directly.

Built around a direct-to-DVD model, with almost no theatrical showings of productions, the films are typically made in just three or four weeks and then released in quick succession to overcome problems with piracy. Other solutions include trying to out-compete pirates by selling DVDs at near cost levels while recouping revenues from other sources such as in-film product placements.

Source: *Peter Rorvik, "Film and Film Development in Africa", December 2012*

JOHANNESBURG, SOUTH AFRICA

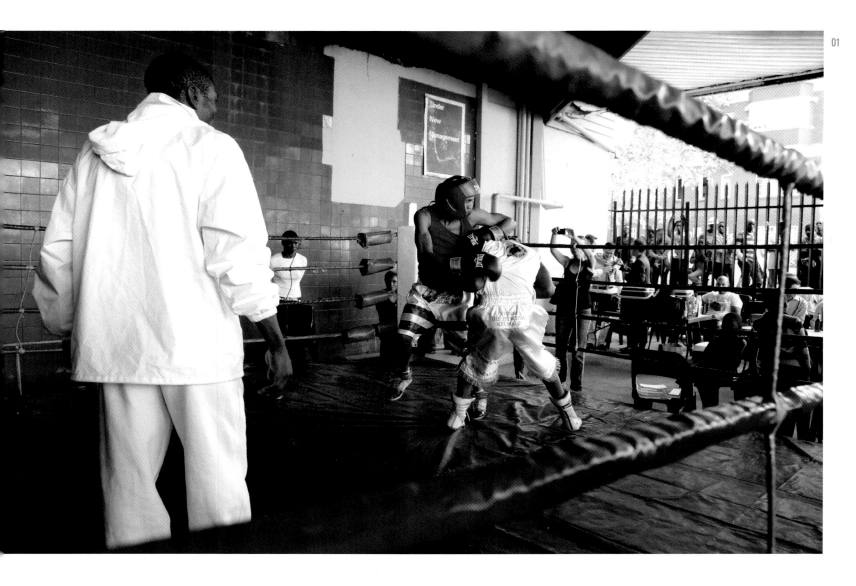

George Khosi, 43, has been running the Hillbrow Boxing Club since the late 1990s, training street kids in self-esteem as well as fighting and giving them a safe place to hang out. He also trains women, including Rita Mrwebi, the current South African ladies' welterweight champion.

Born in Zimbabwe, he came to South Africa aged seven with his foster mother. After a spell in prison as a teenager, he became a professional boxer in the mid 1980s, fighting in bouts across the country.

His life changed in the mid 1990s, when robbers shot him, badly injuring his legs. His recovery took six months. As he was also losing the sight in his right eye, he had to give up boxing. Shortly afterwards, a local housing association asked him to "keep an eye" on buildings in his precinct in Hillbrow. He asked if in return he could use an abandoned petrol station with a building attached. The answer was yes – and he had the premises for his gym and boxing club.

Hillbrow, an inner city neighbourhood of Johannesburg, is a melting pot of immigrants. In the 1970s and 80s, many Greeks, Cypriots, Jews, British and others wishing to escape Europe in search of a new life in South Africa made their way to Hillbrow. Home to a thriving gay and lesbian community, it was one of Johannesburg's most cosmopolitan districts. These days, the area is filled with Africans from countries across the continent, many of them in South Africa illegally. Turf-wars are common and most of its former middle-class inhabitants have long since moved out.

The club's first ring was donated by a church. If they are working, visitors to the gym pay whatever they can afford. If they are unemployed, they are welcome to work out for "mahala" – nothing.

In January 2013, a taxi smashed through a pavement barrier into George's club, killing a pedestrian and demolishing the ring. Within weeks, supporters raised enough funds to rebuild it.

01 James Iak, 47, oversees a sparring session at the Hillbrow Boxing Club. Originally from Nigeria, where he was a boxer, James is now a trainer at the club. Set up in a former petrol station, the club's ring is open on two sides to the street. Passersby stop and watch or encourage whoever is fighting.

Photographer
ROBYN GWILT

TIME'S WOUND

Carlos Gamerro

TIME'S WOUND

Carlos Gamerro

As I looked at the photographs in this book, questions kept running through my mind. How did these images end up here? What do they have in common? Along what obscure routes did they have to travel to arrive on these pages? Collected together in a single volume, how do they interact with each other?

Their heterogeneity is more than cultural or geographic. Some show individuals accompanied by the briefest of captions. Some depict groups or communities. Some focus on events or ceremonies – Ana María Robles' pictures of the Yemanjá rituals on Montevideo's Ramirez beach, for example. (More than once I have attended this festival as a fascinated observer. If my magnifying glass were powerful enough, perhaps I might find myself among the crowd). Many of the photographs show people with scarce resources. But there are also those, such as Chen Jianhua's photographs of young people in Shenzhen, that introduce us to counterparts of figures from the 1980s and 90s novels of Bret Easton Ellis or Douglas Coupland. Here, perhaps, are characters who would rather be on a *Forbes* richlist than in this book. (In the 1980s, travelling through the Amazon, I met Abdul, a long-distance runner from one of the local indigenous peoples. He had managed to stay on in Europe after a race, marrying a young Irish woman and launching a business making and selling clothes in London. He travelled the world with a biography of Adnan Khashoggi in his hand. We have lost touch, but he would undoubtedly choose to be one of *Forbes'* "Billionaires" rather than one of *The Other Hundred*.)

This book's title made me think that the original impulse that brought its images together must have at root have been ethical – to contrast the lives of the rich and famous, exemplified by the names on those lists of billionaires and celebrities, and the tougher, harsher existences of most people that take place in invisibility and anonymity. Are we then to treat these latter lives as models, like those of Plutarch's *Lives of the Noble Greeks and Romans* or the Christian hagiographies? If the subjects of the photographs of this book were asked this question, almost all – assuming they didn't just laugh – would simply say "no".

One characteristic shared by many of the faces in this book is a modesty before the camera. But to suggest that they could be presented as exemplars for others to study would be a disguised form of sentimentalism – too easy an evasion for those of us aware that our lives are comfortable, even self-indulgent, yet don't know what to do with the guilt our privilege generates. Those portrayed, perhaps, might suggest that only those who can choose their destinies can be examples for others.

In the appendix to his great novel, *The Sound and the Fury*, William Faulkner describes the personalities of the Compsons, members of an aristocratic Southern family whose decadence the book traces. Carried along by his own narrative fervour, Faulkner continues to tell their stories even after his tale has finished. Describing what happened to Dilsey, the black servant who has become the moral and emotional pillar of the family, he uses just two words: "They endured." This terse phrase could with justice accompany the majority of this book's photographs. Used without emphasis, it would not move those portrayed to laughter, but rather, I suspect, to a quiet, self-respecting nod of agreement.

Leopold Bloom, the protagonist of James Joyce's *Ulysses*, and the most complete individual that the human imagination has ever conceived, at one point

finds himself assaulted by that anxiety that sooner or later accosts everyone who lives in a major city: "One born every second somewhere. Other dying every second... Cityful passing away, other cityful coming, passing away too... Piled up in cities, worn away age after age. Pyramids in sand."

Joyce wanted to stop "the great wound of time" by preserving one day in the life of his Ulysses – 16 June 1904 – for all eternity. Why this day? Why not. It was, after all, the day on which Joyce started his relationship with his wife-to-be, Nora. But the very arbitrariness of Joyce's choice showed that one day was worth as much as any other – a point underlined by his success in introducing to the world a range of characters, male and female, who would never have made it into the Celebrity 100.

Injustice exists not only because there are rich and poor, or because some lives are hidden by shadows while others take place in full public glare, or even because so many people have to spend so much of their time resisting discrimination, persecution or poverty. It also exists because most lives leave no trace. Because without all those people whose lives pass unrecorded, the obscure force that supports our world would surely vanish.

In his essay "A History of Eternity", Jorge Luis Borges draws a picture of eternity – more specifically, a picture of Christian eternity as propagated by Bishop Irenaeus during the 2nd century AD – as a reservoir that holds every event, every person and every moment lived. "Without eternity, without a delicate and secret mirror of what happened in the souls, the history of the universe – and our own personal history – is wasted time, a notion that haunts us uncomfortably," Borges writes.

Today, the internet, with its seemingly limitless capacity to suck up and store everything, makes Borges' surreal idea no longer seem so implausible. What the internet returns to us is a chaotic flow as variegated as reality itself. Things now can lose themselves twice: once in reality and once in cyberspace. But in this new universe, who guides our eyes to the images worth seeing and the stories worth hearing? The answer is older than the internet, as old as human history – a combination of chance and art.

A book can do this, especially a well-made one with an assemblage of portraits and tales (I say portraits and tales, not lives and people; it would be the height of arrogance to imagine that any individual's microcosm could be captured by any finite arrangement of pixels or words).

Photography, from its very beginnings, was invented to "stop the world and count it, to stop the great wound of time through which men bleed," as the Argentine writer Rodolfo Walsh notes in his short story *Fotos* (Photographs). The 100 sets of photographs and their subjects of this book mutually support each other. Collected in a single volume, they have an opportunity to interact denied by the great scattering of the internet or the non-stop flow of broadcast news. At least for a while, they may resist the passage of time that destroys and disperses everything. Maybe in a distant future, long after the 100 billionaires of the past year have been forgotten, they will still be looked at and remarked on. In this way, poetic justice might sometimes triumph over the power of market forces.

Translated by *Alfred Romann*

BUENOS AIRES, ARGENTINA

Jose Cortina, 80, has worked at IMPA, an aluminium processing plant, since 1947. He began his career as an administrator, and ended up as a sales manager, responsible for contacts with customers.

IMPA, or Industrias Metalúrgicas y Plásticas Argentina, as it is known in full, is legendary in Buenos Aires. Founded by German investors in the early years of the 20th century, it has been through several incarnations. It was nationalised in the 1940s, then transformed by presidential directive into a co-operative in 1961.

The 1960s were a golden period for the company, with staff numbers rising to 700. But gradually it went into decline, until in 1997 it went into receivership with debts of US$8 million. After a workers' occupation, the company was relaunched as a workers' co-operative.

Jose's job is not easy. IMPA's machinery is old and unreliable. Frequent breakdowns delay deliveries. But new machines would make many jobs superfluous. Since every worker of IMPA is also a boss, no one can be laid off. With no bosses, decisions are taken collectively and the income is divided equally. Wages are low, but production continues.

01 Jose at his desk. During his more than six decades at IMPA, he has lived under four military dictatorships.

02 Jose visits IMPA's shopfloor to find out how long it will take to mend a machine that has broken down.

03 Jose leaves the factory. The four panels read: Culture, Work, Resistance and Education.

04 IMPA's factory in Almagro district, at the very centre of Buenos Aires.

Photographer
CHRISTIAN BOBST

02
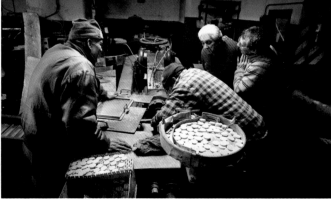

03

04

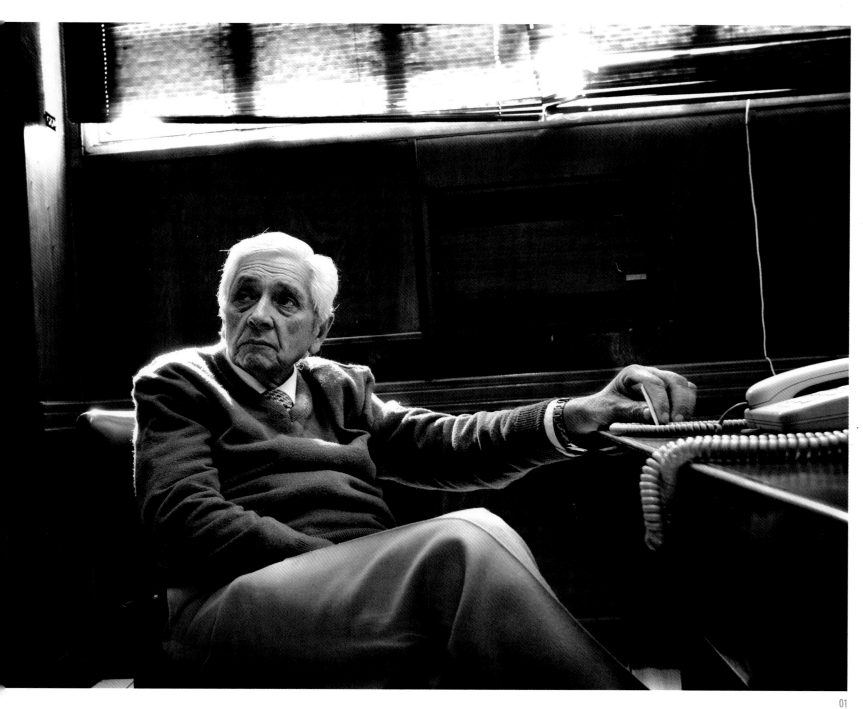

MONTEVIDEO, URUGUAY

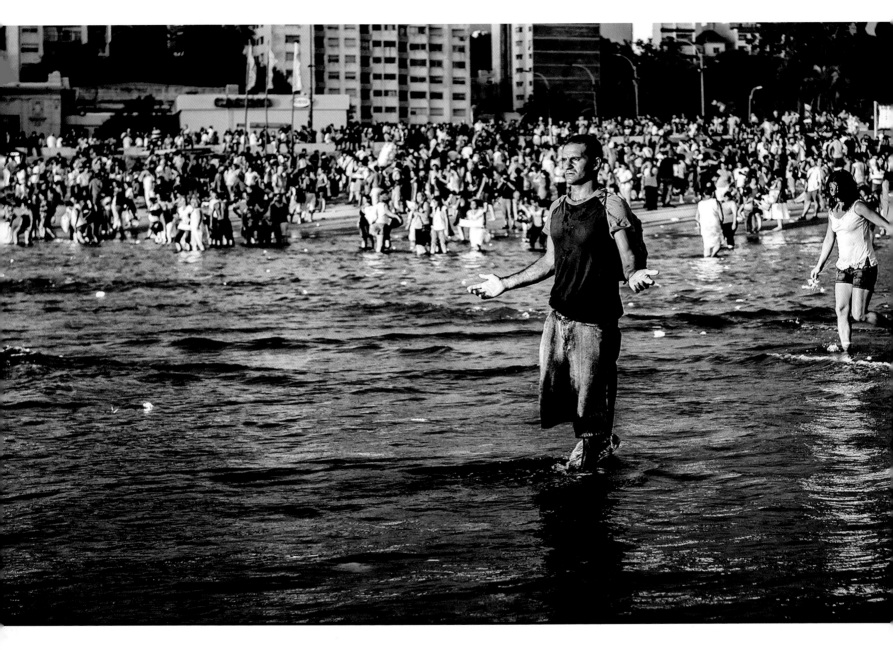

Every year on the second day of February, a large crowd gathers at Ramirez beach in the Uruguayan capital, Montevideo, to celebrate the festival of Yemanjá, an African sea goddess who protects fishermen, symbolises motherhood and owns all the sea's fruits and riches.

Many people bring offerings to thank her and ask for her blessing and protection in the year ahead. Some of these are placed on small altars lit with candles, others are put into small floats that are then released onto the sea.

01 At Ramirez beach, thousands of people gather to celebrate their annual tribute to Yemanjá.

02 Candombé music, an inheritance of Montevideo's Afro-Uruguayan population, plays throughout the day. Dancers moves in circles, searching for the trance that will help them connect with Yemanjá.

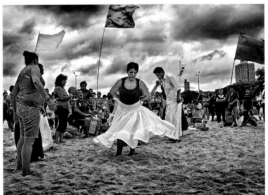

02

03

04

Photographer
ANA MARÍA ROBLES

03 A woman prays at one of the many small altars assembled on the beach.

04 Many people dress up specially for the day in robes of white or light blue, Uruguay's national colours.

05 Although originally a festival of Uruguay's African population, Yemanjá is now celebrated by people from all parts of Montevidean society.

05

AMAZONAS TEPUIS, BRAZIL

Since receiving a doctorate from University of St Andrews in Scotland, Brazilian biologist Gustavo Martinelli has worked for 40 years in the Rio de Janeiro Botanical Garden. Since 2008, the garden's research institute has been at work creating the Official List of the Brazilian Flora. Having collected more than 18,000 species of Brazilian flora, Gustavo is the largest contributor of plants to the garden's herbarium.

Gustavo also runs the National Center for Flora Conservation, a body responsible for working with domestic and international research institutions and environmental agencies to identify and ensure the survival of endangered plants in Brazil.

01 Gustavo collects plants at Pico da Neblina, a remote area of table mountains extending from Brazil's northern Amazonas Tepuis region into Venezuela and Guyana.

HYPER DIVERSE

Brazil is believed to be home to about one-fifth of earth's biodiversity, including more flowering plants than any other country (Colombia and Peru outnumber it for birds; Mexico, Indonesia and Democratic Republic of the Congo for mammals).

ESTIMATED VARIETIES OF FLOWERING PLANTS

Brazil	55,000
Colombia	50,000
China	30,000
Indonesia	27,500
Mexico	25,000
South Africa	23,000
Venezuela	20,000
Ecuador	18,250
Peru	17,120
India	15,000
Malaysia	15,000
Australia	15,000

Source: *UN Economic and Social Commission for Asia and the Pacific*

01

02 Gustavo in the field at Serra do Aracá, another remote area of Amazonas Tepuis.

03 In a field laboratory at Pico da Neblina, Gustavo works with two colleagues identifying, pressing and drying plants.

Photographer
RICARDO AZOURY

02

03

RIO DE JANEIRO, BRAZIL

In the early 1990s, Viviane Moos spent several months on the streets of Rio de Janeiro, sharing and photographing the lives of child street gangs. In 2013, she returned to see what had happened to the children she had known, and in particular to see what difference one man, Robert Smits, founder of Refúgio de Meninos e Meninas da Rua (REMER – Shelter for Street Boys and Girls), had made to the children in his care.

01

01 At five, Adriano ran away from the poverty and abuse of his family to live in the district around Rio de Janeiro's central station, begging, stealing and taking drugs. In 1994, he was living in a REMER refuge with Robert Smits as his guardian. Here, as on many evenings, he has tucked himself onto a shelf to watch television, above Monique (see opposite) sucking her thumb on the couch below.

02 In March 2013, Adriano is a bus change-maker. He has just completed a heavy equipment training programme as an excavator operator and is now planning to change jobs and start working on one of Rio's many construction sites.

02

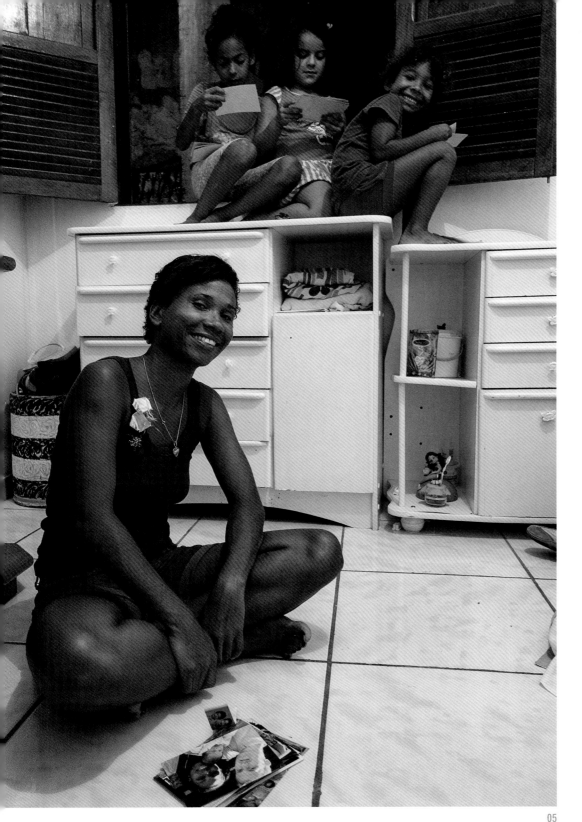

03 In 1991, Monique, aged four, sits on her older sister's lap as they beg beneath a ticket counter in Rio de Janeiro's central station. The two sisters lived with their mother, an alcoholic, in the central station rubbish tip. In 2002, a bus hit and killed their mother as she crossed a street while drunk.

04 In 1994, Monique gives her teacher a dose of street attitude on her first day at school. By then she was living in the REMER refuge. A few months later, the courts allowed her to leave for Shalom farm, another REMER facility, several hours drive from Rio, where she lived until she was 18.

05 In March 2013, Monique, now 25, sits on the floor of her brother's one-room apartment, beneath her daughter, five, and her daughter's two best friends. She has just got a job selling phone plans to customers. With a low base salary, commissions will be the main part of her earnings. Now she wants a closet in which to hang her clothes and then to move out of her brother's home into her own apartment.

03

05

04

Photographer
VIVIANE MOOS

CHIJCHIPA, BOLIVIA

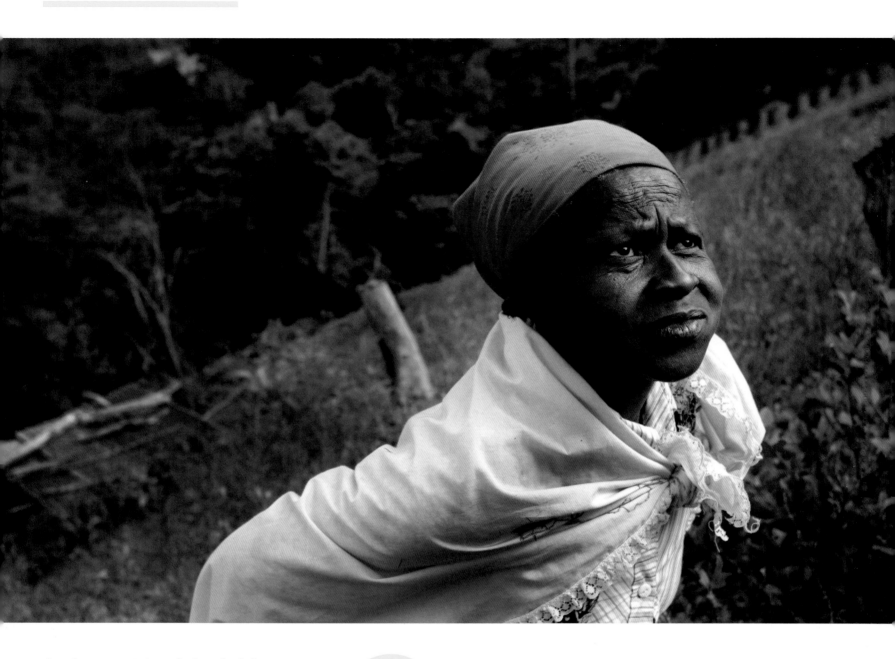

Coca harvesters Anita and Alejandro belong to one of Bolivia's few Afro-Bolivian communities. Their home is at Chijchipa in the northern part of the Yungas, a mountainous forest region that combines extreme altitude and tropical weather. Coroico is the closest town, only 30 kilometres away, but a one to two-hour journey.

Some 300 people live in the village, in 50 households. Since Bolivia's agrarian reforms of 1952, each of these families has had their own piece of land to work. Most households cultivate coca, supplemented by a little coffee and fruit.

Afro-Bolivians have lived in the district for as long as anyone can remember, maintaining their traditions, especially their music, saya, whose origins can be traced back to when Africans worked as slaves in mines and other industries.

Photographer
CELESTE ROJAS MUGICA

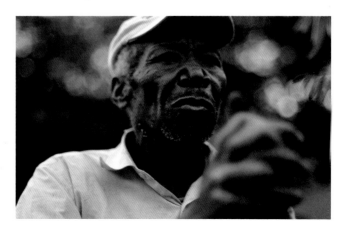

SANTIAGO, CHILE

María Pinda Peye, 82, has spent the better part of her life campaigning for human rights, especially those of her own people, Chile's Mapuche indigenous minority.

She was born in Osorno in southern Chile, part of an area home to most of the country's Mapuche people. As a young woman, she moved north in search of work, first to the city of Los Ángeles in the central Chile, then to Santiago, where she has lived since 1960. Her husband died young, leaving her to raise five children at her home in Cerro Navia, a suburb of the capital. With two of those children dying of illness and discrimination against Chile's indigenous widespread, life was a struggle.

María's response was to become an activist. In the 1970s and 80s, she campaigned for both human and Mapuche rights, organising hunger strikes to protest the disappearance of the thousands of Chileans during the right-wing military dictatorship of Augusto Pinochet.

After democracy returned to Chile in 1990, María was appointed to a presidential committee responsible for raising the political and social standing of the Mapuche and other indigenous peoples. In 2003, the United Nations named her a Messenger of Peace. Today, in her 80s, she continues to push for social and political change.

Photographer
SILKE KIRCHHOFF

01 María stands in front of the house in Cerro Navia on the edge of Santiago, the Chilean capital, where she has lived since the 1960s.

01

ENE RIVER, PERU

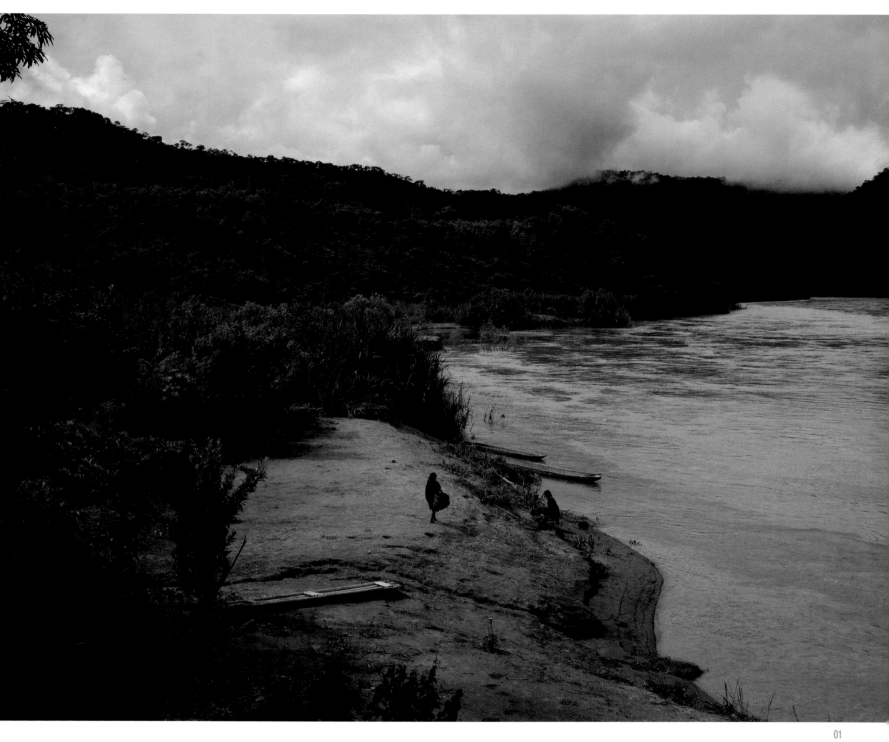

Photographer
TOMAS MUNITA

Since the early 2000s, most of those displaced have returned to inhabit their villages along the banks of the Ene River. Now, however, they face a new peril: a 2,200-megawatt hydroelectric dam that would flood much of the river valley, and once again force thousands of people to move their homes.

Ashaninka leaders are fighting the dam, demanding through Peru's courts that the government disclose all feasibility studies and other information about the proposed project. Although officials say that local people would benefit from electricity generated by the dam, it is already clear that most of its power would be exported to Brazil.

01 Two girls stand on the shore of the Ene River in front of Tsiquireni village. The proposed Pakitzapango dam would be built in the mountains at the rear of the photograph.

02 Victoria Kubirinketu, an Ashaninka woman who also lives in Tsiquireni, walks back to her village after collecting bananas.

03 Ashaninka children watch the Ene River in front of their village, Boca Sanibeni. This area would be flooded by the proposed dam.

THE RIVERS OF PERU

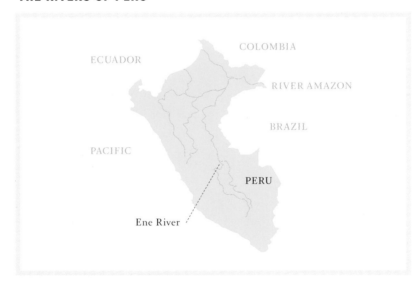

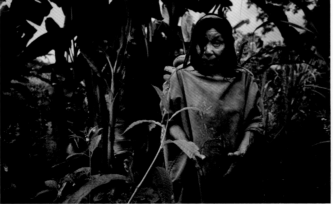

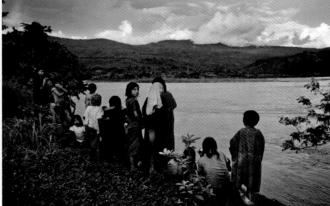

LLANGANATES NATIONAL PARK, ECUADOR

Hernán Pallo, 45, with Wellington, 3, one of his seven sons, at their family home 57 kilometres into the woods of Ecuador's Llanganates National Park. Hernán bought this spot in 1993, three years before the area was declared a national park in 1996.

As well as farming, the family makes wooden spoons from alder. They sell these at a market in Salcedo, the nearest town, some 65 kilometres away, which they travel to in the family truck. Three of Hernán's sons work with him raising pigs. The others go to school in Salcedo, staying there with relatives.

Photographer
ALEJANDRO REINOSO

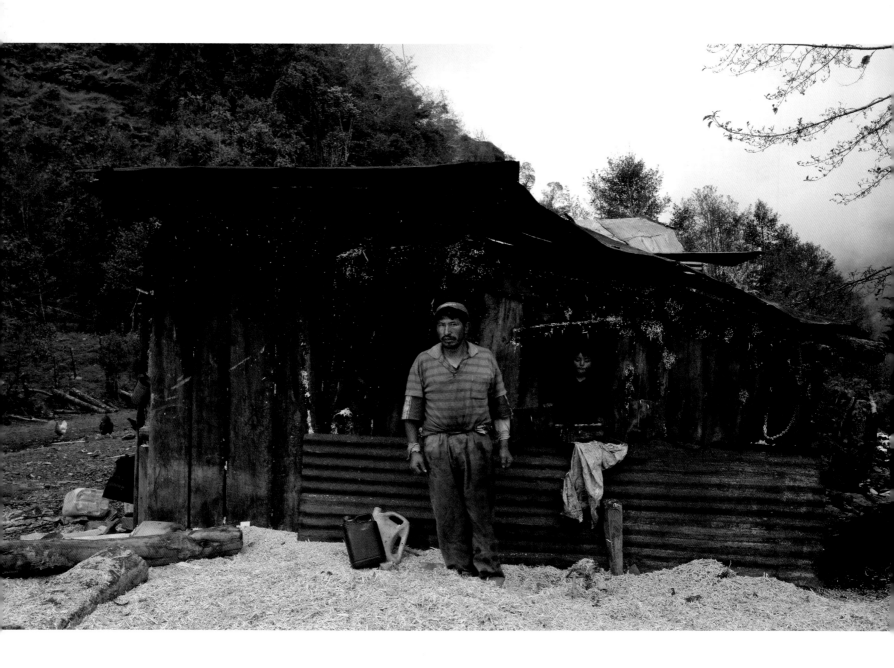

BOGOTA, COLOMBIA

Enrique Lizarzo runs La Moda en Piel, a family-owned shoe store in Bogotá's Chaperino district. Founded by Enrique's father, who still works in the business, all of its shoes are custom-made by hand.

Like shoe sellers across the world, La Moda en Piel faces stiff competition from cheap Chinese imports. But with a loyal customer base – nurtured over the years through word-of-mouth recommendations – and Enrique's moderate prices – between US$40 and US$90 a pair – business is good.

Customers are taken care of in a small space at the front of the shop. The shoes are made in a cramped room at the back, a dusty, glue-smelling 40-square-metre area split into two levels.

Most customers bring a pair of shoes they like and ask Enrique if he can make something similar or suggest some improvements. Once the details are agreed, Enrique and his father set to work, preparing and marking the leather for cutting. Enrique's mother handles the sewing, and two other staff make heels, which they join to soles. With sewing and shaping machines in constant operation, and lasts and nails always being hammered, the room is never anything but noisy.

01 Everyone who enters La Moda en Piel is met by a display cabinet showing off Enrique's collection of model cars.

Photographer
SARAH KINDERMANN

01

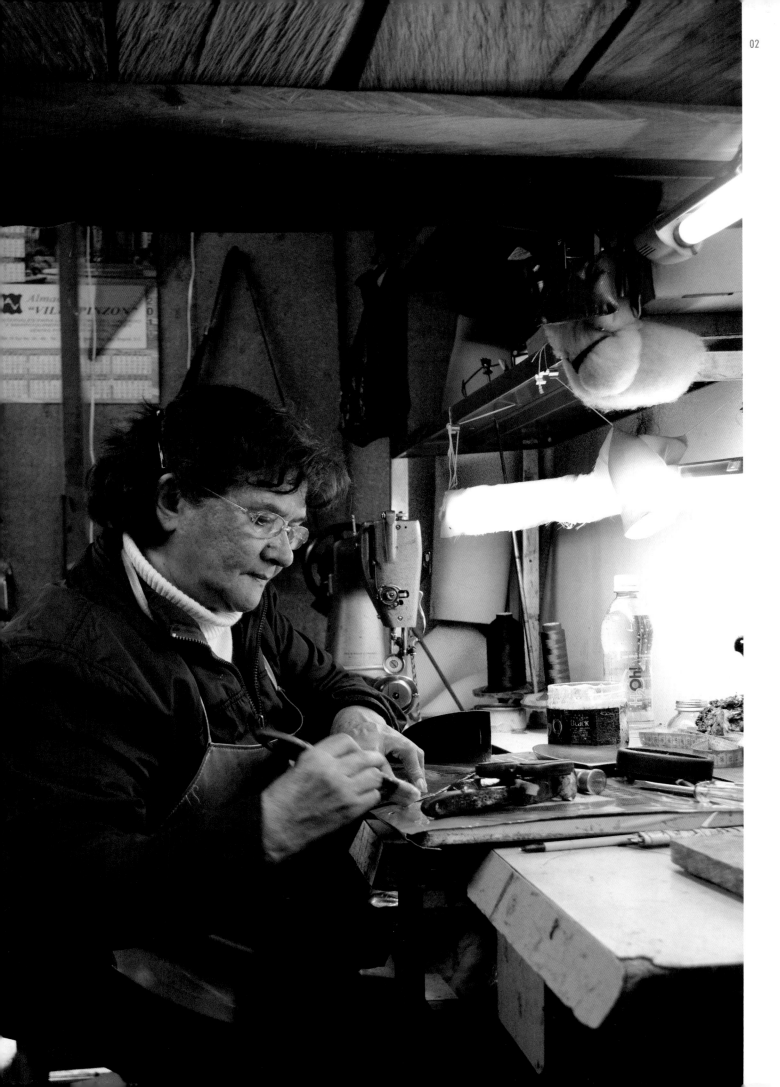

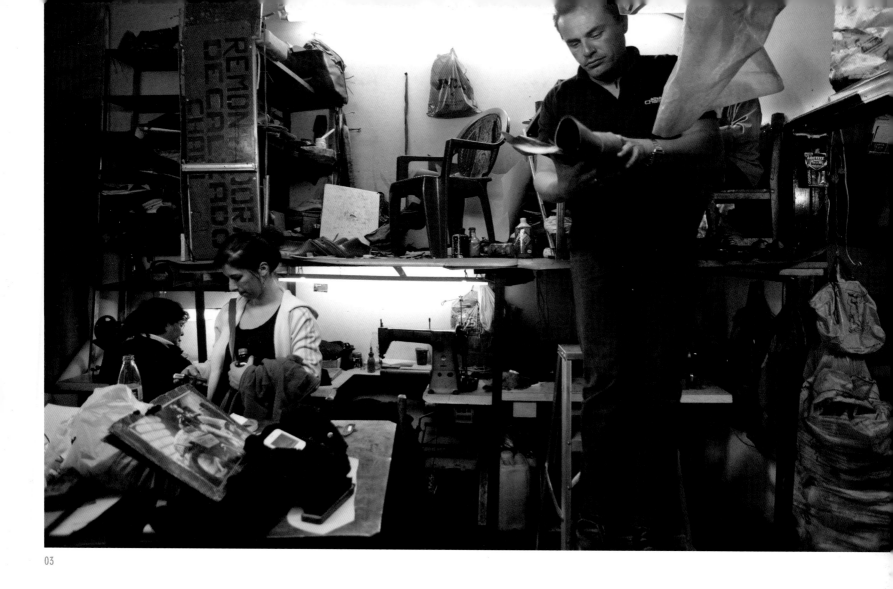

02 Enrique's mother glueing leather in preparation for sewing.

03 Enrique, the owner, in La Moda en Piel's workshop.

04 On a raised platform at the rear of the workshop, one of La Moda en Piel's two staff fixes the heels to a pair of ladies shoes.

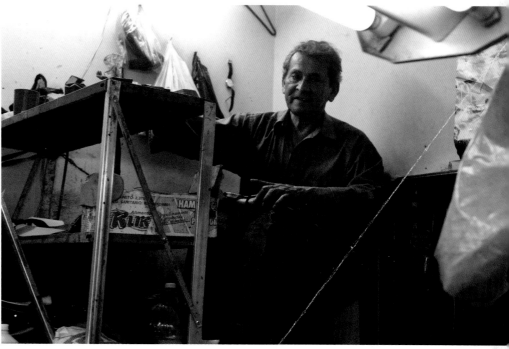

LEON, NICARAGUA

Sustenance farmer Juan Pichardo, 68, in a field of his corn near the town of El Jicaral in Nicaragua's León state. As with rice in Asia and wheat in the Middle East, corn made civilisation possible in Mesoamerica and is still a vital element of life in Nicaragua's countryside. Most families farm small plots of corn whose harvests, after being dried and stored, feed them for the rest of the year.

Juan has planted corn in this mountainous region of northwestern Nicaragua since he was a boy. He still works six days a week. Born around 20 miles away, he has worked his current plot for 45 years. Every day during the year's two planting seasons – May-July and August-October – he makes the 30-minute climb up a steep hillside to tend to his crop, which yields enough corn for him to sell part of his harvest for cash. He also grows beans, which he plants once a year, and raises a few cattle.

Three of Juan's sons and five of his grandchildren live with him and his wife, but many of his relatives have emigrated to Costa Rica, Spain or the United States. In 2006, an electricity supply was installed in his home, and since then he has also added a latrine and a well. Although illiterate, he has a rich knowledge of the names and life-cycles of around 100 different trees and shrubs in his area.

Photographer
RICHARD LEONARDI

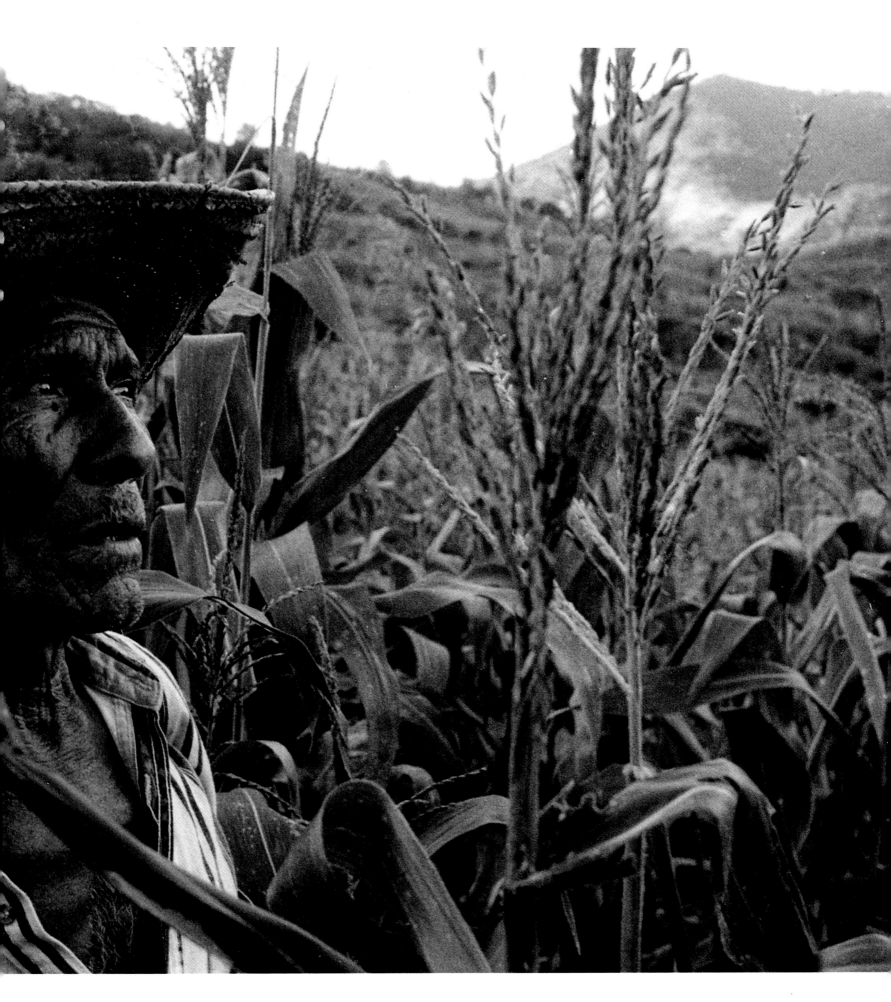

SAN ANDRES, GUATEMALA

Carlos Enrique Marroquin runs Maya Pedal, a non-profit organisation that turns unwanted bicycles into pedal-powered machines. Set up in 1997 in the small southern Guatemalan town of San Andrés Itzapa, Maya Pedal's products include blenders for making fruit drinks or grinders for processing corn. Some are used in small businesses, others to make daily life less arduous.

One local women's group uses a Maya Pedal machine to make aloe vera shampoo. Sales of the shampoo, as well as providing income for the women in the group, have also helped buy saplings for a local reforestation project. Another group uses a pedal-powered pump to raise drinking water in a 30-foot well.

Staffed by volunteers, Maya Pedal also puts together fully working bicycles from donated parts, selling them to local people at affordable prices. With its tools and machines, the workshop is also an important resource for local needs – from sharpening a machete to mending a football.

01 Carlos Enrique Marroquin, Maya Pedal's director, oversees repairs to a football.

02 A pedal-powered fruit blender.

Photographer
ANNA KORTSCHAK

01

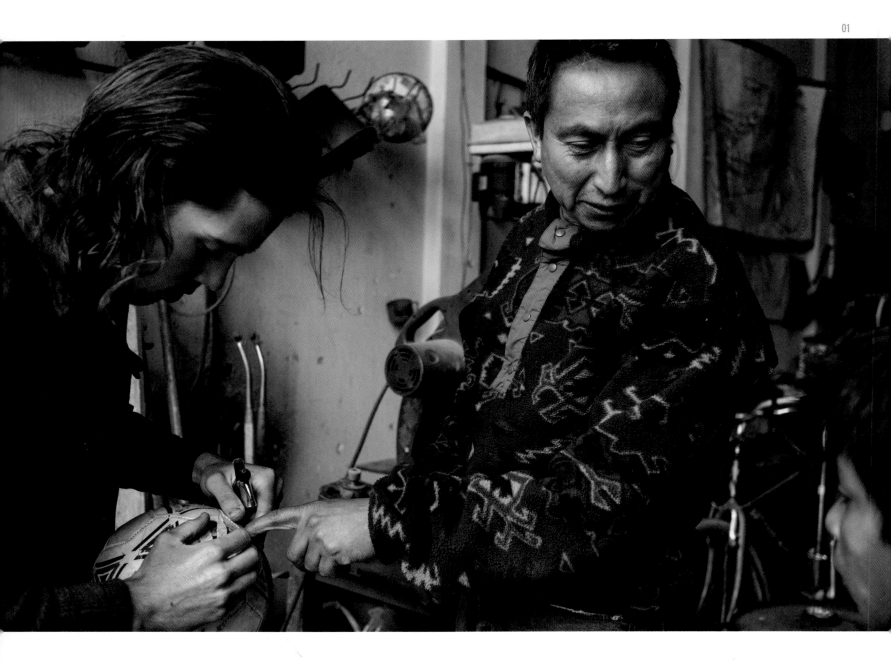

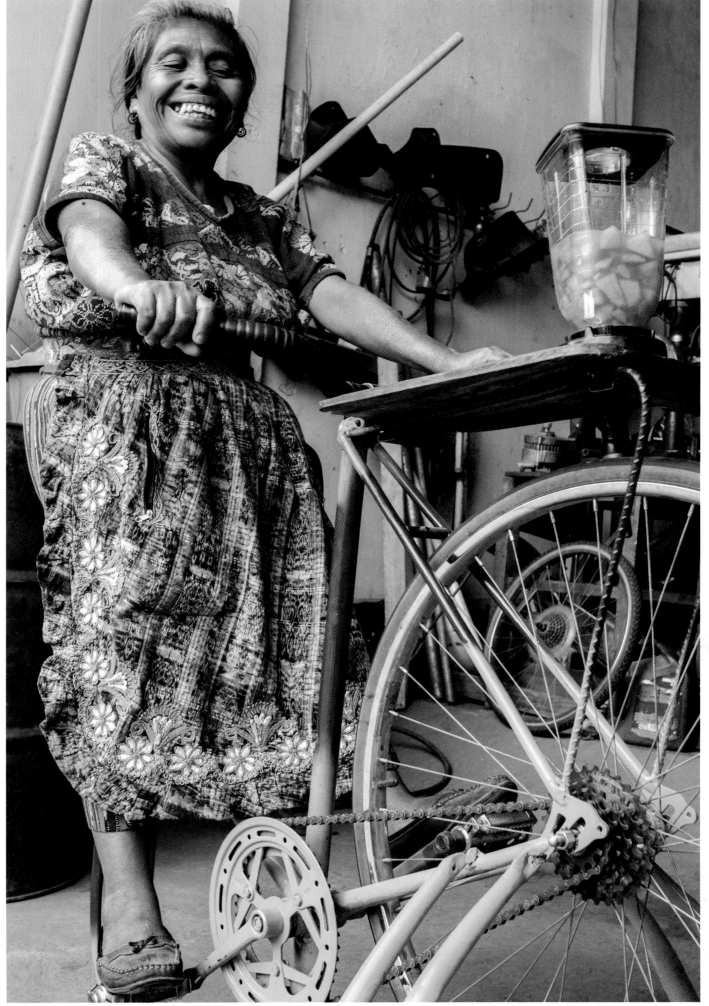

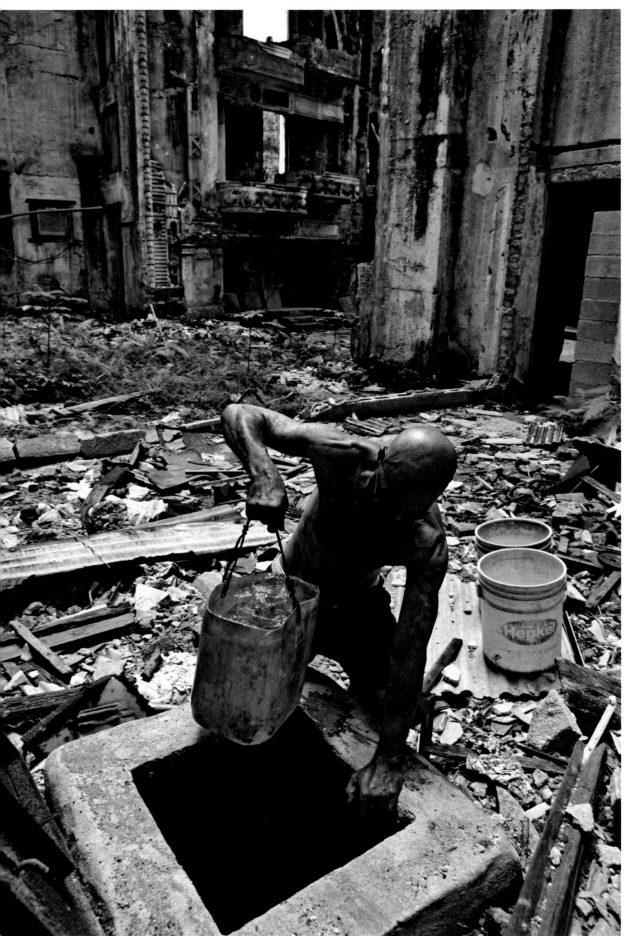

Central Havana's Campoamor Theatre opened on 20 October 1921. For more than four decades, it was one of the country's leading venues for music, theatre and poetry. Singer Rita Montaner, Cuba's most popular performer from the 1920s until her death in 1958, enjoyed her first major show there in 1924. But in 1965, six years after Fidel Castro took power in the Cuban revolution, its curtain fell for the last time and it became a garage for pedicabs and mopeds.

It was then that Reinaldo, now 52, started working in the building as a parking attendant. Then the garage, too, closed down. And so for more than 20 years, the former theatre has been his home. His living room is on the first floor in what was formerly a vanity room. He has a wardrobe for clothes, a bed, a gas cooker, a television, a ventilator to cool the summer air and help keep off the mosquitoes, and – usually – electricity.

Like all Cubans, Reinaldo has a government rations book that guarantees him a supply of food, though not enough to survive. To make ends meet, he works as a cleaner in houses around his neigbourhood or takes on other temporary jobs.

For 30 years, he has practised the Chinese martial art, tai chi. Formerly taught by a master teacher, he now practises alone twice a day, for an hour in the morning and another hour in the evening.

01 Reinaldo gets water from a cistern inside the building near the former stage area, carrying it up to the first floor for his twice daily showers.

Photographer
THOMAS HECKNER

01

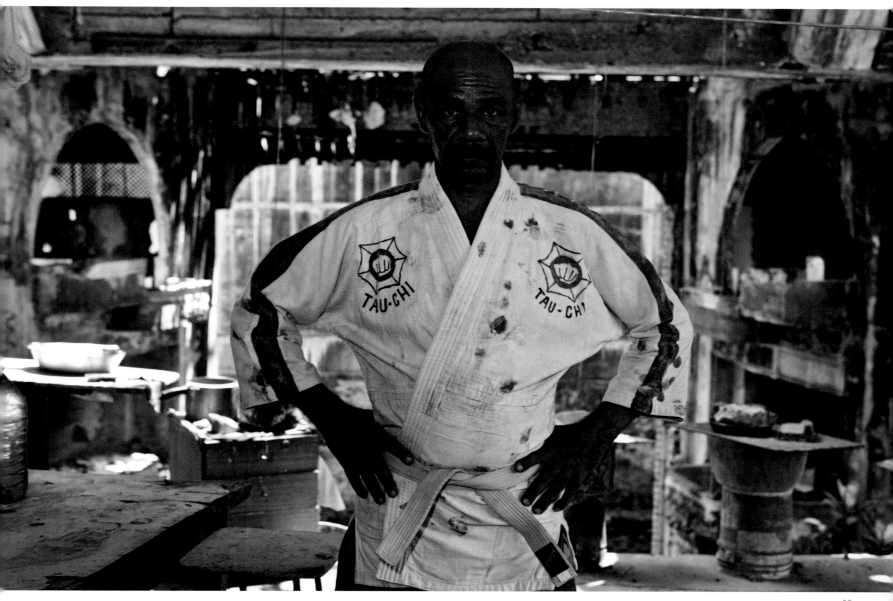

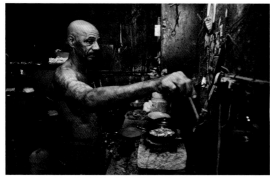

02 Reinaldo in his tai chi clothes. The exercise keeps him in good physical and mental shape, he says.

03 Preparing dinner in his kitchen. Reinaldo moved to the theatre after being forced to leave his former home, a flat belonging to an uncle, when that uncle died.

04 The auditorium of the former Campoamor Theatre.

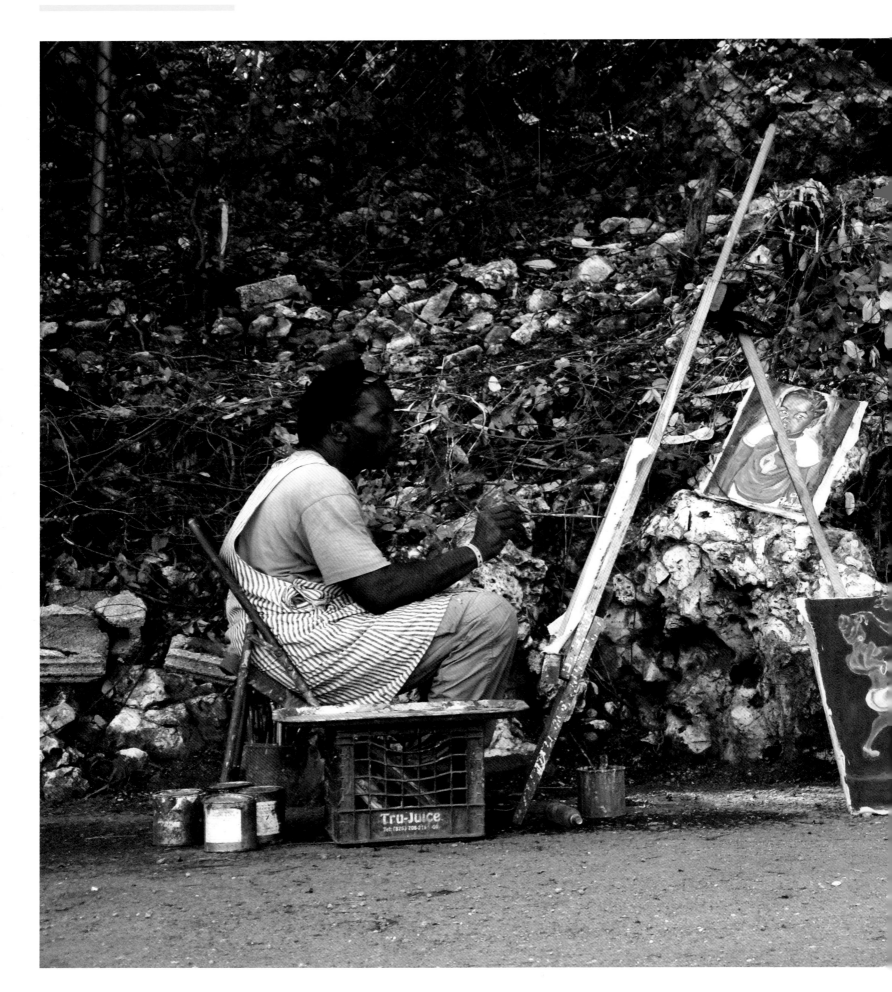

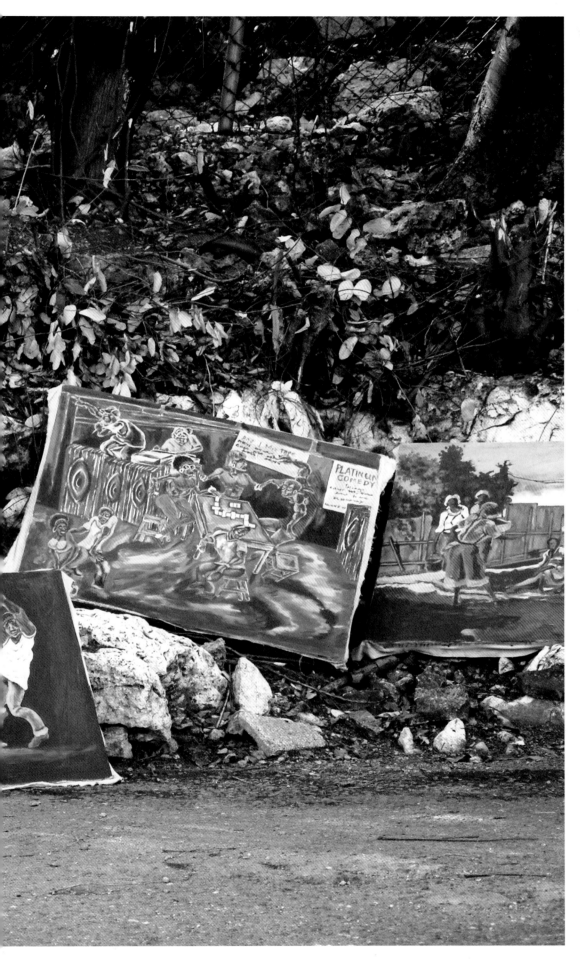

Delroy Anderson is a professional artist. He paints all day at the side of a road in Kingston, Jamaica, selling his works to passersby. Occasionally, someone stops their car and asks whether he can make them a portrait from a photograph of a loved one. He has no idea how many works he has produced since he started painting full-time in 2004.

He became an artist largely by chance. Convicted for his role in a fight, he spent three years in prison. After his release on parole in 2001, he struggled to make a living, working his way through a succession of labouring and street jobs. Keeping a roof over his head was hard.

One afternoon, a brochure for a learn-how-to-paint correspondence course blew against his trousers. He borrowed the money for its fees from his family and signed up. At first, other men on the street laughed at his efforts. That, however, only encouraged him to keep practising. "They criticised me and told me to sell peanuts. But I said to myself, 'I'm gonna prove them wrong'." Now, nearly ten years later, and with one exhibition under his belt – at New Kingston's Wyndham Hotel – he has.

Though he hasn't struck gold, Delroy says his work brings him peace and fulfillment. He also likes being outside, where he can feel the energy of life around him.

Photographer
BERETTE MACAULAY

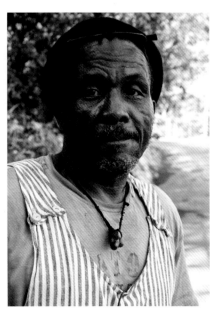

CRUZTON, MEXICO

Cruzton, a small village in the Chiapas mountains of southern Mexico, is home to four families of the Tzotzil people, one of several indigenous Mayan communities in the region. The families have lived in the area for at least several generations, growing corn and raising pigs, chickens and turkeys.

Their homes have electricity, but the area has no medical facilities and its roads remain unmetalled. The nearest town is two hours' drive away, most of it along a dirt track. The families have two off-road vehicles but seldom use them. Apart from in an emergency or for transporting a heavy load, they move around by horse or on foot. Each year, after the corn harvest, they sell part of their produce in the town's market to earn a little cash to buy food and other necessities.

For decades, government officials have been trying to force the families to leave their land. During the Chiapas rebellion, a brief uprising launched by poor peasants from the region in 1994, the families supported the rebellion's call for land reform and greater local autonomy. Nowadays, however, their main hope is to be left alone to farm their fields in peace.

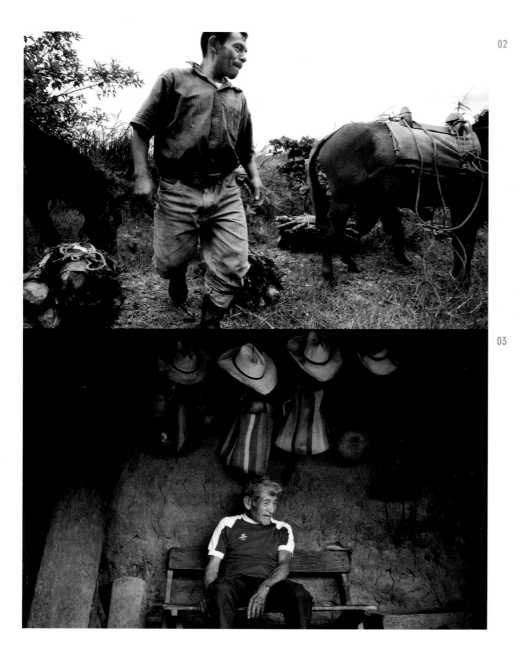

02

03

01

Photographer
MARCUS SIMAITIS

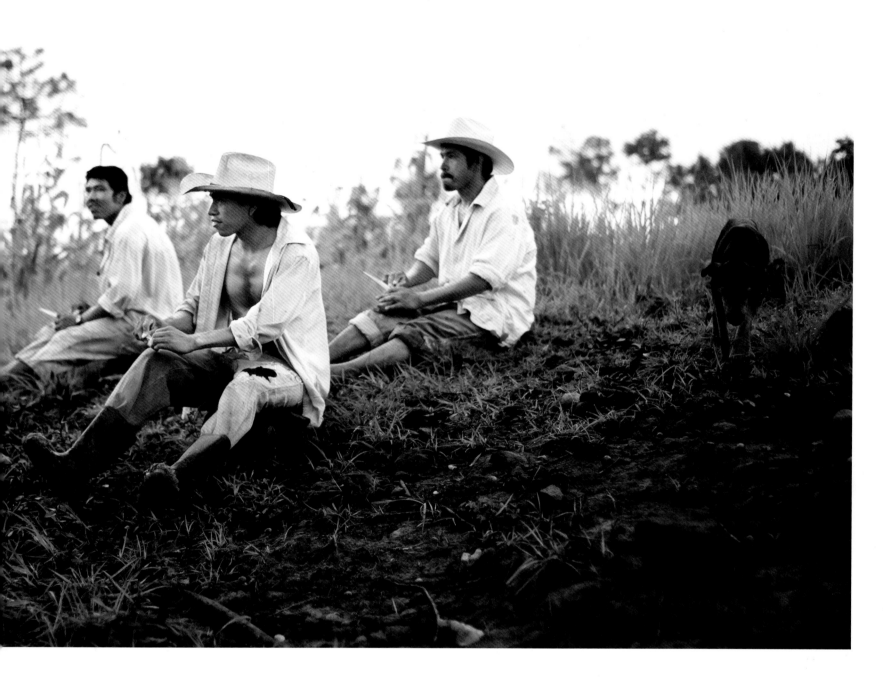

01 Brothers Miguel, Manuel and
 Rafael sharpen their machetes
 before starting work in their
 cornfields.

02 Marcos with firewood he has
 collected. His horses will carry
 the firewood to his village.

03 Martin, one of Cruzton's village
 elders, sits in front of his
 cottage.

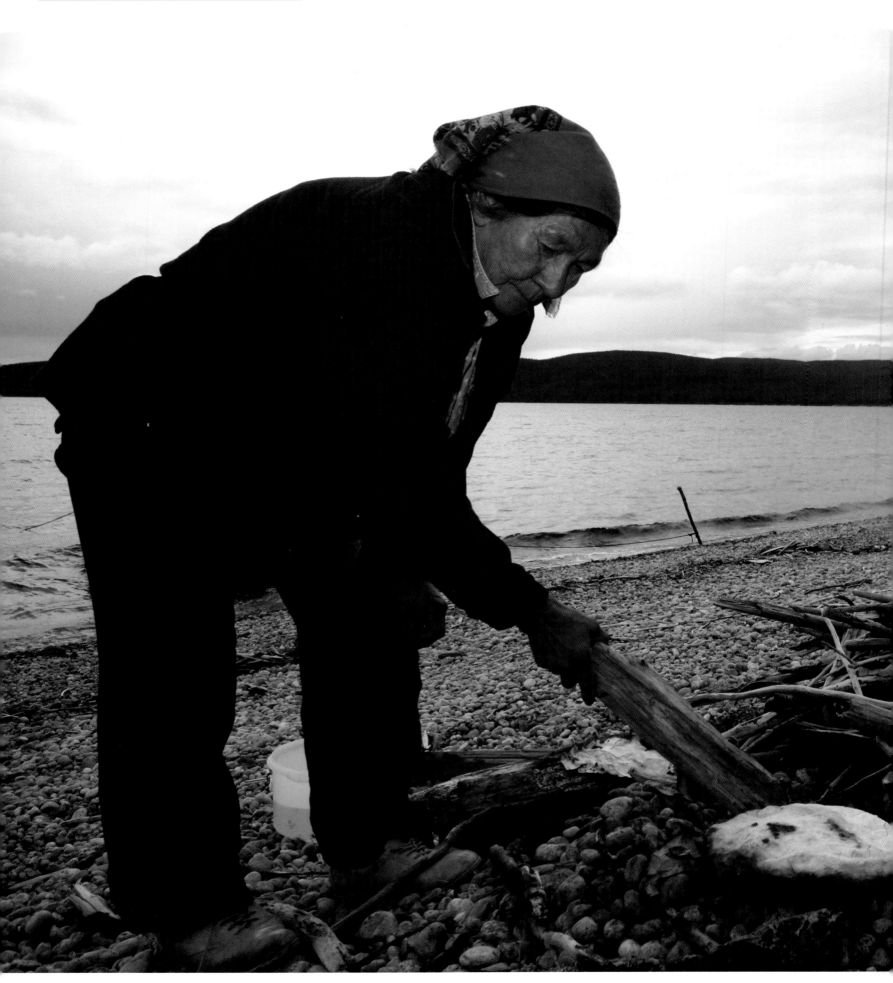

Elizabeth Penahue, 69, wears many hats: environmentalist, activist and Innu elder. Every spring, she leads a walk to Pants Lake in the Mealy Mountains of Labrador on snowshoes, tenting in the bush for three to four weeks. And every summer she leads a 10- to 12-day wilderness canoe trip on the Churchill River, also staying in tents. Her purpose is to introduce people to Innu culture. "I am an Innu woman. I am very proud. If I don't do this, who will?" she says.

Many things worry her, especially increasing drug and alcohol use by young people in Sheshatshiu, her community in Labrador. She has also taken part in protests against developments that she believes threaten the Innu way of life, including low-level military flights, mining at Voisey's Bay and hydroelectric projects on the Churchill River and at Muskrat Falls.

Despite having no formal education, Elizabeth received an honorary doctorate degree from Canada's Memorial University in 2005 and a National Aboriginal Award in 2008 for her lifelong work protecting the environment and keeping Innu culture and traditions alive.

01 Elizabeth making sand bread. First she makes a mound from pea-sized or smaller pebbles on the beach. Then she covers the mound with dry brush and sticks and lights a fire. Once the pebbles are hot enough, the wood is pulled to one side, an indentation is made in the pebbles and a piece of dough the size of a large pancake placed in the middle. Hot pebbles are gently raked on top of the dough and the hot wood placed back on the pebbles. After an hour, the wood and pebbles are removed, exposing the cooked bread.

Photographer
SANDRA PHINNEY

01

Megan works at Crazy Mountain Cattle Company, a 2,000-acre ranch in Montana, near the small town of Big Timber on the Boulder River.

Her job is to take care of the cattle. Every morning, she gets up early and lets the ranch's 20 or so horses out of their barns, then drives its herd of a few hundred cattle to fresh pasture. If she ever needs help, Rick, the ranch's owner, pitches in. She earns US$800 a month plus free meat and accommodation in a trailer home.

Megan spends most of her evenings in the trailer making saddles, a craft practised by her family for generations. She has only recently starting using a computer, and even now doesn't have her own email address. Occasionally her boyfriend comes to visit for a day or two when he has a few days off.

Megan loves both her job and her horses. "There is nothing better than spending all day with horses and having somebody paying you for doing that," she says.

01 Megan in the living room of her trailer. On the right is a partially completed saddle she is making.

02 After a night of heavy rain, Megan rides across a creek to make sure the water isn't too deep for cows to cross.

Photographer
JIA HAN DONG

02

01

NEW YORK, USA

Riley, 2, never seems to leave his stroller as his mother, Brittany, and stepfather, Nelson, panhandle their way from street to street and borough to borough.

He eats little. Most of what he does eat costs less than US$0.99 an item. That seems to be how the family budgets: all food and drink items must cost US$0.99 or less. The rule doesn't hold for cigarettes or K2, a marijuana substitute.

Nelson met Brittany at a shelter. Because couples aren't allowed into shelters in New York, rather than spend any time apart, they decided to live together on the streets with Riley. Riley's stroller is used to carry their few belongings.

01 Nelson, Brittany and Riley leave a flophouse after failing to find a room for the night. "No vacancy" signs are a hazard of taking too long to beg enough money.

02 The couple and their son eat outside a soup kitchen. Because of the cold, Riley is seldom allowed to leave his stroller and walk around.

03 After securing a room at a flophouse in Harlem, Brittany feeds Riley while Nelson contemplates which spots to hit early in the morning to get the next day's food and rent money.

04 On a bitter February day, Nelson and Riley take refuge from the cold at a housing complex in the Bronx.

05 In a park in Harlem, Nelson and Brittany argue about their finances.

06 Riley enjoying one of his favourite foods, chocolate. His parents feed him a steady flow of chocolate and ice teas, items within their US$0.99 panhandling budget.

Photographer
RUDDY ROYE

HUNGRY CHILDREN

In the US, children in 10% of households with children suffer from food insecurity at one point or another during a year.

FOOD SECURITY IN US HOUSEHOLDS WITH CHILDREN, 2010

Food-secure households	80%
Food insecurity only among adults in households with children	10%
Households with low food security among children	9%
Households with very low food security among children	1%

Source: *US Department of Agriculture*

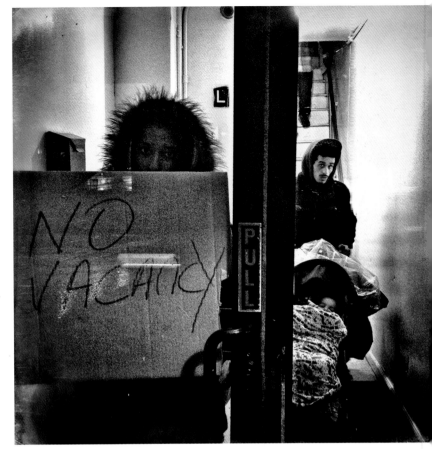

01

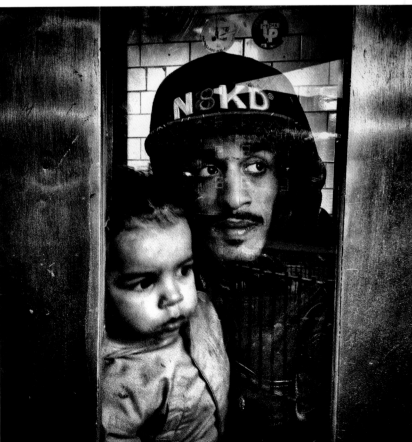

04

02

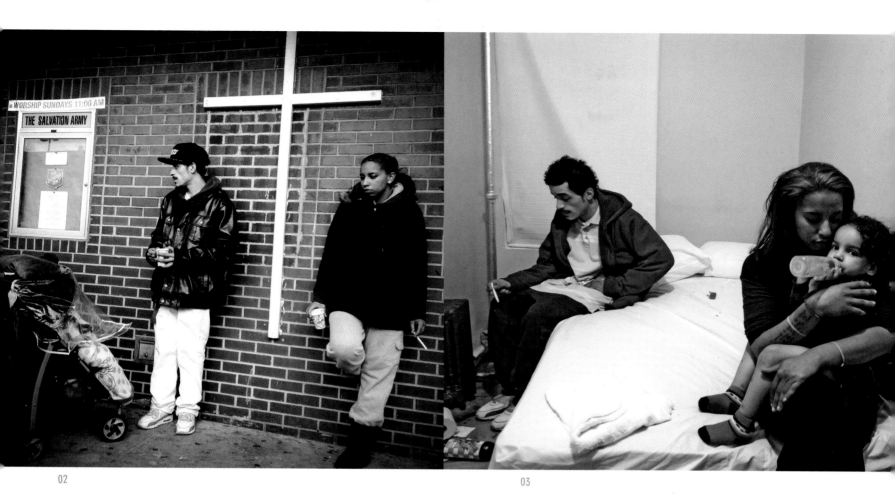

03

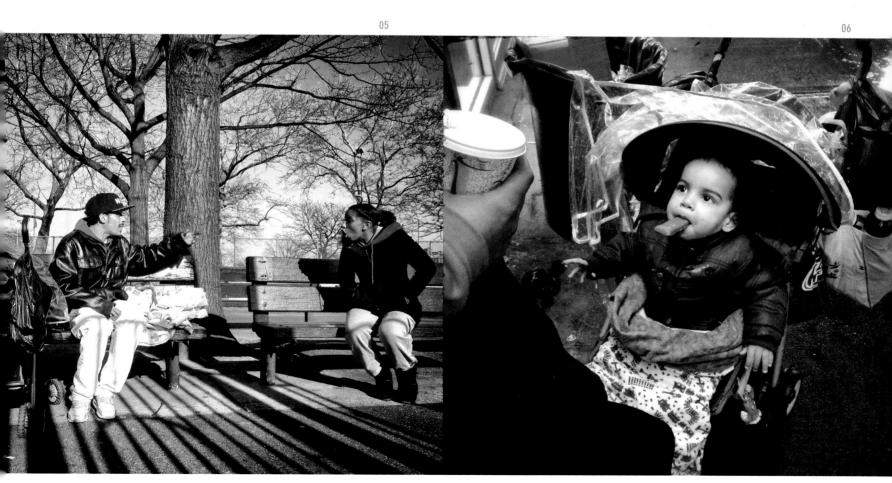

AMARILLO, USA

Frank, Yvonne and their two teenage children, Lisa and Kevin, visit a rich neighbourhood in Amarillo, Texas, to enjoy the Christmas decorations that adorn most of the homes. The family lives in a trailer. Yvonne has diabetes and Frank suffers from insomnia. Neither Frank nor Yvonne have regular work. Sometimes Frank and Kevin gather and sell firewood to earn some cash. The family is very close and likes to spend as much time together as possible. Often, after school, the parents pick up their two children, buy popcorn and soft drinks, and go off for a drive in their car.

Photographer
BIEKE DEPOORTER

HARMONIKA

Janice Galloway

HARMONIKA

Janice Galloway

From the Greek, meaning consonance; a pleasing
unity in sound.
More commonly, an accordion.

It's a striking-looking thing, an accordion. Complex,
rich and self-contained; crafted from wood (pear,
olive, cherry, walnut and maple are favourites) and
fabric, fringed with keys, buttons and mother-
of-pearl, it has the sheen and care of something
precious, even unique. It glitters when played and
its bellows, worked by hand, make the distinctive
sound rise and fall like a breathing voice. In
whatever incarnation – accordion, concertina,
melodion or bandoneon – the instrument almost
invariably invokes the music of *das Volk*. Inflected
with Cajun, Latin, Scottish, Irish, Bosnian,
Russian, Polish, it is almost invariably music for
singing and dancing. It is open to improvisation. It
is cohesive. It is meant for crowds.

The invention of the danceband-in-a-box was in
1822 in Germany. If that seems recent for a "folk"
instrument, it is and it isn't. Folk music is not –
perhaps more accurately was not – static. Whatever
"folk music" might or might not be in the present,
it can be roughly defined as music which: 1) has its
origins in the oral tradition of manual labourers,
ie, not written down but handed down, person to
person, via the ears; 2) contains local or national
flavours; 3) is personal or allied to celebration;
4) can be used, especially by exiles and immigrants,
as a form of historical memory of home or identity.
The Western version of this music is set in stone
or, worse, dead. It now reflects a casting aside of
communal values in favour of solitary striving,
preferably for cash. Stuff, preferably electric stuff, is
where true freedom lies: the rest is for losers.

My own memories of community come from two
uncles – Tommy and Alec – who played accordions
in West Coast of Scotland pubs at weekends.
Already in their forties when I was born, they
were classifiable as ancient by the time my teens
and Glam Rock arrived. Their teenage years were
at the turn of the previous century, when the
family moved to Yorkshire, following coal. My
grandmother had six boys, all coal miners – the
kind with picks and shovels and big square hands.
If I remember correctly, Tommy's right paw covered
half a keyboard when motionless yet shifted like a
scalded crab when pushed into service playing reels.
Everyone in the family sang, regardless of talent.
Talent wasn't the whole point. Tommy and Alec
were the only squeeze box owners.

Accordions, like bowls for the ancient sport of Lawn
Bowling, were frequently inherited. Theirs were
second-hand, paid up in installments. Cared for,
their wood varnished into glass. They learned how
to play from watching those who already knew and
asking questions. Once you were able, you could
beg a spot at the Bowling Clubhouse Friday night
get-together, and self-teach on the job.

Before I hit my smart-ass teens, then, Tommy
and Alec were the bee's knees. They played at
Co-Op wedding receptions for both the dancing
(country dance band, jazz, sentimental ballads
and rockabilly) and for "turns" where relatives
and guests got up to sing, play the spoons or soft-
shoe shuffle. They played as punctuation during
speeches in lieu of drum rolls. Finally, they
signaled the party over with "Goodnight Eileen"
followed by a silence that meant GO HOME. Pub
routines were a cabaret while patrons drank and

called up requests. In clubs, the routine revolved around the pair playing and singing duets or accompanying volunteers ("Silver Threads among the Gold" was my mother's big hit) who were 'called up' to contribute. At all three, they'd announce birthdays, births and even deaths, and leading a general singalong ("I'm sure you'll all know this one – it was Big John's favourite") as tribute.

As a child in the gathering, I could watch without fear of being thrown out of premises that sold alcohol, listening. The experience I recall as smoke-clogged, alcohol-scented bliss. Mixed bliss admittedly, since not all the turns were much good, but the show went on regardless and there was that rare thing – uncompetitive enjoyment. Sometimes children would be "danced" on adult shoes – didn't matter whose. I learned something of local gender expectations so at least I knew what was expected even if I didn't like it. I learned how to join in. I learned all the words.

When I was fourteen I sang at the Bowling Clubhouse myself: Joan Baez, Pete Seeger and "Silver Threads among the Gold". Somebody asked for "Freight Train", the words to which I had learned from THE BIG BOOK OF COUNTRY MUSIC. No accordion, just my own guitar and a Teach-Yourself book got me through. I played there twice, sum total. Then I found Other Things. Mostly boys who thought things like Bowling Green crowds were old men and that discos were how to be. I admit I was easily led.

The seventies made recorded music a cheaper, more modern, more – what? – sophisticated option. They also made accordions into Jimmy Shand dull beasts and sing-songs hokey. When my Uncle Alec died, childless, his accordion went to a second-hand shop. Ten years later, when Tommy died, I read about it in a newspaper. The fate of his much-loved instrument remains unclear. Girls did not play accordions.

Now, the shift from communal to solitary, from welcome join-in culture to competitive X-Factor sit-and-watch seems a done deal. I do not notice I miss what has been lost till I hear the folk music of other cultures, holding on for all it's worth or served up as tourist quaint carries the pang of catching sight of a wolf in the woods. Communal living, communal spirit itself, most certainly communal music and song – harmonika – seem desperately in the balance.

I may have to buy an accordion.

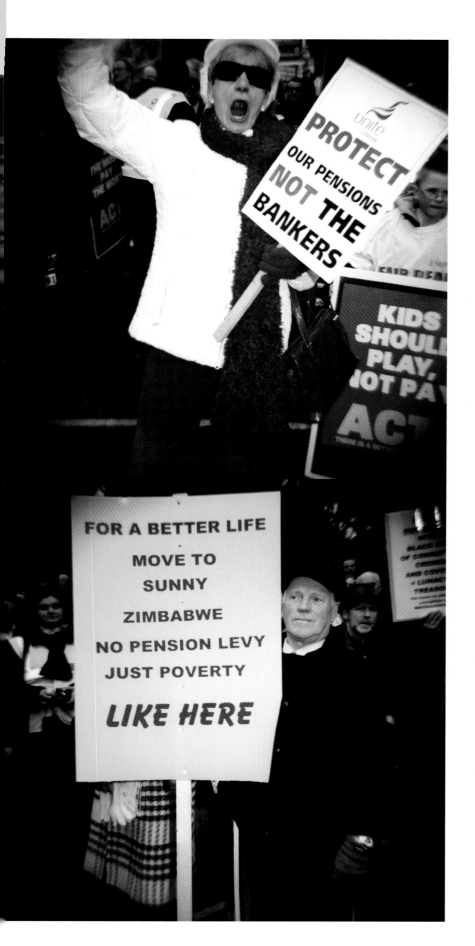

In February 2009, around 100,000 people took to the streets of Dublin, angry at their government's handling of the economic crisis and in particular at plans to impose a pension levy on public sector workers.

Since then, people have protested with their feet in another way – by leaving the country. In 2011, in response to the government raising taxes, lowering social spending and cutting public sector jobs, 80,000 people left the country, about half of them Irish.

Ireland has a long history of mass migration. From 1815 to 1852, the end of the Irish Potato Famine, 2.5 million people left the country, or close to 25% of the population. And through the second half of the 19th century, the population halved from 8 million to 4 million as more people left, mainly for North America, in search of a better life. Mass emigration continued throughout the 20th century, with average net emigration from Ireland consistently exceeding natural population growth until 1961.

Since then, the population has grown: today it stands at 6.3 million. But it was only in 1996 that the country became a country of net immigration – the last member of the EU to do so – as its economic boom of the 1990s led to a major inflow of migrants, many of them Irish nationals returning from living overseas.

With the onset of the Irish financial crisis in 2008, unemployment rose to close to 15%, and thousands of people began to leave Ireland once again. Unlike during previous exoduses, many of today's émigrés are highly skilled, with over 30 percent of them moving to Australia, where there is a shortage of skilled labour.

Photographer
DEIRDRE BRENNAN

ON THE MOVE

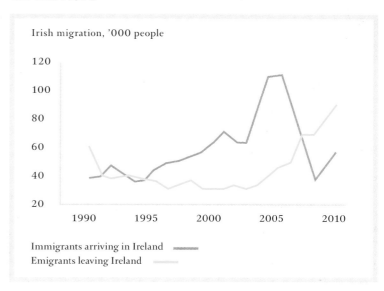

Irish migration, '000 people

Immigrants arriving in Ireland
Emigrants leaving Ireland

01

The Jones family – two parents and seven children – lives in a three-bedroom council house in Wolverhampton, a city in the English Midlands. This is the first house any member of the family has lived in for three generations: the mother and father were brought up in caravans, as were their parents. Despite its limited size, the family says the house has many memories for them, and they have refused council offers to move them into a larger home.

Photographer
LIZ HINGLEY

01 Nicola, 16, shares a bedroom with her three sisters. She covers its
 window with a rug her father gave them to keep in the heat.

02 Stacey, 18, with a blossom taken from a tree in front of the family's house.

03 At Halloween, the youngest members of the family dress up before going to collect sweets around their neighbourhood.

04 The Jones family moves their sofa from the living room into the garden in the summer. Mr Jones used to be a railway worker until ill health forced him into early retirement. With little money to spend, he passes most of his time at home.

05 Nicola sits in the doorway of her bedroom as Michelle pretends to spray perfume on her from an empty bottle. As Michelle has a passion for perfumes and other "smelly things", the family gives them to her as presents at Christmas and for her birthday.

BARCELONA, SPAIN

Across Spain, neighbourhood associations – *asociaciones de vecinos*, as they are known in Spanish – are helping people survive the aftermath of the global financial crisis.

Originally set up to bring the people of a barrio (district) together, during the rule of General Franco from 1936-75, when political parties and trade unions were banned, they were the only bodies able to build a widespread network of resistance to the dictatorship.

In the 1980s, after Franco's death, they emerged as the principal link between citizens and the newly elected democratic officials. That role faded in the 1990s, with many becoming social clubs for retired people. But since 2008, with many local governments short of funds, they have re-emerged as a valuable community resource providing social services such as soup kitchens, barter markets, nurseries, libraries, sport facilities and urban vegetable gardens.

01 Jesus, 35, standing on the scaffold, works with a group of his friends to build a climbing frame for children in Barcelona's La Bordeta neighbourhood. Residents from the neighbourhood donated the frame's materials.

02 The Gregal soup kitchen in Besòs district serves lunch and dinner daily to the unemployed and those evicted from their homes.

03 Volunteers at Gregal soup kitchen have lunch at the end of their shift.

04 A barter market in Navas Square organised by the Poble Sec neighbourhood association.

05 Clara, 26, picks carrots from the Hortet del Forat vegetable garden in Born neighbourhood.

Photographer
MATTIA INSOLERA

01

02

03

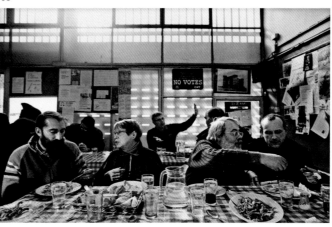

04

05

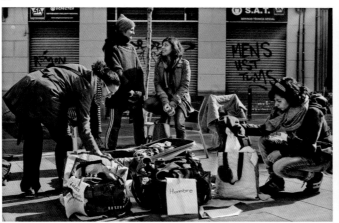

GUESNAIN, FRANCE

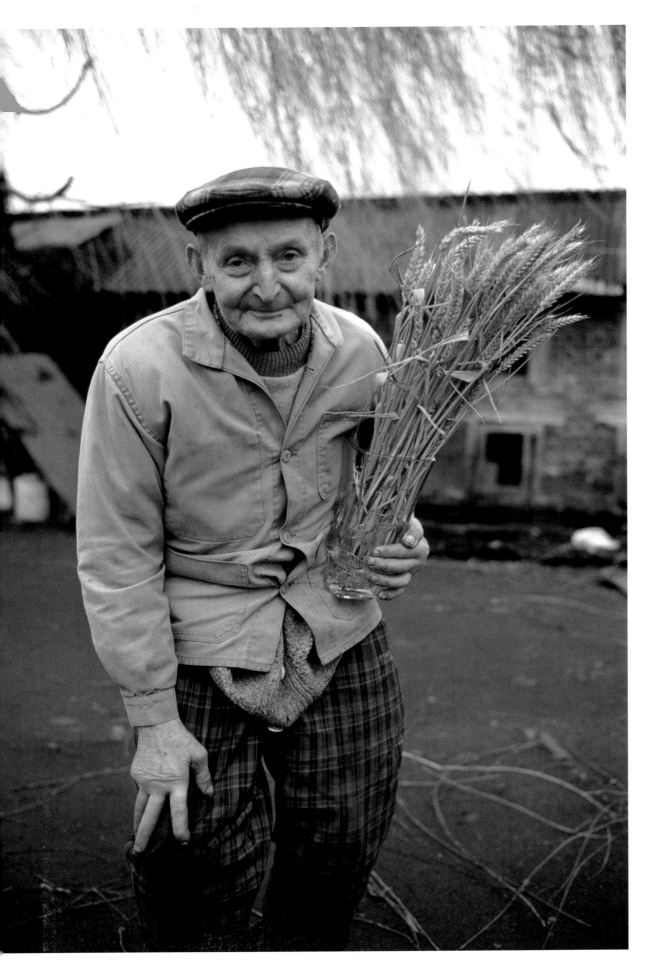

Originally from Silesia in what was then part of Germany, Albert was captured in France towards the end of the second world war. At the end of the war, Silesia was divided between Poland and Czechoslovakia, making it impossible for him to return to his home. Instead, he remained in France, working on a farm in the north of the country for more than 40 years.

An ingenious and hard-working man who made nearly all of his own tools, he was universally admired by the villagers of his adopted home. Right up until his death in 2012, his French mixed a local accent with German pronunciation.

Photographer
ERIC LELEU

FORCED MIGRATION

Eric was not the only German unable to resume life in his previous home at the end of the second world war. By 1950, between 12 million and 14 million Germans had either fled or been expelled from eastern and central Europe – by far the greatest forced migration of any people in European history.

In 1944 and 1945, many German civilians fled with the retreating German forces. After the war, Poland and the Soviet Union expelled an estimated 7 million Germans as borders were redrawn. Another 3 million were expelled from Czechoslovakia and Hungary. Millions of other Germans also fled voluntarily from Romania, Yugoslavia and other countries of southern central Europe.

Source: *Wikipedia*

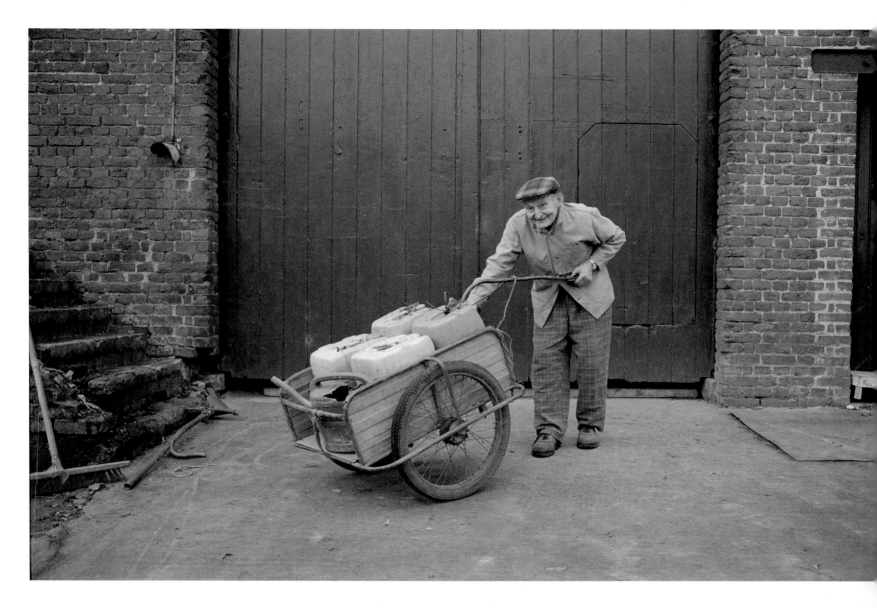

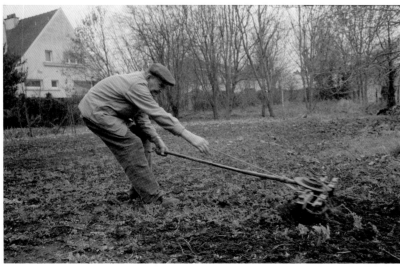

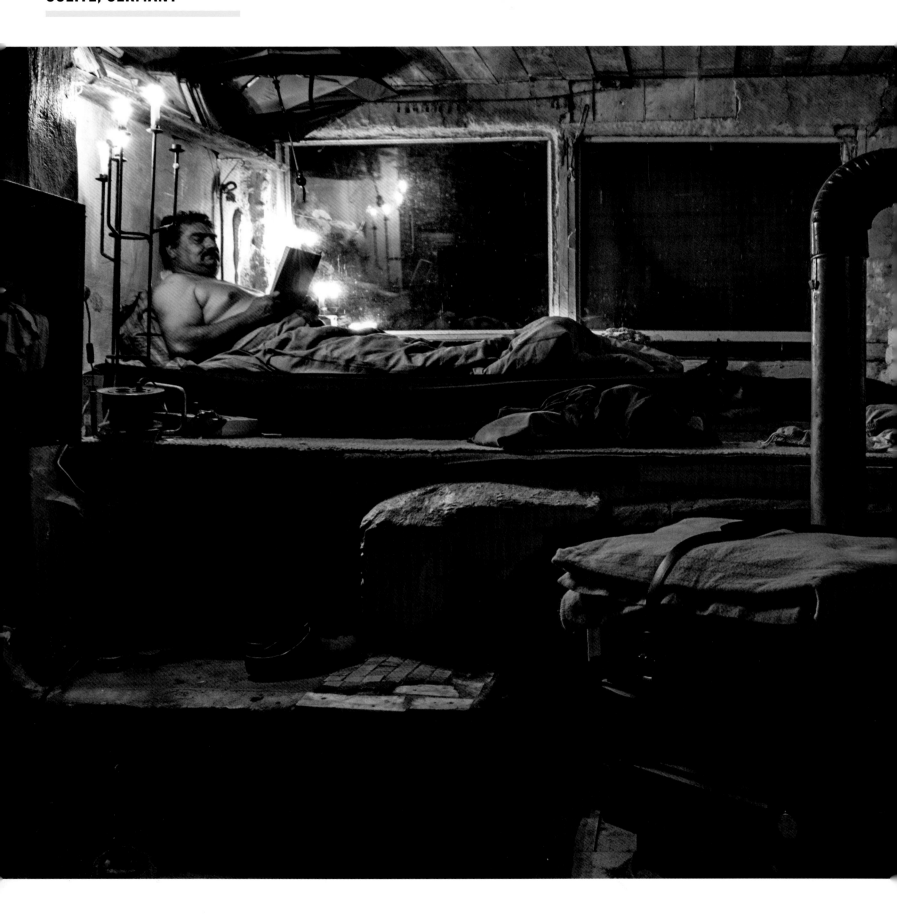

Martin, 52, lives alone in a one-room home without mains electricity or running water, one kilometre from the nearest village. Born near Bremen, he grew up in the city of Hamburg, then later lived for many years in Berlin. But, annoyed by urban hustle and consumerism, Martin moved to the country 12 years ago in search of a quieter, self-sufficient way of life after finding his current home, part of an abandoned brick factory.

Now he mostly lives off what he can raise himself. He has a small farm where he keeps sheep, cattle and poultry and grows corn, beetroot and hay. Fruit trees give him the raw materials for making juices and jams. He also produces his own sausages and shares some of his produce with nearby friends in return for vegetables or home-made bread.

01 Martin reads in bed in his candle-lit cottage.

02 The view in winter from Martin's kitchen.

Photographer
CHRISTINE DENCK

AGAINST THE TIDE

Martin's decision to move to the countryside runs counter to both German and global trends, with country dwellers in almost every part of the world leaving their homes and moving to cities. All the same, Germany's rural population accounts for a bigger share of its total population than in any other West European nation apart from Italy (32 percent) and Greece (38 percent).

GERMANY'S...

Urban population	**60.7 MILLION (74%)**
Rural population	**21.1 MILLION (26%)**

Source: *UN Department of Economic and Social Affairs*

02

01

BELARUS

When Germany invaded the Soviet Union in 1941, most of these women were between 16 and 18. For the next four years, they served as nurses, truck drivers, partisans and communications operators. At the end of the war, they were awarded medals and prizes and named "Heroes of the Nation".

As they approach the end of their lives, and despite the breakup of the former Soviet Union, their contributions are still remembered with invitations to attend parades and to visit schools to tell children about their experiences.

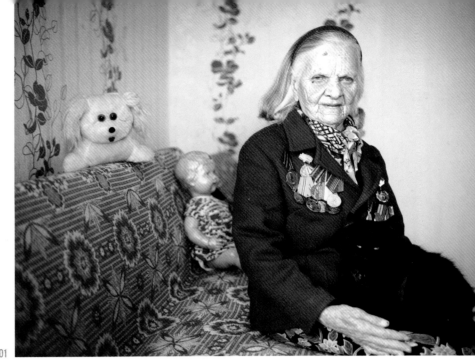

01

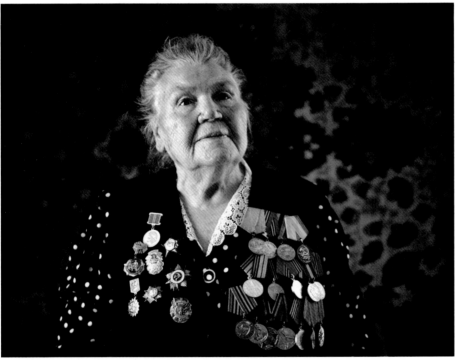

02

01 Lida Pietrovna Bondar, nurse.

02 Zinaida Konstantinovna, army communications worker.

03 Elizaveta Ivanonvna Zienievich, partisan nurse.

04 Anastasia Konstantinova Wishnievska, truck driver.

05 Maria Antonovna Pospielova, partisan.

06 Zinaida Nikolaieva Famienska, partisan.

07 Valentina Pietrovna Baranova, army communications worker, head of the veterans' union in Grodno.

08 Galina Ivanova Pagarelava, nurse.

04

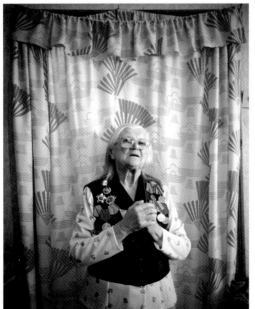

Photographer
AGNIESZKA RAYSS

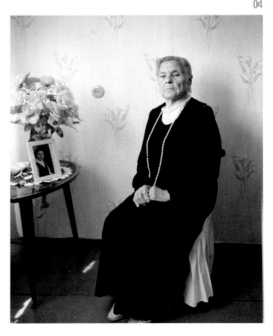

03

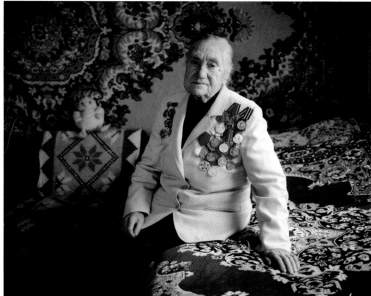

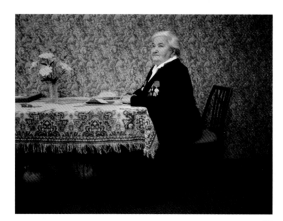

"If you're constantly living in a war, you eventually don't feel any fear because you get used to it. My parents lived through the first world war. Then 1939 came. The whole world lived in a state of war, and in some terrible way it was normal."

– LIDA PIETROVNA

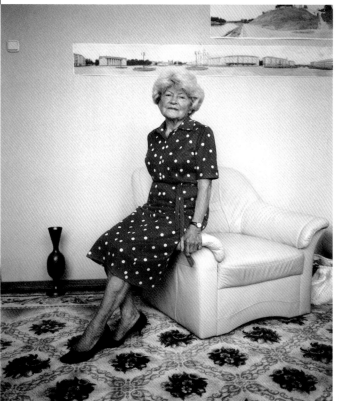

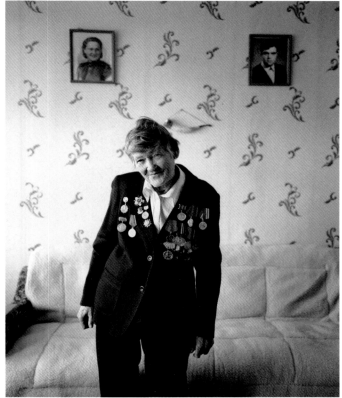

"All through the war I was a truck driver. I lived through a lot. It would be for the best if today's young people enjoyed good lives. God forbid they should go through the same things we did."

– ANASTASIA KONSTANTINOVA WISHNIEVSKA

ALEKHOVSHCHINA, RUSSIA

Sisters Aleftina and Ludmila Sablina spend half of each year in a small Russian village that has changed little over the decades. Both in their 70s, they carry on with their traditional way of life, chopping wood for heating, bringing water from the well and making their own clothes.

The sisters lived together when they were children, then worked in technical jobs: Aleftina in engineering, Ludmila in chemistry. Neither married or had children. Now they live off their pensions and some help from their other siblings. When not in Alekhovshchina, they each stay in their own apartment in separate towns, visiting each other occasionally.

Photographer
NADIA SABLIN

01 The sisters gather the last batch of strawberries in their garden.

02 Ludmila poses on a birch tree stump with a rusty sickle.

03 The sisters use a two-handed saw to cut wood. While most neighbours have upgraded to chainsaws, they continue to use tools that have been in the family for decades.

04 Aleftina and Ludmila bring planks scavenged from a sawmill reject pile. The planks will either be used to build a new fence or burned in their stove.

01

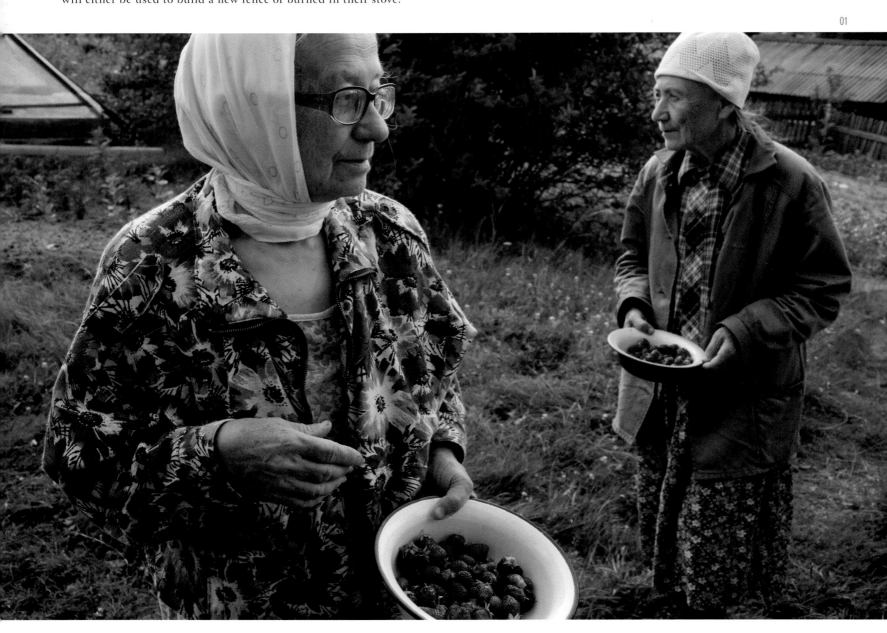

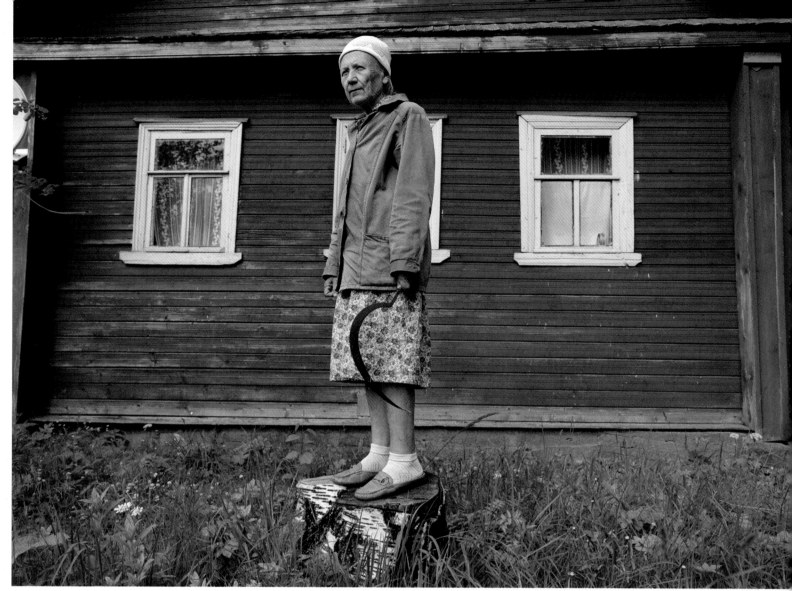

02

03

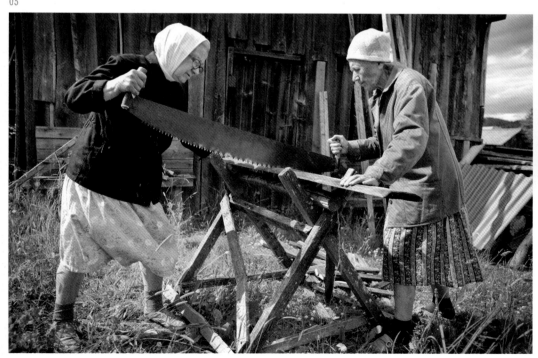

04

SAMTSKHE-JAVAKHETI, GEORGIA

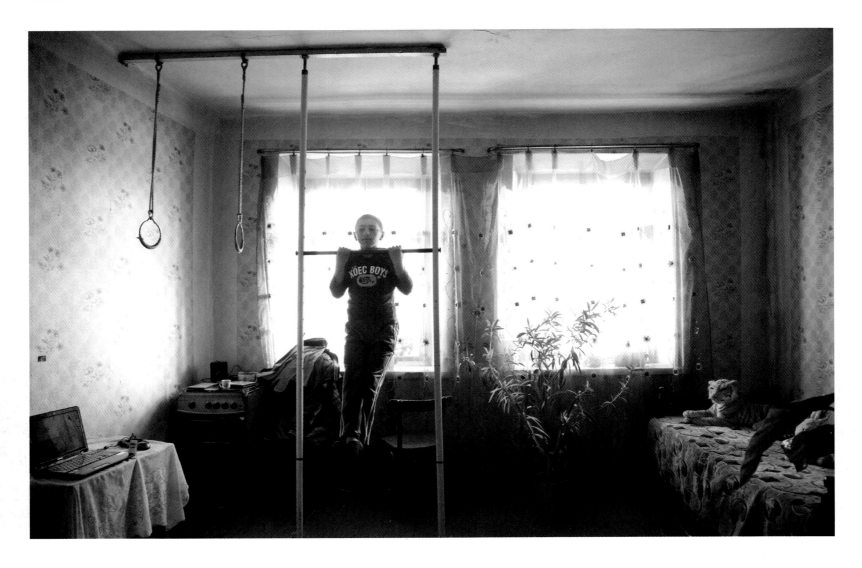

Karen exercises daily at his home in Baraleti village in southwest Georgia's mountainous Samtskhe-Javakheti region. A member of the region's majority Armenian population, he has already won many medals in school running championships.

Bordering Armenia and Turkey, Samtskhe-Javakheti is disconnected from the rest of Georgia. A few years ago, driving the 200 kilometres to Tbilisi, the Georgian capital, took nine hours. Though better roads have shortened the journey time, the region continues to struggle with a lack of investment and high unemployment. Entertainment and other spare-time options are few.

One reason for the region's underdevelopment is that Georgians account for less than one-quarter of the population; ethnic Armenians account for 55 percent, The prospects for integration of the two communities are poor. Mostly they live in separate villages, their children go to separate schools, and they each use their own language. Officially, Armenian cannot be spoken in public offices. Even in the few villages where Georgians and Armenians live together, which includes Baraleti, their lives are separate.

GEORGIA

Photographer
DARO SULAKAURI

DONETSK, UKRAINE

Aleksei Mikheev, from Dokuchaevsk village in eastern Ukraine, lost one of his legs during the battle for Stalingrad in the second world war. On his 90th birthday, he realised one of his dreams when a local parachute club offered him a free jump from one of its aircraft. He left the plane at 3,600 metres. After free-falling for one minute, he opened his parachute and descended for another four minutes before landing safely in a field.

Photographer
KONSTANTIN BUNOVSKY

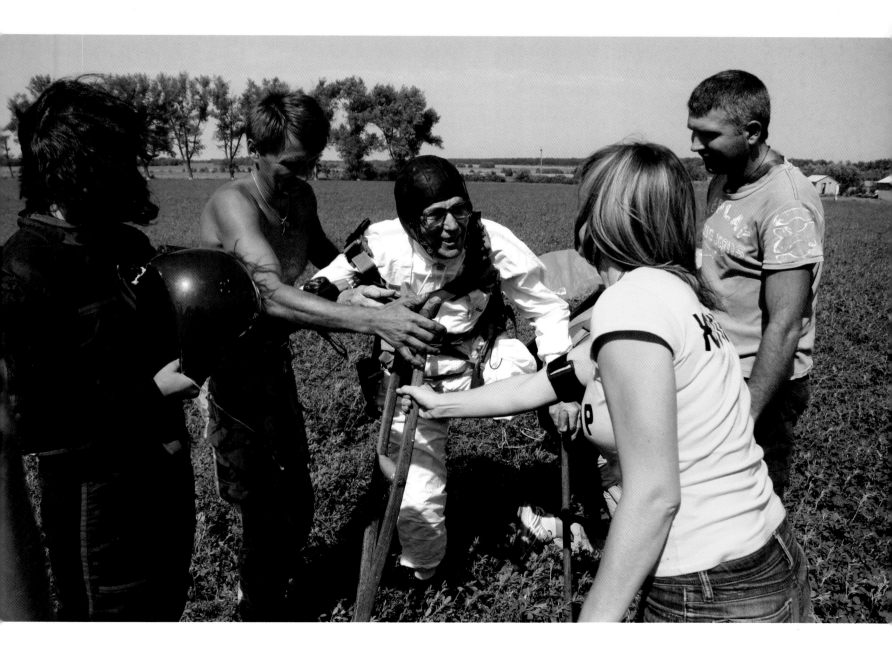

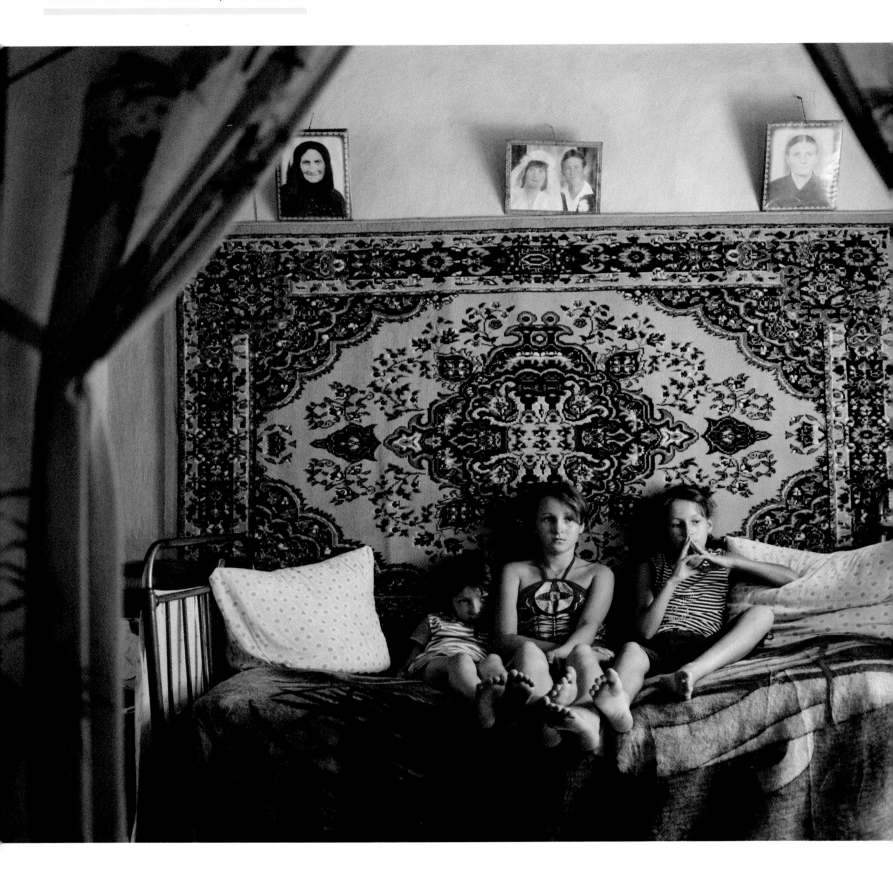

In Moldova, Europe's poorest country, 40 percent of people live below the poverty line. With jobs both scarce and badly paid, more than one-third of adult Moldovans work abroad, the highest proportion of any country worldwide. Remittances from these migrant workers preserve the country from economic collapse.

01 Olga, Carolina and Sabrina were twelve, ten and seven when their mother, Tanja, left to work in Italy five years ago. For three years they lived by themselves until other families in their neighbourhood took them in.

02 Carolina speaking with Tanja. Her mother paid traffickers €4,000 to transport her to Italy, where she earns €850 a month working illegally as a carer for elderly people.

03 A baby whose father and grandmother work in Italy.

04 Alexandra lives with her older sister in a house their mother is gradually building with money from her work in Italy. The mother left Moldova almost seven years ago, paying people smugglers €3,700 to help her make her way on foot over the Carpathian Mountains. She now earns €750 a month working as a carer for elderly people. She was unable to return home during her first three years away, but since then she has made annual trips to see her children.

05 Gabriela and Marina live with their brother, and sometimes their father. Their mother went to Italy eight years ago. For a long period they heard little from her, but recently she has started sending them occasional parcels. Their father works in Moscow, returning home between jobs.

Photographer
ANDREA DIEFENBACH

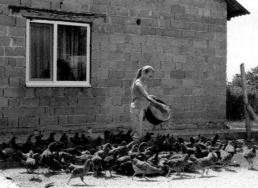

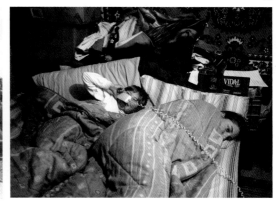

BUDAPEST, HUNGARY

We all have experience of the stresses and strains of life. Most of us cope, acquiring and using a range of tactics, attitudes and habits to navigate our way through daily life. A few go a step further and use their knowledge to help others.

01 János Branyó Baranyecz was born in Angyalföld, Budapest's poorest outlying district. As a young man, he boxed with the Hungarian national team before working as a bouncer, bodyguard and musician. Now he supports anti-poverty and anti-discrimination agencies, teaches martial arts, music and drama, and collects clothes and food for people in his neighbourhood. "I am a 'do-all man', a self-made expert by experience, a guard for the poor in the Angyalföld area... I help those excluded ones who cannot be reached in any other way," he says.

02 Tünde Szakács Mészáros, a mother of five children, works as a nurse at a residential home for the elderly run by the Catholic Church. Previously, she worked at a local government family assistance centre. She and her family have been evicted from one home and forced to leave another after it caught fire while they were out. Her life has been about helping others, but she has also needed help herself.

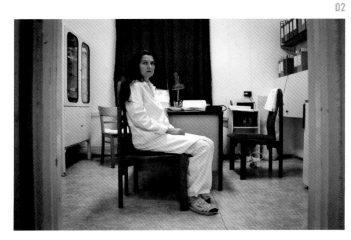

02

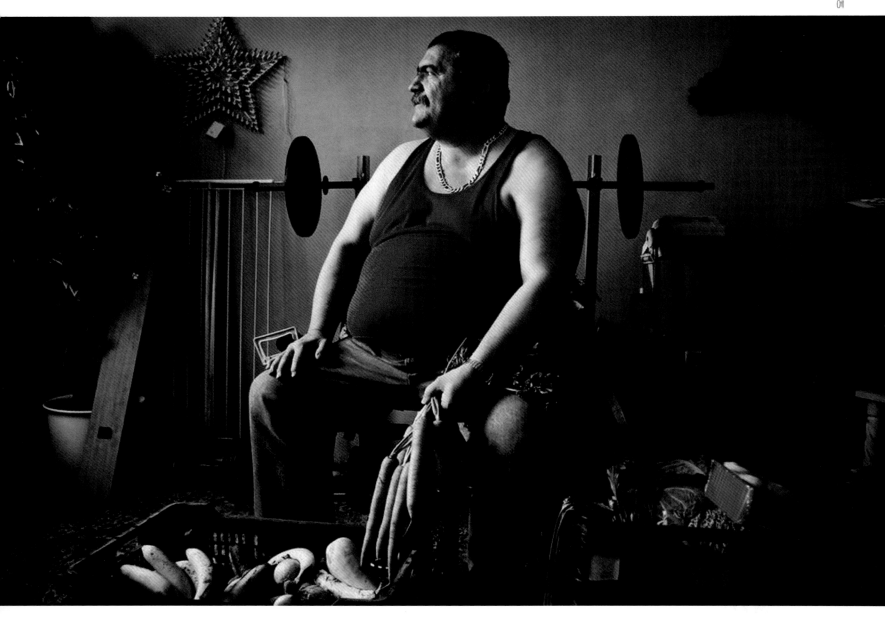

01

03 Géza Gosztonyi has degrees in architecture, sociology and psychology. But for 30 years, despite a lack of formal qualifications, he has worked as a social worker, heading Hungary's first family assistance centre, Budapest's Regional Social Welfare Resource Centre and the Hungarian Association of Social Workers. He founded Civic Radio Budapest and edited a social work magazine. He believes in an equal sharing of knowledge and power between professional helpers and those who have learned by doing. "Both those who help and those being helped can win with the inner insight of the experts by experience," he says.

Photographer
ZOLTÁN BALOGH

04 Bea Bandor has had a roller-coaster life. She has been a well-paid public administrator and a homeless mother. She has hosted a radio show about Roma culture and the social problems of the poor and worked as a cleaner. Now unemployed, with the electricity cut off in her flat, she wants to share her ups and her downs with others. "It is important for me to help others build their lives by learning from my own and my fellow sufferers' experience," she says.

Jasmin, 36, is a volunteer driver with BETAX, a voluntary car-pool for people with mobility disabilities. She works two days a week, driving people to doctors' appointments, hospital medical examinations, shops and on other errands. The rest of the week she works as a freelance window dresser.

Berne-based BETAX was founded in 1984. A nonprofit organization, it is reliant on support from volunteer drivers and funding from donations. It operates every day of the week, using 35 regular drivers such as Jasmin and 20-25 occasional ones to run its pool of 25 cars. Its customers are people with a physical handicap, some in wheelchairs, some not, of all ages.

01 Jasmin helps Erna Urben, 89, from her car. Erna lives in a residential home for elderly people. Once a week she has to go to hospital for medical treatment.

Photographer
WILFRIED HINZ

ROME, ITALY

Around 7,000 Roma live in camps around Rome. Some of the camps are legal, others not. The vast majority of these people come from families that moved to Italy more than four centuries ago. But integration with mainstream Italian society remains a problem both for them and for more recent arrivals.

Suzana, 36, was born in Bari in southern Italy, to parents from Montenegro. In Casilino 900, a camp home to Roma of Bosnian, Macedonian, Kosovan and Montenegrin origin, she was the spokesperson for the Montenegrin community. But in 2010, after complaints from local residents, Casilino 900 was closed and its families moved to other camps around the city.

Now, Suzana, her husband and their seven children, the oldest 16, the youngest three, live at a city-run camp in Salone, just outside the city, in a small mobile home with just two bedrooms and a cramped kitchen-cum-living space.

Although she was born in Italy, she says it's almost impossible for her to find a job. Through the week, she and her husband comb the streets looking for thrown-away metals and other objects. Every Sunday, she has her own stand at Rome's Via Marconi market selling second-hand crockery, paintings and other goods of value they've salvaged.

Photographer
ALFREDO FALVO

EUROPEAN COMMUNITIES

ROMA AND TRAVELLER POPULATIONS, 2010	
Romania	**1,850,000**
Bulgaria	**750,000**
Spain	**725,000**
Hungary	**700,000**
Serbia	**600,000**
Slovak Republic	**500,000**
France	**400,000**
Greece	**265,000**
Macedonia	**260,000**
United Kingdom	**225,000**
Czech Republic	**200,000**
Macedonia	**197,750**
Italy	**140,000**
Albania	**115,000**
Moldova	**107,500**
Germany	**105,000**

Source: *London Council of Europe*

SVETI AREH NA POHORJU, SLOVENIA

Hinko Sernc, 87, is a folk musician. Born in the village of Sveti Areh on
north-eastern Slovenia's Pohorje Massif in 1926, his parents owned a small
village restaurant where music was an ever-present feature of birthdays,
weddings, anniversaries and other celebrations.

Amateur musicians themselves, they started teaching him to play
various instruments when he was four. At six, he took weekly lessons in
a village three hours' walk away, carrying his accordion there and back.
In the second world war, he fought with partisans, always carrying an
instrument as well as his gun.

In the seven decades since the war, music has been his life – teaching,
performing and organising groups. For more than 40 years he has played
in the Frajhajm Brass Band. In 1995, he was named folk fiddler of the year,
and he has long been an instructor at the Šmartno Tambura Orchestra.

01 As well as playing 10 different instruments, Hinko composes folk songs
 and other pieces for the groups he plays with.

02 Hinko relaxing with a glass of wine in his home.

Photographer
MATJAZ TANCIC

02

01

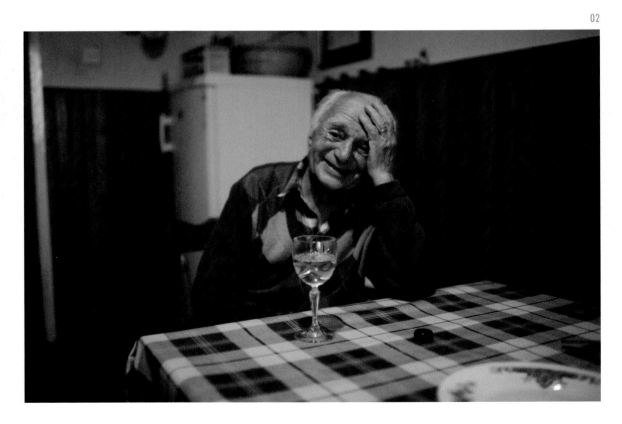

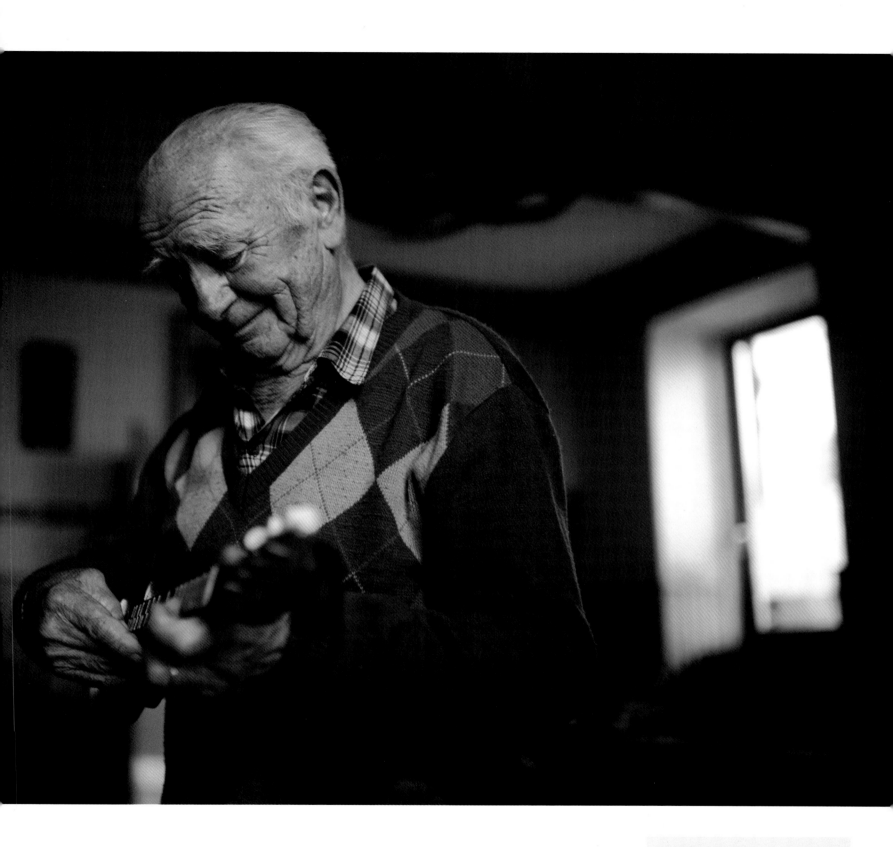

EASY LISTENING

To hear and see Hinko performing,
search for his name on YouTube.

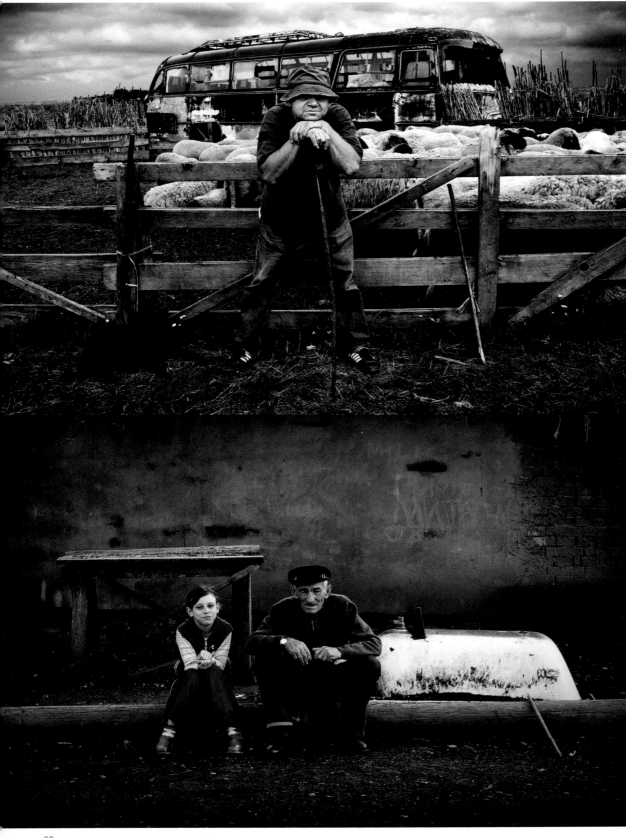

Serbia is experiencing a huge migration of people from the countryside to cities. With almost three-quarters of households employed in agriculture living below the poverty line, villages are dying, and many younger rural residents, especially in the south, are migrating to Belgrade and other cities of the north in search of work and other opportunities. But in places, some traditional customs and ways of life remain.

01 Slavko Jokic, 49, a vet in the village of Mokrin, pretends to be one of the local shepherds whose sheep he helps to keep in good health.

02 Zivko Golic chats with his granddaughter, also in Mokrin. As more and more families with young children abandon the countryside for city life, such a sight is increasingly rare in rural Serbia.

03 Mile Buncic is the only blacksmith in Basaid and its surrounding villages. He works to earn a little to support his retirement, but with few horses left in his district, he has little to do.

04 Radunka Stamenkovic, a housewife in Lipovica, starts her day with the washing up and preparing lunch. Her home has electricity, but it's only used for lighting and her radio. To heat water she still uses her wood-burning stove the whole year round.

02

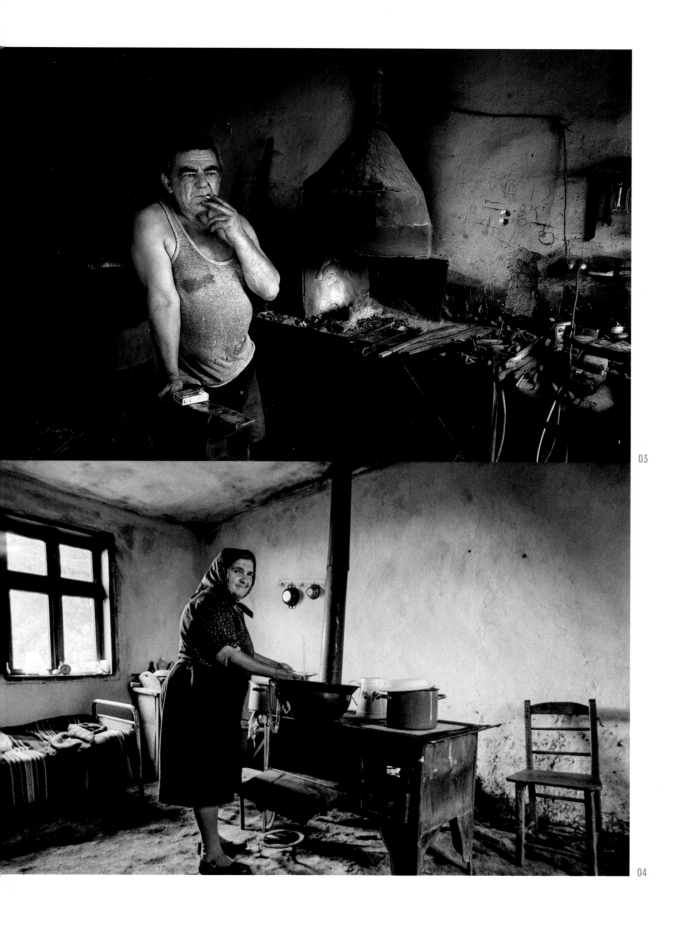

Photographer
GORAN STAMENKOVIC

03

04

GERMAN, MACEDONIA

On the second Sunday of every August, the people of the village of German, near the city of Kumanovo in northern Macedonia, dress up in traditional clothing for a day-long festival of music and dance.

According to local tradition, the village was founded by a Germanic tribe around 400-500 AD, hence its name. The 600-year-old festival began as a gathering to honour Saint Makijaveli, after whom the village's small church is named, and to mark the day on which local farmers started selling their harvest.

Today, about 100 people live in the village, most of its inhabitants having moved to cities across what was then Yugoslavia between 1950 and 1980. On the day of the festival, the villagers are swamped by visitors – 10,000 of them in 2012, many with roots in German returning to remember their ancestral home.

01 Two 17-year-old brothers dance to traditional music more than 500 years old.

02 Celebrating Saint Makijaveli.

Photographer
VLADIMIR JOVANOVSKI

02

01

RIO, GREECE

Guests dance the siritaki, a popular Greek dance, at the wedding party of Anna, 26, and Christos, 44, in Rio, near the port city of Patras. To save money, Christos decided to organise the party in his petrol station.

Photographer
NICK HANNES

COMING TOGETHER, FALLING APART

Selling petrol is unlikely to make Christos and Anna a lot of money, certainly in the short term. Greece's car sales in 2012 were down 40 percent over 2011, and after five years of decline, Greeks are buying less than half the number of cars they were in 2007.

However, they can draw consolation from the fact that, once married, Greeks tend to stay that way. The country's divorce rate is less than one-third that of the world's break-up leader, the United States.

MARRIAGES*		DIVORCES*	
China	8.3	United States	3.7
United States	7.3	United Kingdom	2.4
Brazil	6.6	Spain	2.4
Japan	5.7	Germany	2.3
Mexico	5.6	France	2.1
Ireland	5.2	Japan	2.0
Greece	4.7	China	1.9
Germany	4.6	Brazil	1.4
United Kingdom	4.4	Greece	1.2
Italy	4.0	Italy	0.9
France	4.0	Ireland	0.8
Spain	3.8	Mexico	0.7

*Per 1,000 people; 2008 and 2009.
Source: *Eurostat, UN Statistical Division*

ANTAKYA, TURKEY

For more than 2,000 years, Antakya, or Antioch, as it was known in ancient times, has occupied an important place in the Christian world. It was one of the first great centres of Christianity, becoming one of the first five patriarchates, along with Jerusalem, Constantinople, Alexandria, and Rome.

Today, its Orthodox community, numbering 1,300, continues to use Arabic as the language for its service and bibles, due to the current church being founded just before Antakya was moved from Syria to Turkey in a redrawing of borders in 1939. As in all Christian communities, Easter is the highlight of its year.

01 & 04 Jan Delluller, 66, distributes consecrated bread during Holy Communion on Easter Sunday. A native of Antakya, he has worked as a priest in the Greek Orthodox Church of Antioch since 2008.

02 & 03 As dawn approaches at 4 o'clock in the morning on Easter Sunday, members of the congregation pray together and burn scented candles that symbolise the arrival of Holy Light from Jerusalem.

Photographer
AYDIN CETINBOSTANOGLU

01

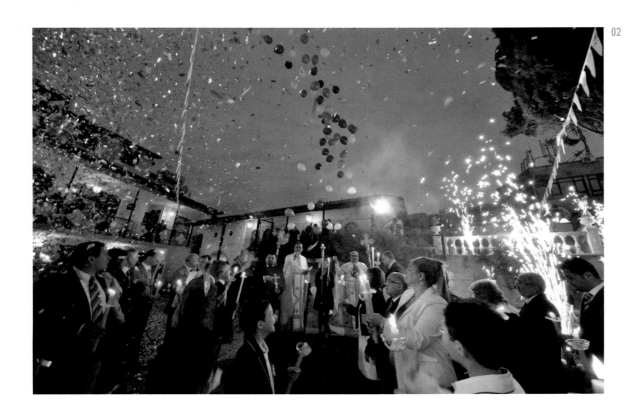

02

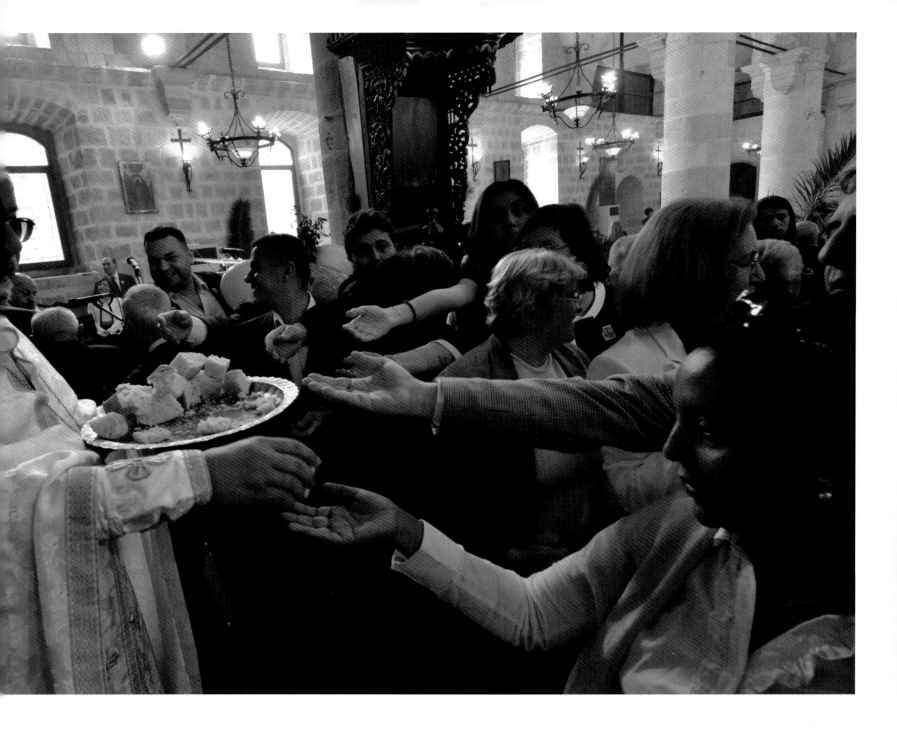

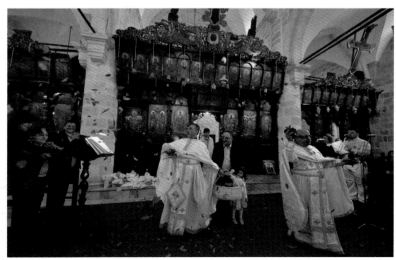

03

04

ALEPPO, SYRIA

Syria's ongoing civil war has left many people jobless. To make enough money to survive, many of these people have become traders, selling whatever they can buy or make – especially food and other essentials such fuel and clothes.

Aleppo's Souk al-Madina, the city's magnificent old commercial district – a former Unesco world heritage size with eight miles of lanes – now lies in ruins. As a result, businesses have relocated to residential areas in the west of the city. Even there, with many shops destroyed or without power, most selling is done on the street.

Syrian manufactured goods have almost entirely disappeared, replaced with imports brought in from Turkey along new trade routes running through rebel-held areas.

01 Maruan Makansi, 30, at the door of his traditional Arab cake shop near the mosque in Bustan Al Qasr district.

02 Youssef Abu Malik, a butcher outside his shop near Bab Antakia Gate, one of the seven gates of Aleppo's old city. As his shop has no power, he has to sell his stock of meat every day.

03 Abu Abdullah is a mechanic. Since his workplace was destroyed, he makes a living selling kerosene at the Jisr Al Haj bridge in southwest Aleppo.

04 Teacher and father of two Abdul Jabbar, 29, near Jisr Al Haj bridge in southwest Aleppo. With his school closed, he sells cumin bread his wife makes during the night.

05 Abdallah, an orange-seller near the mosque in Bustan Al Qasr.

Photographer
FRANCO PAGETTI

01

02

03

04

05

Yael, 66, is a former striptease dancer. Once a well-known figure in some of Tel Aviv's most glamorous nightclubs, she now lives on a small pension. She shares her tiny home-made apartment on the rooftop of a residential building with a dozen cats and three dogs, all rescued from the street. Half her monthly allowance is spent on food for the stray cats in her neighbourhood. Every night she refills plastic containers placed throughout her neighbourhood. "Give from yourself, and you will receive," she says.

01 Yael stands before the Tel Aviv skyline in the garden of her rooftop home.

02 Yael sits outside the entrance to her building, catching her breath before going up the four flights of stairs to her home. She has just completed her daily tour through the neighbourhood refilling plastic containers with water and food for the stray cats she cares for.

Photographer
MARIJN ALDERS

01

02

GAZA, PALESTINE

Jasmine Nebieh, 24, taught yoga at the Yarmuk sports stadium in Gaza City until it was destroyed by an Israeli air strike in November 2012. A student of sport psychology at Al-Aqsa University, she would like to work with children in Spain. Asked to make a wish, she says: "Peace in Gaza. To learn more sport and to practise it outside of Gaza."

Despite the ongoing conflict between the Israeli and Palestinians, people in Palestine treat education as a top priority. Literacy rates for young people – 99 percent for those aged 15-24 – are as high as in Israel and most developed countries, and comfortably above Egypt (88 percent) and Syria (95 percent). Enrolment in further education is also high, with around one-quarter of 18-24 year olds studying at the 48 universities, colleges, polytechnics and community colleges of the Gaza Strip and West Bank.

Photographer
LOULOU D'AKI

For as long as anyone can remember, fishing, particularly for tuna and hammour – the local name for grouper – was the lifeblood of Qantab, a modest village just outside Oman's capital, Muscat.

But that's changing. Villagers such as Juma Al Hasani, 50, whose family has lived in Qantab for several generations, still earn some money from selling fish to visitors or for using their boats to carry tourists on the short trip to the nearby yacht club or the Shangri-La Barr Al Jissah, a five-star resort. But most of them also have regular day jobs in the city, or like Juma, a former government worker with a wife and five children, have retired.

And now, the two-kilometre road to Qantab beach is blocked, and fences have appeared around the beach area. Construction of a hotel-resort will start soon. The Ministry of Tourism has decided developing the beach would attract more visitors and make more money. It seems likely that most or all of the beach will soon only be open to hotel guests.

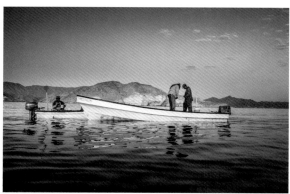

Photographer
BASEL ALMISSHAL

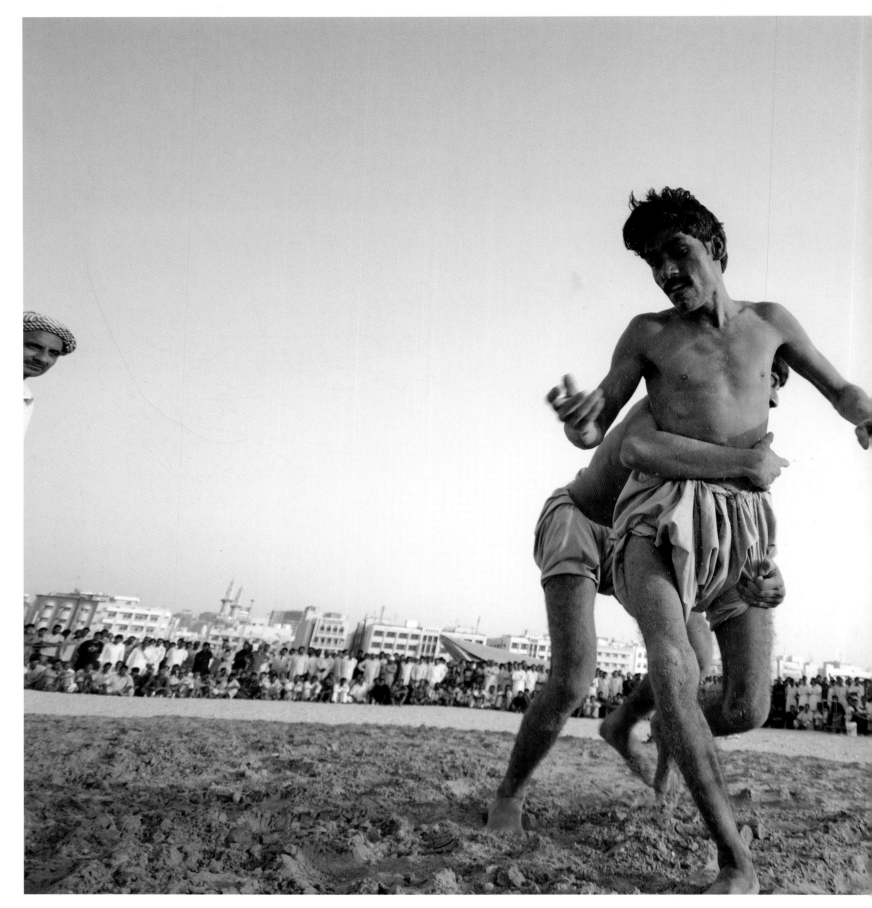

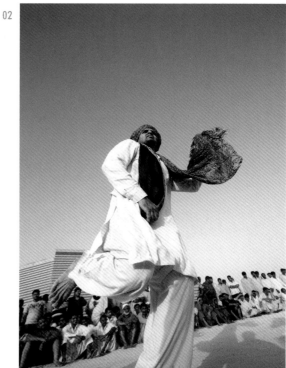

Every Friday, the day of rest in the Muslim world, under the late afternoon sun, men from across the Indian sub-continent gather at a field of sand near the fish market in Deira, Dubai. Mostly day labourers, taxi drivers or dock workers, they are part of the 7.3 million foreigners (5.7 million of them male) living in the United Arab Emirates – nearly eight times as many as the native population of 950,000.

They come to socialise with their compatriots, sometimes to play a game of cricket, but especially to enjoy a bout of wrestling, popularly known as *kushti*. For a few hours, these "sand lords" are celebrities for the transient community assembled by Dubai's construction boom. They flex their muscles for fun, entertaining and performing as much as fighting.

01 Two unknown men from the crowd amuse the audience with a light-hearted wrestling routine.

02 To the beat of a traditional *dhol*, or drum, Pehlwan Gujjar, a popular wrestler, performs a celebratory warm-up dance before a bout.

Photographer
IMRAN AHMED

YAZD, IRAN

Mohammad, 74, is a retired English teacher. He earns a little extra as a street photographer, shooting portraits of local tourists in the square before the famous Amir Chakhmaq complex in downtown Yazd, central Iran. His small backpack contains a cheap portable printer, allowing him to deliver prints on the spot.

Mohammad may not make much money, but he takes his work seriously. "Not many people know this particular place as well as I do. I know what it looks like at the break of dawn, at midday and at sunset. I know how the light and the shadows change during the day, and how to use that to shoot the best possible picture under any circumstances."

Late in the afternoon, after calling it a day and packing up his equipment, he says a quick prayer. The spot has been good to him, he says. But even if it hadn't, he would still have prayed: "Whatever crosses our path, it is not up to us to judge whether it is good or bad. There's someone else out there doing the judging for us. We should be thankful for that and have faith, no matter what happens."

Photographer
GUIDO DINGEMANS

IRAN

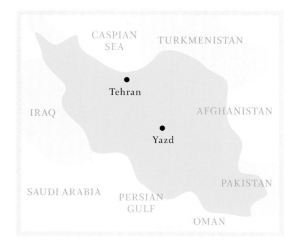

AFTERWORD

Amy Goodman

AFTERWORD

Amy Goodman

Show the pictures. Tell the story. This is the job of reporting. The role of journalism is to cover those in power, not to cover for power. To cover power, we must cover those who hold power and who exert power over others. But we must also seek the sources of grassroots power, to investigate and understand people whose daily lives are in their own way powerful, but who are typically marginalised or ignored by the media. These are the people so movingly presented in the pages of this book.

Unfortunately, the elite media, especially in the United States, have long enjoyed what I call the "access of evil", trading truth for access. In the wealthiest, most powerful country in the world, we have a media system that focuses on celebrity and scandal. This grim aspect of the US system has become one of our worst exports, infecting media landscapes the world over.

Turn the pages of this book. What do you see? One image – on page 26 – is of a child smiling that seems like it could have been taken anywhere. But there's a reason for including her, once you know the story behind her country, Timor-Leste, and its recent history. It is a nation I know well. It was occupied for centuries by Portugal. In 1975, after Portugal pulled out, the Indonesian military invaded, with US approval. The Indonesian regime began a brutal occupation, killing more than 200,000 Timorese – over a third of the population.

In 1991, I went to East Timor, as it was then known, with journalist Allan Nairn. We were covering a peaceful march of Timorese, a nonviolent action that was almost unheard of under the occupation. Outside the cemetery walls in Dili, East Timor's capital, Indonesian soldiers marched on the procession, 15 abreast, their US M-16s at the ready. Without warning or provocation, they opened fire, killing men, women and children indiscriminately. Allan and I were beaten by them. They used their rifle butts like baseball bats, fracturing Allan's skull. Then they held the barrels of their guns against our heads. The Indonesian military had killed journalists before. I threw my US passport at them and they pulled the guns from our heads, because, we think, we were from the same place as their weapons. They would have paid a price for killing us that they never had to pay for killing Timorese.

The Indonesians killed over 270 Timorese that day – not one of the largest massacres on East Timor. Allan and I survived and made our way to Guam, where we were able to report on what happened. Major networks covered the massacre – the first time that East Timor was mentioned on a major network broadcast since the invasion in 1975. Timorese in exile, along with allies around the world, built a grassroots movement, the East Timor Action Network, creating pressure that contributed to East Timor gaining its independence. The story of genocide, of struggle, of liberation, and the hard work of building a nation, literally from burning ruins, all underlie the image you see here of that smiling child.

With each photo in this book, with each turn of the page, we find a new world, an opening into the vast tapestry of experiences and struggles, joys and

agonies, that comprise our human experience. We see the lives of the planet's majority, people from the world of what the protesters at Occupy Wall Street called "the 99 percent".

For the most part, these people's lives are ignored or dismissed by the elite media. We need to reverse this. The media are among the most powerful institutions on earth – far more powerful than any bomb or missile – because through it we learn about each other and the rest of the world. As our numbers grow from 7 billion now to 9 billion or more expected mid-century, and as human activity causes unprecedented global warming, the problems we face will get harder to solve. This demands an independent media system that works for all – not one brought to you by corporations that profit from war or promote the interests of the top 1 percent over those of everyone else.

Journalism is often said to be the first draft of history. But what if they gave a protest and no one reported on it? This is the problem faced by social movements, by people who take risks and organise under duress or march against entrenched power. Too often their actions are ignored and consigned to obscurity by a mass media beholden to those in power. The history of social advancement in the United States and around the world is the history of social movements. The greatest advances have been brought about by activists, building grassroots movements.

Take Rosa Parks – a member of The Other Hundred if there ever were one – whose arrest in 1955 for refusing to give up her bus seat to a white passenger catalysed the US civil rights movement. When she died in 2005, the media said "Rosa Parks was just a tired seamstress, no troublemaker". That's where they got it wrong. She was a first class troublemaker. For more than a decade before her arrest, she had challenged racist laws from her post as secretary of the local chapter of the National Association for the Advancement of Colored People. Her arrest did not happen in a vacuum. Immediately after, her friend Jo Ann Robinson – another troublemaker – mimeographed 35,000 leaflets that began the Montgomery bus boycott. Within a year, the city's transport system was integrated.

We need more such troublemakers, and we need more reporting of the trouble they create. Imagine, if for just one week, we saw the images of war in Iraq, Afghanistan or any of the under-reported conflict zones around the globe above the fold on newspaper front pages and at the top of every newscast – babies dead on the ground, soldiers dead and dying, women with their legs blown off by cluster bombs. People are compassionate. They would say war is not the answer to conflict in the 21st century.

But that's not the only story the world needs to hear. We also need the stories of those who are – despite the odds – creating their own successes on their own terms, not those of the elite media. This book has many such stories. Its publication shows we have the means to create a new media system that works for all – not one brought to you by corporations focused on war, the pursuit of profit and vacuous reporting of celebrities.

THE PHOTOGRAPHERS

The Other Hundred

IMRAN AHMED (UNITED ARAB EMIRATES)

Born in Bangladesh, Imran Ahmed has called the United Arab Emirates his home since 1976. He began taking street photographs in 2009. A book featuring his work, *Dubai Creek*, was published in 2012. He currently works for a global investment bank in Dubai.

MARIJN ALDERS (ISRAEL)

Marijn Alders is a documentary photographer and journalist. Many of her photostories concern issues of identity and the aftermath of war, conflict and migration, showing beauty and everyday life under unusual circumstances.

BASEL ALMISSHAL (OMAN)

Basel Almisshal is an award-winning architect, artist and professional photographer who currently runs his own design studio in the Middle East. He is the founder of the "Capture the Spirit of Ramadan" International Photography Competition, an initiative aimed at using the art of photography to remove misconceptions about cultures and religion.

RICARDO AZOURY (BRAZIL)

Ricardo Azoury is a Brazilian photojournalist.

ZOLTÁN BALOGH (HUNGARY)

Hungarian Zoltán Balogh is a self-taught photographer. Since taking up photography in 2006, he has won awards in national and international competitions, exhibitions and festivals. In 2008, MAFOSZ, the Hungarian National Association of Photographic Artist Groups, named him its Photographer of the Year, and he became a member of FFS, its Studio of Young Photographers. In 2009, he took up freelance photography, working on a variety of projects including landscapes, travel and documentaries. His work has been seen worldwide at exhibitions and in magazines and books.

KECIA BARKAWI (TANZANIA)

Kecia Barkawi, 44, is a business owner with a passion for travelling and photography. She speaks five languages, is married and has masters degrees in both law and business administration.

TANYA BINDRA (SENEGAL)

Tanya Bindra is a freelance documentary photographer and writer based in Bamako, Mali.

CHRISTIAN BOBST (ARGENTINA)

Christian Bobst, born in 1971 in Switzerland, studied graphic design and then worked for almost 15 years as an art and creative director for major advertising agencies in Switzerland and Germany. He then decided to switch focus to documentary photography and photojournalism. Based in Zürich, he works as a freelance photographer and art director.

DEIRDRE BRENNAN (IRELAND)

Irish photographer Deirdre Brennan worked as a photojournalist and documentary photographer in New York for more than a decade before returning to live in Dublin in 2008. On contract with *The New York Times* since 2000, her work has also been published worldwide in *Newsweek, Stern, Marie Claire, Panorama, American Photography, The Smithsonian, The Sunday Times (London)* and *The Wall Street Journal*.

ANZOR BUKHARSKY (UZBEKISTAN)

Anzor Bukharsky was born in 1968 in Tashkent, Uzbekistan, but has lived in Bukhara since 1975. He is a documentary photographer whose main theme is the daily life of ordinary people, often in the countryside. Photographing Uzbekistan's Luli people is a project he has worked on for the past six years.

TESSA BUNNEY (LAOS)

Tessa Bunney is a documentary photographer with a particular interest in landscapes and the way they are shaped by human activity. She is currently based in Vientiane, Laos, where she freelances for non-government organisations as well as working on project titled "Field, Forest and Family" supported by Arts Council England.

KONSTANTIN BUNOVSKY (UKRAINE)

Konstantin Bunovsky is a reportage and documentary photographer. His primary aim is using photographs of ordinary people to show the life of the city, the region and the country.

ROBERTO CACCURI (INDIA)

Roberto Caccuri was born in 1975. Since 2000, he has worked with photojournalistic agency Contrasto producing reportage focused on environmental issues in Italy and other countries.

AYDIN CETINBOSTANOGLU (TURKEY)

Aydin Cetinbostanoglu was born in 1954 in Izmir, Turkey. A student of political sciences and history in Ankara, his photographic life began as an apprentice to a master photographer in the late 1960s. He started his career as a professional photographer in 1973. People are his favourite subject.

CHEN JIANHUA (CHINA)

Chen Jianhua is a photojournalist based in Shenzhen, China. His work currently focuses on documenting rural-urban migration and the lives of China's younger generation.

DERICO COOPER (LIBYA)

Derico Cooper is a professional photographer. A former US Marine staff sergeant, he served almost 10 years on active duty receiving an honourable discharge. A certified rescue diver, he specialises in underwater photography, war photography and other genres.

LOULOU D'AKI (PALESTINE)

Loulou d'Aki was born and raised beside the sea in Sweden. Currently based in the Middle East, her passion is youth – the age of infinite possibilities. "Photography is my way of telling stories I feel should be told," she says.

GREGORIO B DANTES JR (PHILIPPINES)

Gregorio B Dantes Jr is a freelance photojournalist for news agencies, a visual artist and a freelance photography lecturer. A person with a disability, he has paralysis in his left hand as a result of polio.

RODNEY DEKKER (KIRIBATI)

Rodney Dekker documents what he believes to be one of the most important issues of our time, climate change. This ongoing project has taken him to the rural outback of Australia, to remote villages in Bangladesh and to the tiny islands of the South Pacific. "I've documented how livelihoods are being impacted by climate change, and how people are responding," he says.

JAMES WHITLOW DELANO (MALAYSIA)

James Whitlow Delano is a reportage photographer based in Japan for 20 years. He is about to publish his fourth book.

CHRISTINE DENCK (GERMANY)

Bored by the flood of illusory gloss in the mainstream media, Christine Denck is on the search for the lost happiness. "Often I find a glimpse of a less popular reality behind everyday life," she says.

BIEKE DEPOORTER (USA)

Born in 1986, Bieke Depoorter received her master's degree in photography from the Royal Academy of Fine Arts in Ghent in 2009. She mostly works on independent projects. In search of family intimacy, she spends the night at people's houses. Currently she is working on "I am about to call it a day", a project in the United States. In 2012, she became a nominee member of Magnum Photos.

ANDREA DIEFENBACH (MOLDOVA)

Andrea Diefenbach is a German photographer who works for magazines and on personal projects. Her work about labour migrants from Moldova and the children they leave behind has just been published as a book, *Land Ohne Eltern* (Land Without Parents).

GUIDO DINGEMANS (IRAN)

Guido Dingemans is a freelance travel photographer. His work is focused almost exclusively on his fellow human beings and their daily routines and rituals. When not on the road, he lives in Tilburg, the Netherlands.

AIDAN DOCKERY (BHUTAN)

Aidan Dockery is a British photographer based in Southeast Asia. He photographs humanitarian projects, events and weddings.

KIERAN DODDS (UGANDA)

Kieran Dodds, born in 1980 in the United Kingdom, studied zoology before becoming a professional photographer. His work explores the role of the environment in human identity and culture. A particular focus is the beauty of the world and the suffering that pervades it.

JIA HAN DONG (USA)

Jia Han Dong's passion for photography started more than 30 years ago in high school. "No two people see this world in the same way," he says. "In this digital age, it is crucial that we document those lifestyles around us that will soon disappear."

GWENN DUBOURTHOUMIEU (SIERRA LEONE, DEMOCRATIC REPUBLIC OF THE CONGO)

Gwenn Dubourthoumieu became interested in photography while working in Africa for non-governmental organisations. He started working in the Democratic Republic of the Congo in 2007. From 2010 to 2012, he worked as a professional photographer in Kinshasa for, among others, Agence-France Presse. He recently moved to Paris.

ANDREW ESIEBO (LIBERIA)

Andrew Esiebo is known for his visual stories and reportages on religions, urban spaces, culture, sexuality and football. He has worked with non-government organisations, cultural institutions, universities and magazines. His work has appeared in many exhibitions and international journals and magazines.

ALFREDO FALVO (ITALY)

Alfredo Falvo studied at the International Center of Photography in New York. In 2005, he documented the difficult reality of life on *Los Angeles'* "Skid Row", a work that subsequently was made into a book, *Lost Angels*, and was awarded first prize in the International Photography Award for 2010. He is represented by Contrasto photo agency.

MARCO GAROFALO (NIGERIA)

Born in Milan in 1976, Marco Garofalo is a social and cultural photographer working for international magazines and social projects. He divides his time mainly between Italy and Africa.

PETER GOSTELOW (MOZAMBIQUE)

Peter Gostelow is an English teacher and adventure cyclist with a strong passion for exploring the roads less travelled.

RACHEL GOUK (CHINA)

Rachel Gouk is a self-taught photographer based in Shanghai. Her work covers a diverse range from street photography to fashion spreads. Currently, she supports the underground music scene in Shanghai by photographing live performances, filming music videos and producing mini-documentaries. Her website is www.rachelgouk.com.

MAREIKE GÜNSCHE (MONGOLIA)

After working as a press photographer in Berlin, Mareike Günsche studied photography in Hannover, Berlin and Hamburg. Her diploma work, "Dragkings", was awarded the Canon Award for Young Professionals. Since 2009, she has lived and worked in Mongolia. Her website is www.mareike-guensche.com.

ROBYN GWILT (SOUTH AFRICA)

Robyn Gwilt is a Johannesburg-based photographer, wife, mother, sister, friend and lover of life.

NICK HANNES (GREECE)

Nick Hannes is a documentary photographer based in Belgium who mostly works on long-term, self-initiated projects on social and political issues. His first book, *Red Journey*, was about transition in the former Soviet Union. In 2010, he started work on a new book, *The Continuity of Man*, a documentary about the Mediterranean region.

THE PHOTOGRAPHERS

The Other Hundred

THOMAS HECKNER (CUBA)

Thomas Heckner enjoys travelling and meeting people of different cultures to find out about their ways of living and surviving. "If my protagonists let me take part in their everyday life, I'm happy." he says.

LIZ HINGLEY (UNITED KINGDOM)

Liz Hingley's socially engaged work is grounded in her photographic and social anthropological education. She is a member of Agence Vu and affiliated with universities worldwide. Her award-winning book *Under Gods* was published in 2011. Her images and writings are regularly exhibited and published in magazines and journals internationally.

WILFRIED HINZ (SWITZERLAND)

Wilfried Hinz was born 1959 in Berne, the Swiss capital. He lives with his wife and two children in Belp, near Berne. About his photographs he says: "I always found it fascinating, to capture a split second for eternity by taking a picture of it. Whenever I look at a picture afterwards, the whole range of emotions that I felt when I took it is present again."

MATTIA INSOLERA (SPAIN)

"I use photography to represent reality rather than just documenting it."

JIA DAITENGFEI (CHINA)

Jia Daitengfei was born in China 1986. He works for the *Changjiang Daily* in Wuhan. In 2012, he took part in the World Press Photo Joop Swart Masterclass. His website is www.jiadaitengfei.com.

VLADIMIR JOVANOVSKI (MACEDONIA)

Vladimir Jovanovski was born in 1983 in Kumanovo, Macedonia. He inherited his love and foundation in photography from his father, Dusko Jovanovski, one of the founders of Macedonian modern art photography. He has won many international awards, and in 2009 was elected president of the Photo Association of Macedonia. In 2010, he was elected president of the Switzerland-based International Association of Art Photographers, and in 2012, he was elected as the Macedonian representative for Image Sans Frontière.

JONATHAN KALAN (RWANDA)

Jonathan Kalan is an award-winning independent photographer and journalist. He covers innovation, technology, startups and hidden stories of creativity in emerging economies.

SASWATA KAR (INDIA)

Photography, painting and creative writing have been Saswata Kar's passion from a very young age. Currently an information technology consultant, Saswata Kar's ambition is to be a photographer and writer.

THEODORE KAYE (TAJIKISTAN)

Theodore Kaye is a documentary photographer covering south, central and east Asia. As a mixed-race American, culturally and linguistically fluent in Chinese and various Turkic and Persian languages, he can "go native" from Istanbul to Okinawa.

CHRIS KEULEN (ERITREA)

Chris Keulen is a Dutch documentary photographer, interested in and concerned by the small stories of daily life. His website is www.chriskeulen.com.

SARAH KINDERMANN (COLOMBIA)

Daughter of a Venezuelan mother and a German father, Sarah Kindermann was raised in a village near Tübingen in Germany. Since 2004, she has lived and worked in Berlin as a photo assistant for various well-known German photographers. In 2010, she was awarded a degree from Berlin's Ostkreuzschule für Fotografie.

SILKE KIRCHHOFF (CHILE)

Silke Kirchhoff's focus as a freelance photographer lies on documenting the social and political circumstances of human beings, especially those fighting for justice, self-determination and human rights. In 2008, she graduated with a degree in photography and photojournalism from the University of Applied Sciences and Arts in Hannover, Germany.

RICHARD KOH (MYANMAR)

Richard Koh considers photography a mystical art where "one harvests light from above". Since leaving a career in engineering research in 2003, his photography has won him multiple awards from the Paris Photo Prize and International Press Association, among others. He runs Amaranthine Photos, focusing on documentary and editorial work, including aerial photography. His website is www.amaranthinephotos.com.

EDWIN KOO (SINGAPORE)

Edwin Koo is a Singaporean documentary photographer best known for his black-and-white imagery. His subjects range from Pakistan to Singapore, often exploring themes of home and displacement.

ANNA KORTSCHAK (GUATEMALA)

Anna Kortschak is travelling the world by bicycle documenting what she sees. She has lived and worked in Australia, Brazil, the United Kingdom, the Czech Republic and Panama, launching a number of participatory media projects with young people in various communities.

LEO KWOK (HONG KONG)

Leo Kwok is an enthusiastic amateur photographer whose goal is to touch people's hearts with his photographs.

ERIC LAFFORGUE (NORTH KOREA)

Since he was young, faraway countries and travelling have fascinated Eric Lafforgue. He took up photography in 2006. His work on North Korea, Papua New Guinea, Ethiopia and other countries has appeared in magazines and newspapers worldwide.

ERIC LELEU (FRANCE)

Eric Leleu is a photographer based in Shanghai, China. His work ranges between documentary, conceptual and fine art photography.

VALERIE LEONARD (MALI)

Valerie Leonard has always lived surrounded by images. Her mother was a painter and her father, Herman Leonard, a photographer. Whenever she presses the shutter button, she recalls her father's words: "Always tell the truth, but in terms of beauty." Her work focuses on the search for truth and beauty and showing the dignity and courage of people living and working in hostile environments. Her awards include first prize in the Photo par Nature competition (2011) and National Geographic Photographer of the Month (April 2012).

RICHARD LEONARDI (NICARAGUA)

Richard Leonardi is a US-born freelance photographer based in Nicaragua since 1996. His photographic work has been published in Europe, Latin America and the US. To see more of his work, visit www.nicaraguaphoto.com.

LY HOANG LONG (VIETNAM)

Ly Hoang Long is a freelance photographer specializing in travel and landscape photography. His website is www.lylongphoto.com.

BERETTE MACAULAY (JAMAICA)

Berette Macaulay is an award-winning photo-based artist. Originally from Sierra Leone, she was raised in Jamaica and the United Kingdom, and now lives in New York. A television and theatre actor and dancer before switching to visual arts, her curiosity and work are influenced by her mixed cultural and artistic background.

TOBIAS SELNAES MARKUSSEN (BANGLADESH)

Tobias Selnaes Markussen is a documentary photographer trying to cover the weird and complex world we live in.

JENNY MATTHEWS (AFGHANISTAN)

Jenny Matthews is a photographer and teacher. Since 1982, she has documented social issues, focusing in particular on the lives of women. She is currently working on a project titled "Women and War".

SERGEY MAXIMISHIN (KENYA)

Sergey Maximishin is a freelance photographer and photojournalism teacher. He works with Focus (Germany) and Panos Pictures (United Kingdom) photo agencies.

MARTIN MIDDLEBROOK (AFGHANISTAN)

Martin Middlebrook is an English photojournalist. He describes himself as above all a "humanitarian photographer", as he believes this offers the best way of representing the human condition most honestly in his images.

JAMIE MITCHELL (NEPAL)

Jamie Mitchell is a student at college in Glasgow. His main photographic interests are landscape and travel.

FERNANDO MOLERES (EGYPT)

Fernando Moleres was born in Bilbao, Spain in 1963. A self-taught freelance photographer, he mostly works on his own projects.

VIVIANE MOOS (BRAZIL)

Viviane Moos is an international photographer. Her work centres on visual communication and storytelling about the world we live in.

FLORIAN MÜLLER (SRI LANKA)

"Following the tradition of humanistic photojournalism, I feel strongly committed to concerned photography and express my respect and empathy through this powerful medium. As good images take time and understanding, I like to work intensively on deeper-perspective projects to raise awareness and responsibility on social grievances."

CELESTE ROJAS MUGICA (BOLIVIA)

Celeste Rojas Mugica, born in Chile in 1987, is a photographer and visual artist. Her art centres on the issues surrounding identity, life and absence, and has been exhibited at exhibitions and in publications in Chile, Uruguay, Argentina, Brazil, the US and the UK, among others. Her last creation, "El espacio de la resistencia", was a multidisciplinary work of imagery created in Latin America. Her website is www.celestrip.com.

MOHAMED MUHA (MALDIVES)

Mohamed Muha is a freelance photographer based in the Maldives. He specialises in travel and hospitality photography.

TOMÁS MUNITA (PERU)

Tomás Munita, born in Chile in 1975, is an independent documentary photographer primarily interested in social and environmental issues. He has worked in Latin America, Afghanistan, India and the Middle East. He has received numerous awards, among them three World Press Photo prizes.

SHEHZAD NOORANI (MALAWI)

Shehzad Noorani worked as a documentary photographer with a special focus on social issues affecting the lives of urban poor and marginalized children for more than 20 years in over 60 countries. His work has appeared in *Geo Magazine*, *Newsweek*, *The New York Times*, *Le Monde*, *Marie Claire*, *The Independent*, *New Internationalist*, *The Guardian*, *International Herald Tribune* and *British Journal of Photography*, as well as featuring on the BBC and Canadian Broadcasting Corp.

FRANCO PAGETTI (SYRIA)

"Conflict situations attract me because they afford the opportunity to observe people and societies in extremis – under tremendous duress. This brings out the best and worst in people. With my pictures I hope to capture both the incredible heroism and the grisly brutality of war zones. War and its aftermath seem to affect vastly different societies in almost exactly the same way. This is why I want to be there."

SAM PHELPS (PAKISTAN)

Sam Phelps is an Australian based in Pakistan. He works in documentary and portrait photography.

SANDRA PHINNEY (CANADA)

Sandra Phinney is a freelance journalist and photographer. Her work celebrates the extraordinary lives and stories of ordinary people. Often drawn to nature and the outdoors, she can sometimes be found paddling in the wilderness.

ANDREW QUILTY (FIJI)

Andrew Quilty is an Australian photographer whose career includes commissions from *Time*, *GEO* and *The New York Times* to cover the Queensland floods, Black Saturday bush fires, Cyclone Yasi, and Hurricane Sandy. He is a member of the Australian photographic collective, Oculi, and the recipient of many awards, including a World Press Photo Award and the Walkley Young Australian Photojournalist of the Year in 2008.

ARI JALAL RAFA'AT (IRAQ)

Ari Jalal Rafa'at is a professional photographer based in Duhok, Iraq, whose work centres on portraying people's experiences of life.

THE PHOTOGRAPHERS

The Other Hundred

AGNIESZKA RAYSS (BELARUS)

Agnieszka Rayss is a freelance photographer based in Warsaw, Poland. A multiple award winner, including World Press Photo Picture of the Year awards in 2011 and 2012 and a two-time finalist for the Hasselblad Masters Award, she is also the creator of *American Dream*, an album about pop culture in Eastern Europe. Her portfolio can be seen at www.agnieszkarayss.com.

ALEJANDRO REINOSO (ECUADOR)

Alejandro Reinoso is a self-taught photographer interested in the relations between people and their environment. Initially a student of business administration, he switched to multimedia design. "I chose what I like to do," he says.

REZA (GHANA)

Working for *National Geographic* since 1991, Reza Deghati has travelled to more than 100 countries, photographing conflicts, revolutions and tragedies, but also humanity's beauty. He has started photographic training programs around the world since 1983. In 2001, he founded Ainaworld, a non-governmental organisation committed to children's education and the training of women in communications.

ANA MARIA ROBLES (URUGUAY)

Ana Maria Robles is a veterinary medic whose passion is photography. "I like to know the stories and the diversity of ways of life of people. We may look different, but in essence, we are one," she says.

THOMAS ROMMEL (BURKINA FASO)

For Thomas Rommel, taking photographs is a way to tell stories in a more emotional way than writing them down. "Also, when I tell stories with words, I can't keep it short!" he says.

RUDDY ROYE (USA)

Jamaican-born, Brooklyn-based photographer Ruddy Roye seeks to make sense of his environment through photography.

MITI RUANGKRITYA (CAMBODIA)

Miti Ruangkritya, born in Thailand in 1981, was named among the Selected Winners and Honourable Mentions in the UK's Magenta Flash Forward – Emerging Photographers awards in 2011 & 2012, and won the Silver Medal at the Prix de la Photographie in 2012.

NADIA SABLIN (RUSSIA)

Nadia Sablin was born in the Soviet Union and spent her adolescence in the American Midwest. She now divides her time between Brooklyn, New York and Saint Petersburg, Russia. Her photographs have been shown at the Philadelphia Art Museum, Griffin Museum of Photography, and Jen Bekman gallery, among others.

PHILIPPE SCHNEIDER (PAPUA NEW GUINEA)

Philippe Schneider was born in France in May 1967. In 1998, he found his calling as a humanitarian aid worker. "I have been exposed to the spectrum of human existence whilst working in Iraq, Lebanon, Palestine and Darfur. I believe that the commentary of human experience can ideally be shared through the medium of photography. I strive to create work that informs the social conscience."

OLAF SCHUELKE (INDIA)

Olaf Schuelke is a self-taught German documentary photographer based in Singapore. He holds a master's degree in architecture but works as a freelance photographer.

MARCUS SIMAITIS (MEXICO)

Marcus Simaitis is a freelance photographer specialising in reportage and portrait photography based in Dortmund, Germany. He works for print media and non-government organisations worldwide. His website is www.marcus-simaitis.de.

DAVID MAURICE SMITH (AUSTRALIA)

David Maurice Smith is a documentary photographer based in Sydney, Australia but originally from Canada. Much of his work focuses on cross-cultural issues and marginalised communities. In 2012, he joined Australia's Oculi photographic collective.

GORAN STAMENKOVIC (SERBIA)

Goran Stamenkovic was born in 1963. Living in Serbia, by profession he is a veterinarian, while photography is his favourite hobby. He is a member of the Photo Association of Serbia and has participated in more than 100 exhibitions in the country and abroad.

DAVID STANLEY (TURKMENISTAN)

Since 1979, David Stanley has authored numerous travel guides to the Pacific Islands, Alaska, Canada, Cuba and Eastern Europe for Lonely Planet and Moon Handbooks. His travels have taken him to 185 of the 193 UN member countries.

JULIA STROKINA (KAZAKHSTAN)

Julia Strokina took her first pictures when she was six years old. Her favorite theme is exploring the social problems of cities. "The main characters in my photos are the people," she says.

DARO SULAKAURI (GEORGIA)

Daro Sulakauri is a freelance photojournalist and documentary photographer.

MATJAZ TANCIC (SLOVENIA)

Matjaz Tancic is a fashion, portrait and 3D photographer who is passionate about life and photography. Born in Ljubljana, he studied in London and is living in Beijing.

TOMASZ TOMASZEWSKI (INDONESIA)

A graduate of Warsaw's Academy of Fine Arts, Tomasz Tomaszewski specialises in press photography. For more than 20 years, he has been a regular contributor to National Geographic Magazine, which has published 18 of his photo essays. He has also taught photography in Poland, the US, Germany and Italy.

SANTO UMBORO (INDONESIA)

Santo Umboro is a photographer and lecturer. He and his family live in Yogyakarta.

AMI VITALE (ETHIOPIA)

Ami Vitale's journey as a photographer and filmmaker has taken her to more than 85 countries. Almost every major international publication has commissioned work from her, and her images have been exhibited around the world in museums and galleries, as well as being found in numerous private collections.

BEN WELLER (SOUTH KOREA)

Ben Weller is a photojournalist and educator based in South Korea. His website is www.wellerpix.com.

CLAUDIA WIENS (TUNISIA)

Claudia Wiens is a photographer based in the Middle East for more than 14 years, working for international publications and non-governmental organisations. Her most recent personal photo-project was on women's football. Currently she is working on one about post-revolution art. Her website is www.claudiawiens.com.

BERNICE WONG (THAILAND)

Bernice Wong is a young photographer from Singapore. A background in sociology combined with a sense of adventure has led to her documenting parts of society that are often unreported or poorly represented. Her aim is to produce visual narratives that elicit empathy, raise awareness and inspire action.

SCOTT A WOODWARD (TIMOR-LESTE)

Scott A Woodward calls his photographic style "Choose Your Own Adventure Photography" after books he read as a child. For him, serendipity is the beauty of photography. Literally and creatively, he can go in one direction and discover a remarkable photographic opportunity, or he can take another and find something entirely different.

SAMUEL ZUDER (JAPAN)

Samuel Zuder is a German photographer. Born in 1965 in Leutkirch, he is now based in Hamburg. In 2012, he was awarded a project grant by VG-Bild-Kunst for his work 'Face to Faith – Mount Kailash – Tibet'. He does commissions for international magazines, publishers and advertising agencies as well as working on his own projects focused on Asia. His work has been exhibited at museums and galleries in New York and Tokyo as well as across Europe. He is represented by Cologne's laif photo agency.

CONTRIBUTORS

The Other Hundred

PANKAJ MISHRA

Pankaj Mishra, born in 1969 at Jhansi in Uttar Pradesh, is an Indian thinker and writer. A graduate of Allahabad University and New Delhi's Jawaharlal Nehru University, his first book, *Butter Chicken in Ludhiana: Travels in Small Town India* (1995) is both a travelogue and an exploration of globalisation's impact on Indian society. His second book, *An End to Suffering: The Buddha in the World* (2004) combined an account of the Buddha's life with reflections on history, contemporary India, western philosophy and the author's experience moving between Asian, European and American cultures.

His third book, *Temptations of the West: How to be Modern in India, Pakistan and Beyond* (2006) explores contemporary life India, Pakistan, Afghanistan, Nepal and Tibet. His most recent book, From the *Ruins of Empire: The Intellectuals Who Remade Asia* (2012), describes Asian intellectual reactions to the experience of western imperialism, and how these reactions shaped Asian thinking through the 19th, 20th and early 21st centuries. He has also written one novel, *The Romantics* (2000), which won the Los Angeles Times' Art Seidenbaum award for first fiction. His essays have appeared in many publications, including *New York Review of Books* and *London Review of Books*, and he is also a regular columnist for Bloomberg.

AMY GOODMAN

Amy Goodman, born in 1957, is a celebrated American journalist. Since 1996, she has been the host and executive producer of Democracy Now!, a daily national news programme aired on more than 1,100 public television and radio stations worldwide. She was the first journalist to receive the Right Livelihood Award, widely known

as the "Alternative Nobel Prize", and was the first co-recipient of the Park Center for Independent Media's Izzy Award, named for the great muckraking journalist I.F. Stone.

She is the author of five books, most recently *The Silenced Majority: Stories of Uprisings, Occupations, Resistance,* and *Hope*, written with Denis Moynihan, which rose to 11th place on *The New York Times* bestseller list. Her other books include, *Breaking the Sound Barrier*, which gave voice to the many ordinary people who stand up to corporate and government power, and three bestsellers she co-authored with her brother, journalist David Goodman: *Standing Up to the Madness: Ordinary Heroes in Extraordinary Times* (2008), *Static: Government Liars, Media Cheerleaders, and the People Who Fight Back* (2006) and *The Exception to the Rulers: Exposing Oily Politicians, War Profiteers, and the Media That Love Them* (2004).

Her reporting on Timor-Leste and Nigeria won numerous awards, including the George Polk Award, Robert F. Kennedy Prize for International Reporting, and the Alfred I duPont-Columbia Award. Her many other awards include being honoured by the National Council of Teachers of English with the George Orwell Award for Distinguished Contribution to Honesty and Clarity in Public Language.

BEI DAO

Bei Dao, born in 1949 in Beijing, is one of China's most important contemporary poets and authors, whose work has been translated into more than 30 languages. Originally known as Zhao Zhenkai, he adopted the pseudonym Bei Dao ("north island") to reflect his north China home and his preference for solitude. In the 1960s, he was briefly a Red Guard during the Cultural Revolution before being sent to the countryside to be a construction

worker. It was during that period that he started writing poetry.

During the 1970s and 1980s, he was a leading member of the "Misty Poets" group of avant-garde writers. Much of his early work appeared in *Jintian* (Today), a periodical he co-founded in 1978. *Jintian* flourished during the Beijing Spring period of 1978-79, but was then banned once Deng Xiaoping had consolidated his grip on power. In 1989, he was exiled from China after the suppression of the student-led protests of that year. For nearly two decades, he lived and worked in several European countries and the United States before being allowed to return to China in 2006. He now divides his time between Hong Kong and Beijing.

CHIKA UNIGWE

Chika Unigwe, born in 1974 at Enugu in Nigeria, is a novelist writing in both English and Dutch.

Her most recent work, *Night Dancer* (2012), written in English, explores how a daughter discovers the secrets of her mother's life. Her debut novel, *De Feniks* (2005), written in Dutch, was shortlisted for Holland's Vrouw en Kultuur Debuutprijs for the best first novel by a female writer. Her second novel, *Fata Morgana* (2008), was also published in Dutch. Her first novel in English, *On Black Sisters' Street* (2009), about African prostitutes living and working in Belgium, won the 2012 Nigeria Prize for Literature.

In 2003, she was shortlisted for the Caine Prize for African Writing, and in 2004, she won the BBC Short story Competition and a Commonwealth Short Story Competition award.

She has a PhD in literature from the University of Leiden in the Netherlands. As well as having short fiction published in several anthologies, journals and magazines, she has also written two children's books. She lives in Turnhout, Belgium.

CARLOS GAMERRO

Carlos Gamerro, born in Buenos Aires in 1962, is an Argentinean novelist and translator. He has published five novels, *Las Islas* (1998), *El sueño del señor juez* (2000), *El secreto y las voces* (2002), *La aventura de los bustos de Eva* (2004) and *Un yuppie en la columna del Che Guevara* (2011), and a collection of short fiction, *El libro de los afectos raros* (2005).

He also has written works of criticism and has translated works by Shakespeare, WH Auden, and Harold Bloom into Spanish. Two of his novels have been translated into English, The *Islands* (2012) and *An Open Secret* (2011).

He studied and taught Literature at Buenos Aires University, and now teaches at the Universidad de San Andrés and MALBA, the Latin American Art Museum of Buenos Aires. In 2007 he was a visiting fellow at Cambridge University and in 2008 he took part in the International Writers Workshop (Iowa). He lives in Buenos Aires.

JANICE GALLOWAY

Janice Galloway, who was born in 1955 at Saltcoats in west Scotland, is a writer of novels, short stories, prose-poetry, non-fiction and libretti. Her first novel, *The Trick is to Keep Breathing* (1989), is now widely regarded as a Scottish contemporary classic. She has published two other novels, *Foreign Parts* (1994) and *Clara* (2002), three collections of short stories, *Blood* (1991), Where You *Find It* (1996) and *Collected Stories* (2009), and a book of poetry, *Boy Book See* (2002).

Her first memoir, *This Is Not About Me*, was published in 2008. *All Made Up*, an "anti-memoir" of her teenage years, was named Scottish book of the year for 2012. She was the first Scottish Arts Council writer-in-residence to Barlinnie, Cornton Vale, Dungavel and Polmont prisons. A graduate of Glasgow University, she lives in Lanarkshire in central Scotland.

ACKNOWLEDGEMENTS

The Other Hundred

PROJECT DIRECTOR
Chandran Nair

PROJECT MANAGER
Tingting Peng

PHOTOGRAPHY DIRECTOR
Stefen Chow

EDITOR-IN-CHIEF
Simon Cartledge

BOOK DESIGN
Valerie Kwong

COVER DESIGN
Claudia Fischer-Appelt
(Karl Anders)

ASSISTANT EDITOR
Surya Balakrishnan

EDITORIAL ASSISTANTS
Jeffrey Cheuk
Ming Chun Tang

PROJECT ASSISTANTS
Yuxin Hou
Bridget Noetzel
Shawn Koh

VOLUNTEERS
Minji Xie
Cristina Tahoces
Claudia Wanner

INTERNATIONAL JUDGES
Ruth Eichhorn
Richard Hsu
Stephen Wilkes

VIDEO PRODUCTION
Chris Gelken & Shirley Han Ying
(Ridealist)
Eric Grinda (Artisan Ltd HK)

SPECIAL THANKS
Eric Stryson
Karim Rushdy
Mei Cheung
Feini Tuang
Yuyun Chen
Caroline Ngai
Helena Lim
Marius van Huijstee
Paul French
Peter Kravitz

SPONSORS

ADDITIONAL PROJECT SPONSORS
TC Capital
Quam Financial Services Group
Swire Properties
Uniplan Hong Kong Limited
International Herald Tribune
(International New York Times)
PROVAAT

PROJECT SUPPORTERS
FleishmanHillard
Cocoon Hong Kong
Zermatt Summit

The Other Hundred is a project of the Global Institute for Tomorrow

A Oneworld Book

First published by Oneworld Publications 2013
Copyright © Global Institute for Tomorrow 2013

The moral right of Global Institute for Tomorrow to be
identified as the Author of this work has been asserted by
it in accordance with the Copyright, Designs, and
Patents Act 1988

ISBN 978-1-78074-375-2

Designed by Valerie Kwong
Cover design by Claudia Fischer-Appelt (Karl Anders)
Photographs, Introduction, Afterword and essays © individual
photographers and contributors
Printed and bound in China by C&C Offset Printing Ltd

Oneworld Publications
10 Bloomsbury Street
London WC1B 3SR
United Kingdom
www.oneworld-publications.com

Stay up to date with the latest books,
special offers, and exclusive content from
Oneworld with our monthly newsletter

Sign up on our website
www.oneworld-publications.com